3D Photoshop for Creative Professionals

Starting with the fundamental tools, shaping techniques and lighting tricks and ending with advanced resources, *3D Photoshop for Creative Professionals* guides you with a clear voice and creative exercises that encourage you to work as you read. As you progress through techniques to custom build 3D creations in Photoshop, you will also learn how to easily import your 3D objects from other software into Photoshop. Accompanied by a free app that includes video tutorials, interactive models to compare against your activity work from the book and updates on the latest Photoshop releases, this book will elevate your art off the page and into a new world of possibilities. As a digital artist and educator, Stephen Burns demystifies the digital tools to help artists work more intuitively with their digital toolsets.

- Free accompanying app makes this book an interactive experience through videos, interactive models, rolling updates and more
- Clear and easy to follow instructions for creating custom 3D graphics that will take your work into the next dimension
- All techniques presented will work with images imported from other software like 3DMAX, Maya and ZBrush

Stephen Burns (www.chromeallusion.com) is a digital artist and an AEL (Adobe Education Leader) and has taught digital creativity internationally. He is also the president of the San Diego Photoshop User Group, which is currently the largest Adobe Photoshop user group in the USA. He is a guest writer for a number of magazines including *Photoshop User Magazine*. This being book number 8 in a series of books he has written, he is also known for the *Photoshop Trickery & FX* series and *The Art Of Poser and Photoshop*. He has been a corporate instructor and lecturer in the application of digital art and design for the past 15 years internationally. He also exhibits digital fine art around the world at galleries such as the Durban Art Museum in South Africa, the Citizens Gallery in Yokahama, Japan and the CECUT Museum Of Mexico.

3D Photoshop for Creative Professionals

Interactive Guide for Creating 3D Art

Stephen Burns

Routledge
Taylor & Francis Group

LONDON AND NEW YORK

This book is dedicated to Linda and Lamont Burns for being exceptional parents.

First published 2016
by Focal Press

Published 2017 by Routledge
2 Park Square, Milton Park, Abingdon, Oxon OX14 4RN
711 Third Avenue, New York, NY 10017, USA

First issued in hardback 2017

Routledge is an imprint of the Taylor & Francis Group, an informa business

Library of Congress Cataloging-in-Publication Data
Burns, Stephen, 1963–
 3D Photoshop for creative professionals : interactive guide for creating 3D art /
Stephen Burns.
 pages cm
 1. Adobe Photoshop. 2. Photography, Stereoscopic—Data processing. 3. Photography—
Digital techniques. 4. Three-dimensional imaging. 5. Computer art. I. Title.
 TR267.5.A3B8623 2016
 006.6'96—dc23
 2015018254

ISBN 13: 978-1-138-40063-4 (hbk)
ISBN 13: 978-1-138-84225-0 (pbk)

Typeset in Myriad Pro
by Apex CoVantage, LLC

Contents

Acknowledgements

Without the help and guidance of the following individuals, this book would not have been possible.

A huge thanks to Deirdre Byrne and Anna Valutkevich for being so patient. You are great to work with.

Also, a huge thanks Kenneth Johnson, Kevin Loughran and Wesley Gunn of Zephyr images. A big thanks also to Gina Zdanoics for the music. You guys created an awesome app that we can all be proud of and you were a joy to work with. Thanks for being patient.

Thank you to Steve Smith and Tony Arredondo of WACOM technologies for their friendship and support. It is an honor to be a part of your team.

A big thanks to Bert Monroy for an inspiring foreword. Thank you so much.

A huge thanks to Brian Haberlin, Lee Kohse and Jack Whidden for their never-ending willingness to share their knowledge and give advice and critique.

A special thanks to Adobe, Newtek, Smith Micro and CamRanger, for their wonderful support. You make fantastic products.

Thanks to my tech editor David Good for being diligent in testing out the tutorials and certifying proper and effective workflow.

Finally, thanks to the members of the San Diego Photoshop User Group (www.sdphotoshopusers.com) for their dedication and support in helping me build a strong network of digital artists from which I draw my inspiration.

About the App

Accompanied with this book is an app that you will be able to interact with on your Droid or Apple mobile device. Within this app you will have the ability to view an interact with 3D objects and videos for various tutorials throughout the book. For the 3D objects use your fingers to swipe and rotate them or use two fingers to pinch to zoom in or out. The videos included will further assist you on getting a better grasp on the techniques provided in the book. The purpose of the app is to help you to compare your results to mine. Keep in mind that I do encourage creative freedom so your results do not have to exactly match what I produced. There are notes indicating these videos and tutorials throughout the book.

The app is available for the iPad and iPhone in the iTunes App Store, and Android users can find it through Google Play. Just search for 3D Photoshop on either of these platforms and download it to your device.

References to the app in the book are accompanied by the following icon:

Foreword

The world of 3D graphics has dramatically transformed the way we approach the creation of images. Compare sci-fi movies of the 1950s to the visually stunning and believable blockbusters we see today. Long gone are the days when the camera would pick up the strings that held the flying saucer as it flew across the sky. Today, a simple automobile can suddenly transform into a gigantic robot and go running down the street! And look real!

TV commercials have taken on a new life as well. Cars speeding up along a vertical track reaching into the sky would never be attempted save for the fact that the stunts are really being performed by a 3D generated car. Those "scrubby bubbles" never looked so lifelike!

The days of cell animation are giving way to the life-like characters that kids today take for granted. No longer do the characters pan and zoom through a flat landscape. Today they interact with the environment and twirl around it as if it was a real world that they inhabit.

These 3D tools have been around for some time now. Mostly they were tools that required a massive financial investment and a learning curve that would terrify even the most adventurous. With the advent of personal computers, however, we started to see tools that were manageable price-wise, though a bit limited in what they could do. It wasn't long before we started seeing the tools get more and more powerful with prices that didn't require a second mortgage on your house. Still, they were pricey and difficult to use. You really needed to justify laying out a large chunk of change and spend many hours learning how to use them.

The world of 3D does have tremendous advantages for anyone involved in the graphic arts. It provides you with a virtual photo studio where you have all the lights and backdrops you could ever want. It also turns you into a sculptor that can create any object, imagined or real, made of any material from solid marble to crystal-clear glass.

I asked Adobe why they were venturing into this world of 3D graphics that was already populated by so many players. Their response was that they wanted to offer 3D capabilities within Photoshop to users who would normally avoid the concept altogether. It made sense—Photoshop offers all the tools you need to manipulate photographic elements and create additional items from scratch. 3D offers a whole new way of generating that one little item you need to complete your image, including a way to light it and have it interact with the rest of the image.

Ah, but there is still that learning curve! There are terms and tools that will leave you scratching your head. That is where this book comes in!

Stephen is a very creative and talented artist. He also happens to be a fantastic teacher. The surreal and colorful images that Stephen creates mesmerize the senses. They are testimony to the fact that he dedicates himself to mastering his craft. He has spent long hours tinkering with these 3D tools in Photoshop to see what they are capable of doing. He has done the legwork for you and presents it in a way that will help you to understand what these tools will let you accomplish.

The teaching skills that he so effectively uses in a classroom situation are clearly presented in the pages of this book.

This book will introduce you to the complex world of 3D in a way that is not only easy to comprehend, but inspirational, and will motivate you to explore these tools further on your own.

Whether you realize how important 3D can be in your workflow or are just curious what all the fuss is about, this book will open your eyes. Oh! Did I mention 3D printing? This all leads to a new world where you will create art that you can literally wrap your arms around. Get ready to expand your horizons!

—Bert Monroy

Introduction

This is a book for those who are new to 3D and are looking for artistic ways to include it into their workflow. However, this is not a book for Photoshop beginners. This book assumes that you understand Photoshop's interface and navigation. This book also assumes that you have a working knowledge of selections, layers, masks, adjustment layers, applying clipping paths as well as an understanding of layer blend modes and their applications. However, the unique nature of this book and app combination will be beneficial for all. **All files for the book can be downloaded at https://www.routledge.com/ products/9781138842250**.

In my career as an instructor & lecturer, I have found that everyone learns differently and that learning comes in several flavors. For example, some learn visually while many are more hands-on, and yet there are a great many who learn audibly. There is a great excitement and hunger for knowledge relating to new creative technologies but we have challenges in today's environment in getting the education that connects with our unique personality.

In my observation, in-class education is often forsaken in favor of books and online workshops by pros or through videos like YouTube or Vimeo. We want to learn from the professionals but we are not always in a position to apprentice under them in person. So, just as books originally dealt with that immediate need so too do social media and videos address the same need to a larger audience.

I felt it was time for a book that addressed the cognitive, tactile and visual ways of learning. I wanted all three possibilities combined in one book as a unified learning experience. To do this I chose to create an app that encompasses 3D, video and touch.

Adobe has made some game changing decisions in how we work and see ourselves as digital artists. It all began when Adobe made Photoshop and their entire suite affordable through subscription pricing. This has leveled the playing field giving the common person access to several types of industry-professional software to include video (Premier Pro), compositing (After Effects), sound (Audition) and now 3D (Photoshop). Now we must think and create in a multifaceted manner if we want to be relevant in the game and art of digital creation.

Another game changer in today's industry is the proliferation of mobile computers and tablets. Their popularity proves that we as creative individuals prefer not to be locked inside a studio but to have the flexibility to move back and forth on location as well as back into the office as needed. Another

interesting observation is the need to use our hands and fingers to interact with the screen monitor as part of one's interactive workflow, like creating with a Wacom Cintiq Companion, Microsoft Surface, iPad or Droid mobile. All visual content in this book is created using the Wacom Cintiq Companion 2 (http://www.wacom.com/en-us/products/pen-displays/cintiq-companion). It is important to note that you do not need to have a tablet computer to learn from this book but it is recommended that you at least have an Intuos Pro tablet (http://www.wacom.com/en-us/products/pen-tablets/intuos-pro-se), which also has touch capabilities. Using a mouse will work but you will miss the experience of a touch-integrated environment.

Be sure to watch the videos in the app, "Wacom Tablet Workflow" and "Wacom Tablet & CamRanger." I hope that they will add insight as to the practicality of the new direction the technology is growing toward.

 See the app for a video on Wacom Tablet Workflow

 See the app for a video on Wacom Tablet and CamRanger

I truly hope that this benefits your education.

Enjoy!

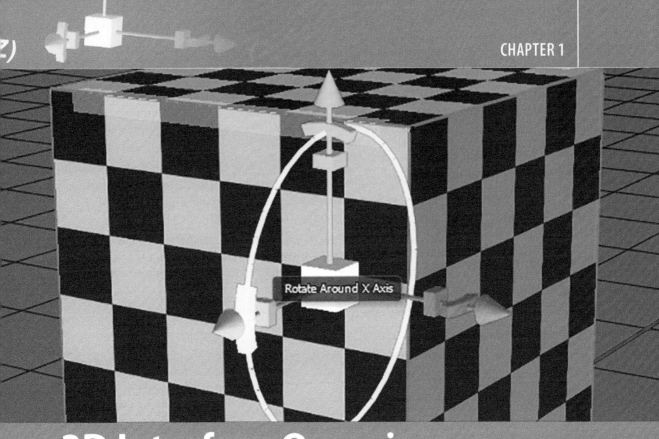

3D Interface Overview

This chapter will give a brief overview of the 3D workflow that I have found to be a time-effective way to improving your productivity as well as producing the best 3D results. We will begin with easy approaches to creating custom 3D shapes that will be used to create more sophisticated 3D models.

Photoshop has come a long way and now it is ready for primetime in the use of integrating 3D. Most do not realize the power and flexibility that Photoshop has when integrating 3D into their workflow, or even that it has one. This

book will also address the criticisms that 3D functionality in Photoshop is not good enough by showing you the enhanced lighting and texturing capabilities.

So, let's discover the inner workings of the 3D interactive space in Photoshop that will bring your work to an all-new level. To use 3D in Photoshop make sure that you have a compatible graphics card with a minimum of 512 megabytes of RAM with Open GL 2 capabilities.

Keep in mind that Photoshop is optimized for NVidia cards so if you do not have a NVidia card then you may notice small differences in what it displays for the interface. Also, it is recommend that you make sure you have the latest drivers for your graphic card.

View below the complete system requirements published by Adobe:

Photoshop CC 2015 System Requirements and Language Versions

Windows
- Intel® Pentium® 4 or AMD Athlon® 64 processor (2 GHz or faster)
- Microsoft® Windows® 7 with Service Pack 1, Windows 8 or Windows 8.1
- 2 GB of RAM (8 GB recommended)
- 2 GB of available hard-disk space for installation; additional free space required during installation (cannot install on removable flash storage devices)
- 1024x768 display (1280x800 recommended) with 16-bit color and 512 MB of VRAM (1 GB recommended). Note: 3D features are disabled and some enhanced may not be functional with less than 512-MB VRAM
- OpenGL 2.0–capable system
- Internet connection and registration are necessary for required software activation, validation of subscriptions and access to online services.

Mac OS
- Multicore Intel processor with 64-bit support
- Mac OS X v10.7, v10.8, v10.9 or v10.10
- 2 GB of RAM (8 GB recommended)
- 3.2 GB of available hard-disk space for installation; additional free space required during installation (cannot install on a volume that uses a case-sensitive file system or on removable flash storage devices)
- 1024x768 display (1280x800 recommended) with 16-bit color and 512 MB of VRAM (1 GB recommended)**
- OpenGL 2.0–capable system
- Internet connection and registration are necessary for required software activation, membership validation and access to online services. Note: Video features are not supported on 32-bit Windows systems

In the process of creating this book I used the Wacom Cintiq Companion 2 (http://www.wacom.com/en-us/products/pen-displays/cintiq-companion) that has a graphics card with approximately 2 GB of memory. Look at the specs in Figure 1.1.

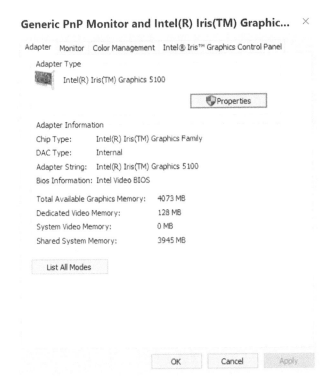

Generic PnP Monitor and Intel(R) Iris(TM) Graphic... ×

Adapter Monitor Color Management Intel® Iris™ Graphics Control Panel

Adapter Type

 Intel(R) Iris(TM) Graphics 5100

Properties

Adapter Information

Chip Type: Intel(R) Iris(TM) Graphics Family
DAC Type: Internal
Adapter String: Intel(R) Iris(TM) Graphics 5100
Bios Information: Intel Video BIOS

Total Available Graphics Memory: 4073 MB
Dedicated Video Memory: 128 MB
System Video Memory: 0 MB
Shared System Memory: 3945 MB

List All Modes

OK Cancel Apply

FIG 1.1 Graphic card specs for Wacom Cintiq Companion.

The Cintiq Companion 2 is a 13 inch tablet that uses a stylus that has the capability of 2048 levels of pressure sensitivity for realistic interaction, and gives the user tactile feedback close to using traditional paint brushes, pens, charcoals and more. The Companion 2 uses a Windows 10 Professional operating system with 8 GB of RAM, which are the system resources that I recommend. It also has graphics card resources of close to 2 gigabytes of RAM as shown in Figure 1.2. If you would like to get more specifications, I have provided a PDF file in the "Chapter 1 Work Files" folder called "CitiqCompanion_FactSheet.pdf" for your convenience on the website.

 Check out the app for the Cintiq Companion Workflow.

Since the tablet has both stylus and touch-screen technology, you can navigate the interface with your fingers or take advantage of the 2048 levels of pressure to paint onto any 3D objects. We will cover tips and tricks of using the pen and tablet as we create together.

Although it would be helpful to have a Wacom pen and tablet, it is not necessary to follow along with the exercises in this book. A mouse at the minimum will suffice.

FIG 1.2 View of system resources for Cintiq Campanion 2.

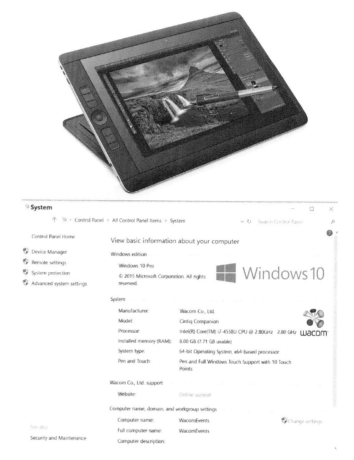

Setting Up the UI for 3D

Have as clean an interface as possible to address any real estate challenges, especially if you are going to include the use of the mobile computer tablets that allow you to work out of the studio. You want to make it as easy as possible to share your work with clients as well as work in an uncluttered interface. All files for this chapter are located in the "Chapter 1 Work Files" folder on the website.

 See the app for a video on UI and Navigation.

Step 1

In the "Chapter 1 Work Files" folder open "3D Navigation.psd."

Step 2

Go to Window>Workspace>3D (Figure 1.3) and let's take a look at Adobe's default for 3D as shown in Figure 1.3. In my humble opinion, it's too crowded. Let's clean it up.

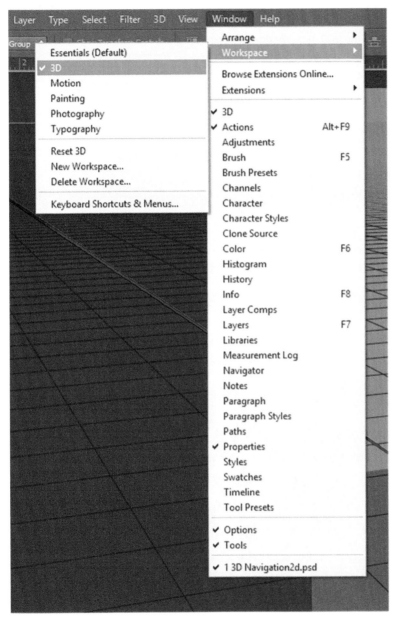

FIG 1.3 Default Adobe 3D interface.

Step 3

Close out all panels with the exception of the 3D, Layers, Channels, Paths and Libraries. Consolidate them into a single panel and place it to the right side of the UI. Also, change the Tools layout from single to double layout.

 See the app for General 3D Navigation.

Step 4

Save the UI choice (Window>Workspace>New Workspace, see Figure 1.4) and call it what you like. I called mine "Steves 3D Workflow" (Figure 1.5).

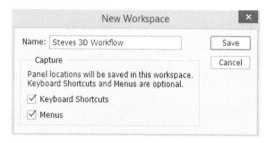

FIG 1.4 Save the 3D UI change.

Now whenever you open Photoshop this will be an option to default to and will appear in the Workspace panel as shown in Figure 1.6.

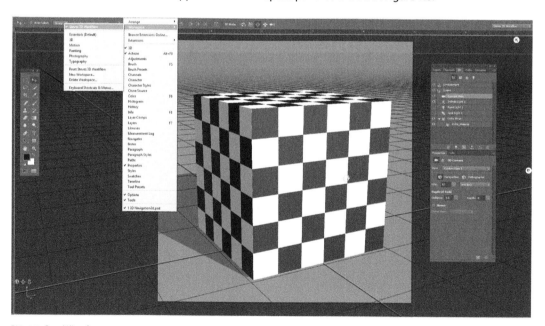

FIG 1.5 Saved UI preference.

Step 5

In finalizing UI go into Preferences (Ctl/Cmd-K) and target the Interface option and set the Color Theme to a something that you prefer. I like the darker interface, which for me is less visually distracting. Also, I choose the "Enable Narrow Option Bar" which uses symbols in place of spelling out of the various options in that location. So, check this option so that your UI matches mine (Figure 1.6A).

Step 6

Click the Performance option and set your RAM usage to somewhere close to 80%. Keep your History States under 140 so that they don't use up a lot of RAM and set the Cache Tile Size to 1028 in anticipation that you will be using larger file sizes (Figure 1.6B).

Step 7

Scratch Disks is an important option because if you run out of RAM then this option allows you to use the physical space on your hard drive as a memory storage device, so allow this to have as much space as possible. Figure 1.6c shows that I have avoided my main "C" drive in favor of three other internal drives.

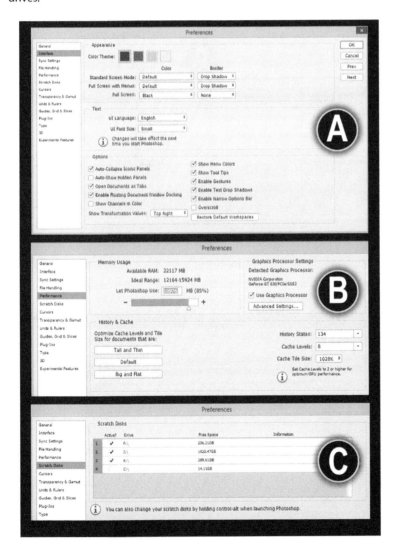

FIG 1.6 Set UI color, memory use in preferences and set scratch disks in preferences.

Step 8

Target the 3D preference and set the 3D Overlay colors to what you see in Figure 1.7A. Then in the Ray Tracer, on the center-right, set the Render Tile Size to Extra Large. Leave everything else at default for now. It will become apparent as to why we set these up is this way in upcoming chapters.

FIG 1.7 Set 3D preferences and sync all preferences.

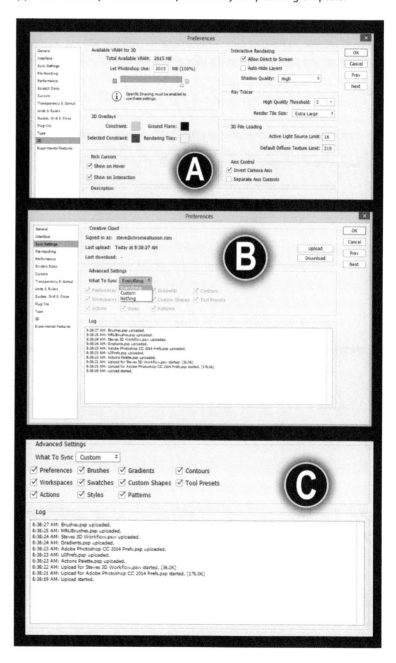

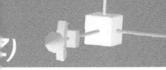

Step 9

Click on the Sync Settings option. Now that you have everything set up the way that you like it, it's time to back them up or Sync them to the cloud using the "Everything" option in the "What to Sync" drop menu shown in Figure 1.7B. Then click "OK."

If you would prefer to sync specific features then Figure 1.7C shows your choices in the "Custom" menu.

Custom choose Preferences to sync.

3D Panels and Adding More Content

Once you have a 3D layer you will then spend most of your time in the 3D Panel. This is where your 3D content and their properties will be accessed. Let's explore it.

Note: 3D layers have a cube symbol in the lower right corner of the layer's image icon as you can see in Figure 1.8.

FIG 1.8 View of a 3D layer.

Target the 3D panel (Window>3D). This is where you will find all of your 3D objects and their attributes. Take note of the four buttons across the top of the panel. Each will give you access to the Scene, Mesh, Materials and Lights.

Clicking each one will restrict your access to a different 3D attribute.

Target the first icon to access the Scene panel. This gives you access to everything in the 3D scene, which includes the Environment, Current Camera, Lights and Mesh. (See Figure 1.9A). You can show or hide any of these features by clicking the eyeball symbol to the left. You can also expand or collapse subfolders relating to each attribute. Below are some descriptions for each attribute.

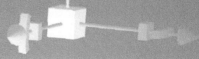

Environment: The Environment allows you to import an image and use its colors and values to light a 3D scene as well as cause reflections on 3D Mesh surfaces.

Current Camera: The Camera is your view to the composition of the scene, making you the director. It can be rotated, paned or moved throughout the space. Unlike professional 3D programs, you can only have one camera but the positions of the camera can be saved for you to access at any time.

Lights: This is your means to illuminate the 3D scene and add style and depth to it. Lights come in three versions: Infinite, Point and Spot. We will get more into these later.

Mesh: This is your 3D object. A Mesh is simply a vector surface joined together by points in 3D space.

Once again, we will get deeper into each one of these as we create the tutorials together, so let's move forward to the other three icons in the 3D panel.

As you target the second, third and fourth icons you will be restricted only to the attributes for any one of the 3D Mesh objects (Figure 1.9B), Materials for texturing (Figure 1.9C) or the 3D Lights respectively (Figure 1.9D).

FIG 1.9 View of the Mesh, Materials and Lights panel, along with their properties.

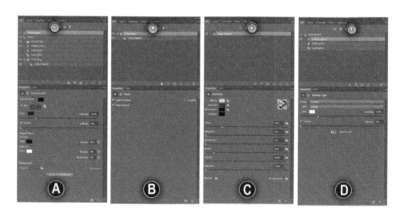

Adobe is always providing a means to keep 3D functionality interesting and productive, so they have provided a way to add more content for your 3D experience. Add new features by accessing the Get More Content Command (Window>Get More Content). Use Figure 1.10 as a guide. This takes you to an Adobe sponsored page (Figure 1.10A) where they have provided various additions for 3D Lights, textures and 3D content (Figure 1.10B). Keep an eye out for this page, as it will be updated with new information and features as 3D in Photoshop advances.

FIG 1.10 Add more 3D C=content to Photoshop.

3D Navigation

Here is where you are going to get used to moving your 3D objects around. Don't get focused on trying to match the images that you see but instead just play with and get used to the 3D navigation features.

In the 3D world you are dealing with three coordinates, which are "X", "Y" and "Z". We are most familiar with "X" (left and right) and "Y" (up and down), which most designers work in on a daily basis. However, 3D adds a third that takes you in or out of the scene and that is along the "Z" coordinate. This third dimension is the reason for 3D taking up so much memory as well as giving it a steep learning curve for its general application. In most 3D programs the "X", "Y" and "Z" coordinates are color coded to Red(X), Green(Y) and Blue(Z). In your Photoshop 3D scene, "X" is designated with a red horizontal line on the ground plane, "Y" is invisible and "Z" is coded with blue on the ground plane. On the 3D Widget, you will see the color coordination accurately display for the corresponding access, as you can see in Figure 1.11. Now, let's go explore.

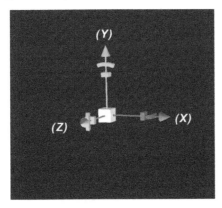

FIG 1.11 3D navigation widget.

Step 1

To assist you I have provided a document that you can use to follow along. Open "3D Navigation.tif." In order to view your 3D tools you must have the Move Tool (V) selected, as shown in Figure 1.12.

FIG 1.12 Open "3D Navigation.tif" and select the Move tool (V).

Make sure that you are displaying the 3D secondary View, 3D Ground Plane, 3D Lights, 3D Selection and UV Overlay (View>Show) (Figure 1.13A). These are on by default but it is always good to double-check. Also, most of your 3D features will be listed in the 3D menu (Figure 1.13B).

To your left, target the drop menu located on the top left of the 3D Secondary View to see orthographic views of left, right, top, bottom, back and front. This will help you to align and compose your 3D scene (Figure 1.14). By default, the secondary view window is small, so resize it by placing your mouse on the bottom right corner and then drag out the window to enlarge.

To enlarge the interior contents hold down Alt/Opt and click and drag, up to zoom in or down to zoom out.

 Check out the app: Navigating 3D Objects.mp4

Now let's explore how to navigate the 3D scene. Keep in mind that the visual results of navigating the Scene view is identical to what you will see when navigating in Camera view. The scene gives you the overall view of the 3D content and space. Essentially the camera does the same. So, with that in mind we will focus on the Scene view here but explore the camera view.

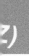

FIG 1.13 View of the 3D menu options and attributes.

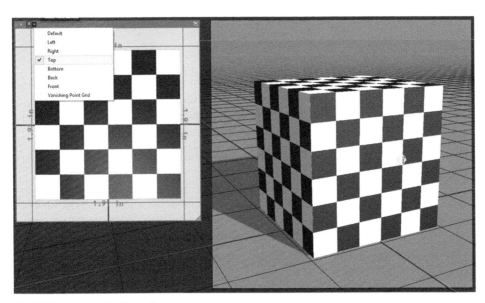

FIG 1.14 View and resize the 3D secondary view.

(Z)

Step 2

You should still have the "3D Navigation.psd" file already open. Target the Scene layer in the 3D panel.

You will see a 3D layer with a cube and a checker material on its surface. To be able to move or rotate the object you **must have your Move tool (V) activated.** Figure 1.15 shows the 3D Rotate, 3D Roll, 3D Pan, 3D Slide, 3D Scale and 3D Zoom tools, which we are now going to practice with. All will be located on the Options bar. So, target the Rotate tool.

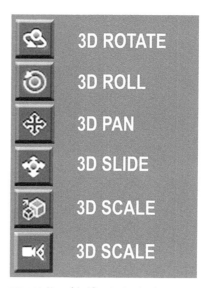

FIG 1.15 View of the 3D navigational tools.

Step 3

With the Move tool (V) activated target the Rotate option on the Options bar. Place your cursor outside of the cube and drag left to right to rotate the scene on the "Z" axis. You will see the contents rotate as if you are moving around them. Essentially, that is what is happening. This option allows you to navigate around everything along the center "Z" axis (Figure 1.16A).

Note: Hold down Alt/Opt to be placed into the 3D Roll tool and vice versa.

Step 4

Now target the Roll option on the Options bar. Place your cursor outside of the cube and click and drag left to right to roll the scene on the "Z" axis. You will see the contents rotate along the Z axis (Figure 1.16B).

Step 5

Now try the Pan option and move the cube right to left and up and down.

Note: Hold down Alt/Opt to be placed into the 3D Slide tool to push the object away or toward the user (Figure 1.16C).

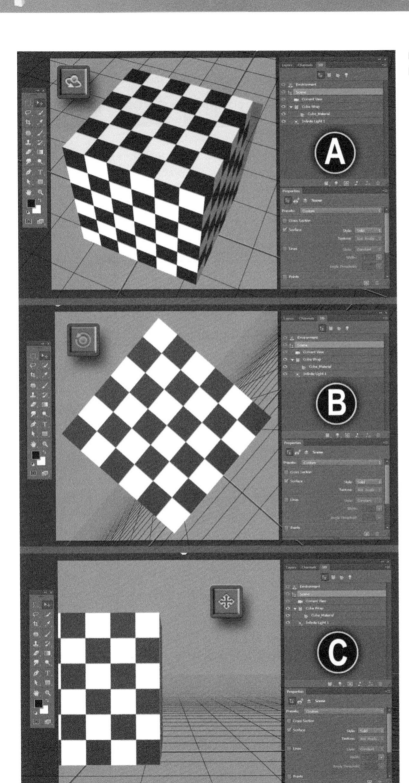

FIG 1.16 Apply the Rotate, Roll and Pan tools.

Step 6

Now try the Slide option and move the cube in and out of "Z" space.

Note: Hold down Alt/Opt to be placed into the slide tool (Figure 1.17A).

Step 7

In the 3D panel, target the Cube Wrap. This is the name of the only 3D object in this scene. We are now going to practice navigating it. So, target the Rotate tool on the Options panel and click and drag just outside of the 3D-object bounding box to rotate it above the ground plane (Figure 1.17B).

Note: Hold down Alt/Opt to be placed into the Roll tool.

Step 8

Now, target the Roll tool on the Options panel and click and drag to get a feel of how the 3D object rotates around the Z axis (Figure 1.17C).

Note: Hold down Alt/Opt to be placed into the Rotate tool.

Step 9

Use the Pan tool to practice moving the Cube Wrap in the 3D space. Remember that this tool restricts you moving using only the "X" and "Y" coordinate.

Note: Holding down Alt/Opt toggles to the Slide tool.

Step 10

Use the Slide tool and practice moving the Cube Wrap mesh in and out of the "Z" axis (Figure 1.18B). Move the mouse up or down to move the mesh toward or away from the camera. This tool not only navigates on the "Z" axis but it allows you to Pan on the "X" axis as well. So, if you drag left to right you can move the object along the "X" axis.

Note: Hold down Alt/Opt to toggle into the Pan tool.

Step 11

One of the last tools on the options bar for navigating the mesh is the "Zoom the 3D Camera" option. This essentially changes the focal length of the 3D lens to simulate what a real-world photographic lens would produce. Figure 1.18C shows the focal length at 10 millimeters, while Figure 1.19 shows the results of the lens at 200 millimeters. Play with this and get used to the 3D lens effects.

Note: You can control the camera's depth of field with the mouse or by entering the depth of field in the Properties panel.

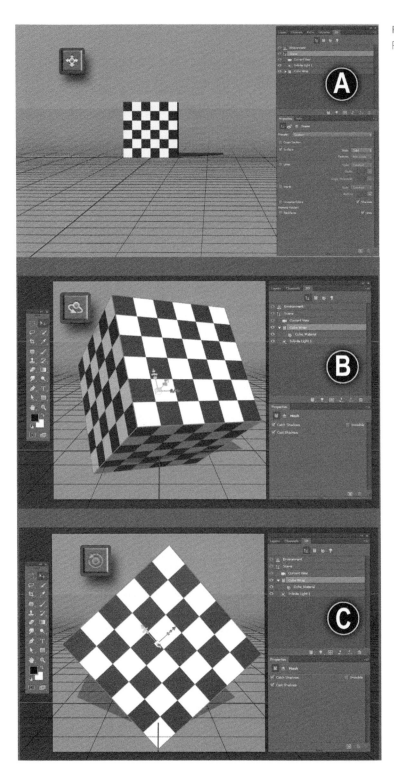

FIG 1.17 Apply Slide, Rotate and Roll to the 3D object.

(Z)

 See app for video on 3D camera navigation.

FIG 1.18 Use the Pan tool to reposition the Cube Wrap. Use the Slide tool to reposition the Cube Wrap mesh along the "Z" axis.
Figure 1.18C displays view of the FOV (Field Of View) "Zoom the 3D Camera" option.

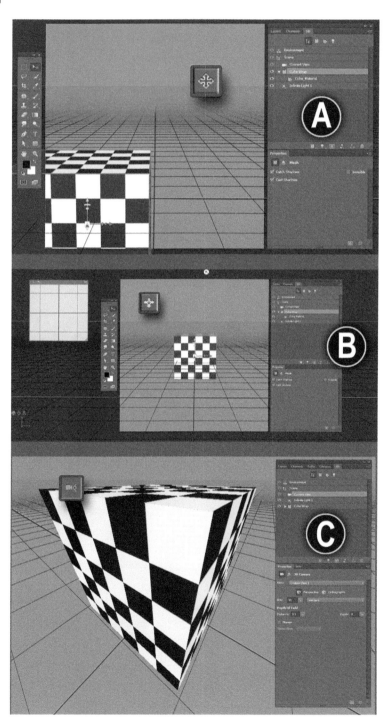

FIG 1.19 "Zoom the 3D Camera" option set to 200 mm.

Using the 3D Widget

Another way to translate the position of your 3D mesh is with the use of the 3D Widget. When your mesh is selected you will have the navigational widget positioned at the center of the mesh, which also corresponds to the rotational point of the 3D mesh.

 See app for video on Navigating with 3D widget.

Step 1

The widget is small and in my humble opinion harder to work with. So, to enlarge it place your mouse over the center cube on the 3D widget (Sale Option) until it hightlights yellow then just hold down the "Shift" key and click and drag your cursor upward to make it larger and downward to make it smaller (Figure 1.20).

Step 2

Hover your mouse over one of the curved cubic symbols on the widget to isolate the rotation on either the X, Y or Z axis (Figure 1.21A). Click and drag to rotate. Also, hover the cursor over the face of the mesh to activate an orange highlight plane over the face of the object. This will restrict movement only along that axis. Click and drag and observe the movement of the mesh along that axis (Figures 1.21B and C). You can also accomplish the same by highlighting the tip of the arrow on the X, Y, or Z axis and dragging.

See Figures 1.21 B and C as examples.

FIG 1.20 Resize the 3D widget.

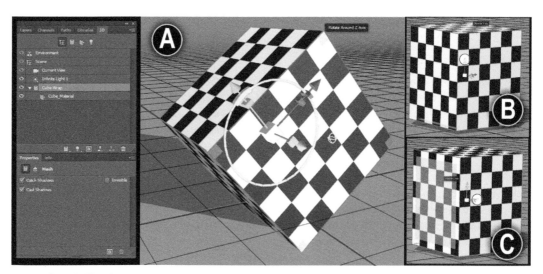

FIG 1.21 Rotate the 3D mesh.

Step 3

Hover your mouse over the edge of the mesh to activate an orange highlight plane along the corner of the object. This will restrict the rotation along that axis. Click and drag and observe the rotation of the mesh along that axis (Figures 1.22 A, B and C).

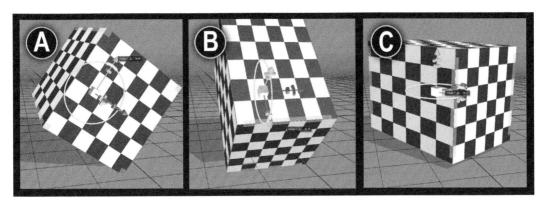

FIG 1.22 Click on highlighted corner to rotate the 3D mesh.

Step 4

Now, hover your mouse over the rectangle near the end of the axis arrow. This will restrict the resizing of the mesh along that axis. Click and drag and observe how the mesh stretches along that axis (Figures 1.23 A, B and C).

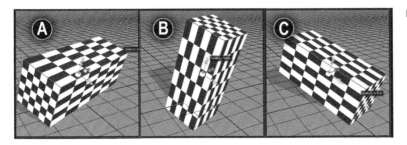

FIG 1.23 Resize the 3D mesh.

3D Lighting Types

The lighting is where you give depth and action to your 3D scene. The lights set the mood of the story and help define the character of the composition. Here we are going to simply explore how to navigate various light types. We will learn more about light in-depth in chapter 2. So, let's get started.

Step 1

In your "3D Navigation.psd" file, you will have the Infinite light as your light type (Figure 1.24). To keep organized, get the original view back for the 3D Navigation.psd using the Revert (File>Revert) command, target the light in the 3D panel and with your move tool (V) selected rotate the light around your scene and observe the quality of the light and the shadow. This represents distant light similar to sunlight. So the only navigational tools that will function are the Rotate and Roll.

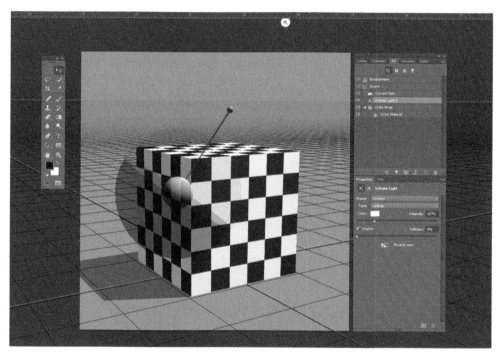

FIG 1.24 Rotate the Infinite Light.

 See the app for a video on Infinite light Navigation.

Step 2

Target the second icon from the left on the bottom of your 3D panel and add a Point light from the drop list (Figure 1.25). This represents light sources like the bare light bulb that illuminates in a 360-degree direction. Take note that the only navigational tools that work on this type is the Pan and Slide, which makes sense since there is no need to rotate a source that casts light in all directions.

 See the app for a video on point light Navigation.

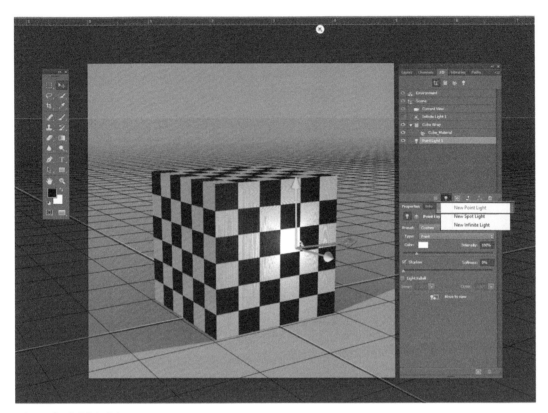

FIG 1.25 Pan the Infinite Light.

Step 3

Again, from the light type drop list add a Spot Light (Figure 1.26). This represents directional light such as stage light where you can control the angle and degree of edge falloff of the spot. Play with moving it around in 3D space and take note that all of the navigational tools will work with this light. So target each tool and practice navigating the Spot Light. Use the Cube Wrap to see how the light affects it as you move closer and farther away at various angles. We will get more in depth with light sources in chapter 2. For now, let's move on to 3D mesh viewing styles.

 See the app for a video on spotlight navigation.

 See the app for a video on spotlight angle and falloff.

 See the app for a video on light source color.

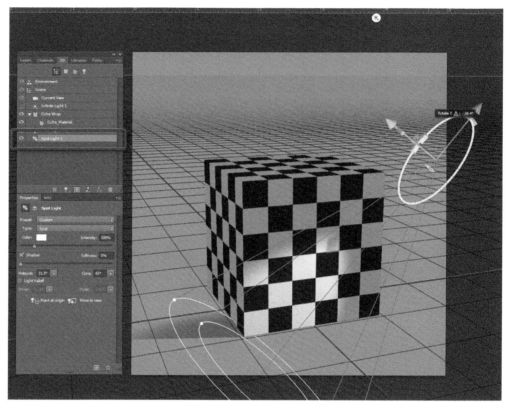

FIG 1.26 Use all of your navigational tools to move your Spot light.

Importing Third-Party Meshes and 3D Mesh Viewing Styles

3D meshes are nothing more than vector objects to which we can apply color, luminance values and images. When you are working with multiple meshes, it is sometimes easier to set viewing states of other objects so that they are not visually distracting. So we are going to begin by importing a third-party 3D mesh created in Poser 3D, and we will use it to explore our 3D viewing styles.

Step 1

Open a new document and make it 5x7 inch at 200 DPI.

Step 2

Import the Simon 3D mesh into Photoshop (3D>New 3D Layer From Files).

Step 3

The first thing you will see is a dialogue asking from where to import (Figure 1.27). Navigate to the "obj export" folder and target "poser.obj."

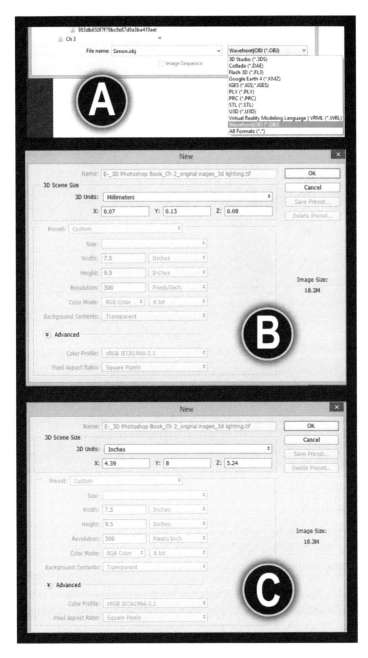

FIG 1.27 The various formats that Photoshop is compatible with. You will be working mostly with 3D Studio (.3DS), Collada (.DAE), STL (.STL) and Wavefront|OBJ (.OBJ). The most reliable of all of these formats is Wavefront|OBJ (.OBJ).

Figure 1.27 shows various formats that Photoshop is compatible with. You will be working mostly with 3D Studio (.3DS), Collada (.DAE), STL (.STL) and Wavefront|OBJ (.OBJ). The most reliable of all of these formats is Wavefront |OBJ (.OBJ). The import dialog box will also allow you to set the 3D print dimensions for the mesh By default, it is in millimeters (Figures 1 27B) but you have the option to set Inches as well (Figure1.27C).

Note: I have provided a Collada (.DAE) file as well in a folder called "collada export" so feel free to play with that. If you choose to import your 3D object from scratch then your figure might come in with brighter-looking surface textures. That is because Photoshop is interpreting the Poser 3D object slightly different from the Poser 3D program. So, if you have any problems you are welcome to open the "fighting Man.psd" file and follow along with that.

FIG 1.28 View of the imported 3D object.

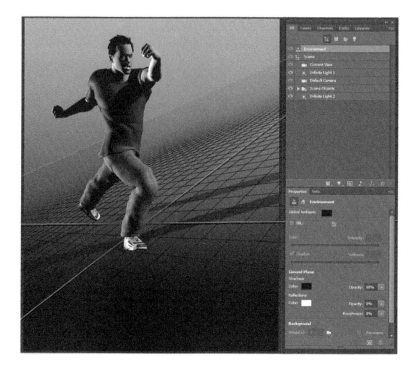

Step 4

Next click "OK." If Photoshop asks "If you would like to switch to the 3D workspace?" simply click "No" to keep your custom UI setup.

Step 5

If your figure was not imported onto the ground plane, then go to the 3D menu and target "Move Object to Ground Plane." Also, I have tilted the camera a bit to provide a more dynamic look so use the Roll tool and roll the camera to get close to what you see figure 1.28. By default, the light will be facing the character face-on so make sure that you have two Infinite lights in the scene and angle one so that it illuminates from the far right and the other coming from the left rear. The results do not have to be exact but try to get something similar to what you see again in Figure 1.28.

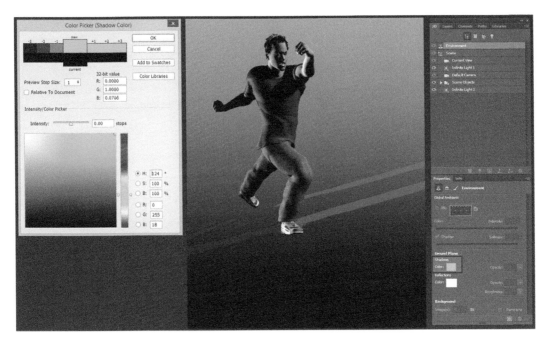

FIG 1.29

- Import "poser.obj."
- 3D print Dimensions in millimeters3D print Dimensions changed to inches.

Step 6

Select the Infinite Light 1 then target Environment in the 3D panel and focus your attention onto the Properties panel, taking note of the Color swatch on the bottom left. This is where you can change the shadow's color, so click onto the color swatch and play with selecting various colors and notice how the shadow updates instantly (Figure 1.29).

Step 7

Below Shadows in the Properties panel you will see the option to add reflections to the ground plane. To the right of it, target the drop list for the "Opacity" to view the slider and move the slider to the right to see the reflections reveal themselves like magic. The closer to 100% the more you will get an exact duplicate of the 3D objects. The further from 100% the more the colors and tones will blend with the grayish ground plane (Figure 1.30).

FIG 1.30 Change the color of the shadow and add a reflection to the ground plane.

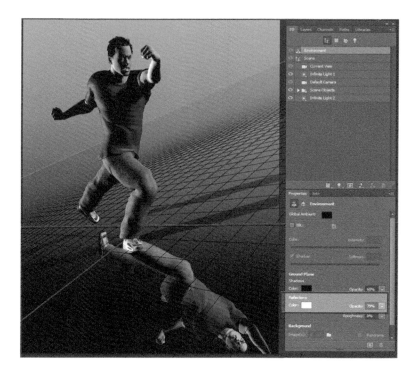

FIG 1.31 Add Roughness to the reflection onto the ground plane.

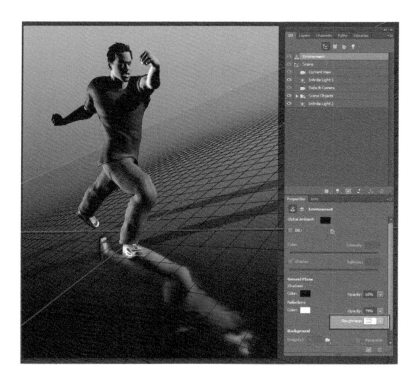

Step 8

Below Reflections in the Properties panel you will see the option to add Roughness to the ground plane. This option adds blurred distortion so that the point of the subject that is furthest from the ground plan will distort the most. The closer to 100% the more distortion will be added to all areas of the reflection. This is ideal for simulating rippled water surfaces or textured glass (Figure 1.31).

Step 9

To the left of the Reflection opacity slider is a color swatch. Target the color to change the tint of the reflection (Figure 1.32). This is handy in situations where the shadow will not be neutral in color but part of the ambient color of the scene.

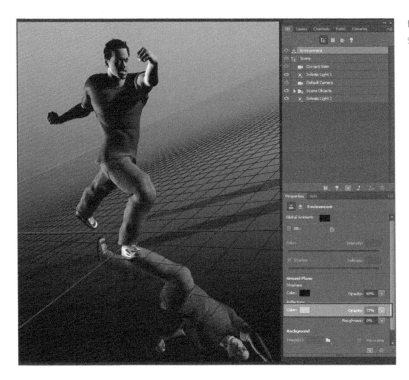

FIG 1.32 Change the color of the shadow.

3D Mesh and Surface Attributes

Sometimes you may want to work through a composition without the distraction of the textured surfaces. So, let's see what Photoshop has to offer in that respect.

Step 1

In some instances, you might want to create projects that illustrate how something is constructed. As an example, you might want to display the

internal workings of some sort of mechanical device. In other words you cut it in half to reveal the inside mechanics. The "Cross Section" option creates cutting planes that is ideal for this.

In the 3D panel, target the Scene layer. In the properties panel check the Cross Section option and choose "X-Axis" from the drop list for the Slice. As you can see in Figure 1.33, a plane is created where you can change its Color, Opacity, Offset as well as its rotation, using the "Tilt Y" or "Tilt Z" options.

FIG 1.33 Apply a cross section to the mesh.

Step 2

You can also switch which side gets viewed by hitting the "Swap Cross Section Sides" button (Figure 1.34).

Step 3

Take a look at the Style pull-down box in the Surface and Lines option below the Cross Section. Click both Surface and Lines (Figure 1.35). This option displays both the outline of the mesh and the surface texture, which is in this example a "Solid." Open the drop list and explore your options here.

Step 4

Revert (File>Revert) your document back to its defaults to keep organized. 3D objects are made up of triangular or quad polygons that are

FIG 1.34 Inverse what is displayed in the cross section option.

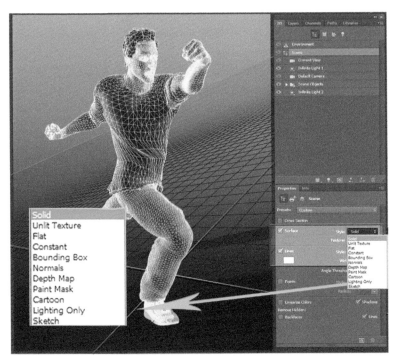

FIG 1.35 Explore the various surface options.

joined together using points. Let's view where those points are located. Uncheck the Lines checkbox and activate the Points. Now you can view where the points are on the 3D figure. In addition, you can change their color and enlarge the points using the Radius option to help you see them easier (Figure 1.36).

FIG 1.36 Explore the various surface options.

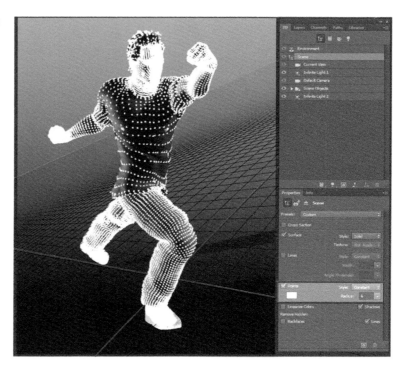

3D Environment

The difference between good and great 3D work is the subtlety of the details. Two of the most important details is reflections and ambient lighting. Everyone knows these two items instinctively and unless they are spot on people will know something is just not right. Let's take a look at the Environment option to see how that can provide the needed details that can improve a 3D scene.

Step 1

Create a new file that is 5x5 inches at 200 PPI and duplicate your layer (Ctl/cmd-J).

Step 2

In your 3D panel select "Mesh from Preset" and select the "Sphere" for the drop list (Figure 1.37), then click "Create."

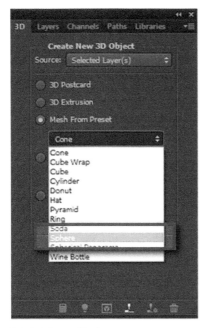

FIG 1.37 Create a 3D sphere.

Step 3

Turn off all of lights in the scene and select the Environment tab (Figure 1.38). Activate the IBL (Image Based Lights) in the Properties panel. This is where you will bring in any image and use its colors and luminance values to light

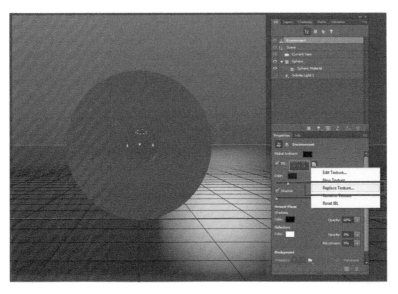

FIG 1.38 Replace the texture in the IBL option.

your 3D scene. This is utilized to merge the 3D objects into a graphic scene to visually integrate it seamlessly, making appear that it is originally part of environment.

By default Adobe has provided an image for the Image Based Light source; however, let's replace it. Target the drop menu to the right of the image and target "Replace Texture."

 See the app for a video on Environment.

Step 4

Navigate to the "Chapter 2 Work Files" folder and target the "sunset.CR2." Although this is a RAW file you can use most of the standard formats that Photoshop will recognize, including TIF, JPEG and PSD. You should see something like what you see in Figure 1.39.

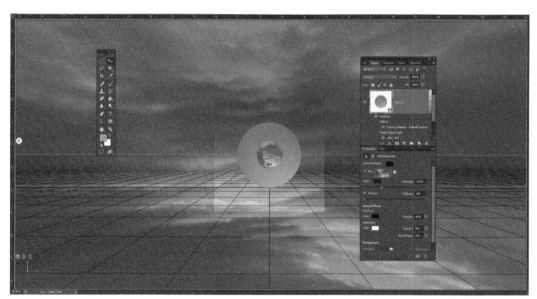

FIG 1.39 Replace the texture in the IBL option.

Adjust the "Intensity" slider to intensify the brightness in the scene (Figure 1.40).

Hold down the spacebar and Alt or Opt together and click and drag your mouse to the left to zoom back from the document. This allows you to see that the image is wrapped around the 3D space in a spherical fashion to light the environment and provide something for the mesh to reflect.

Step 5

On that note, if you would like to see the image reflected onto the surface of the 3D object, simply increase its reflectivity by sliding the "Reflection" slider to the right as shown in Figure 1.41.

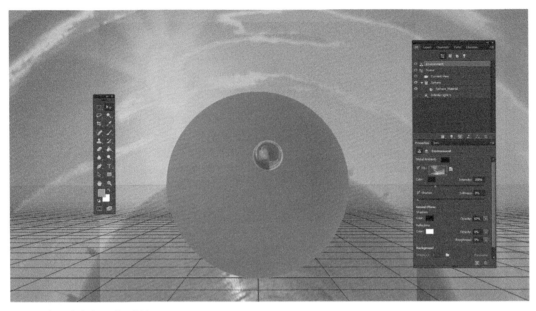

FIG 1.40 Intensify the Image Based Light.

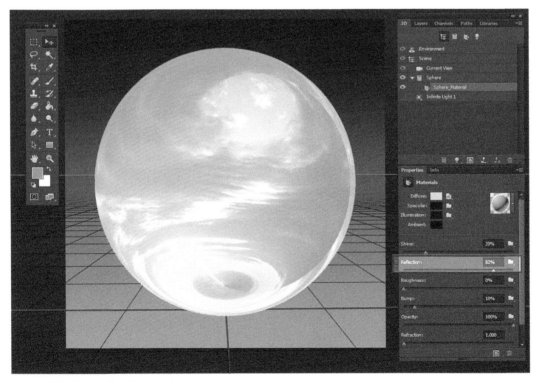

FIG 1.41 Reflect the Image Based Light onto the object.

What You Have Learned

- It is necessary to have a video card with Open GL2 and a minimum of 512 megabytes of RAM.
- You can sync your preferences to cloud once you set up Photoshop the way that you like to work.
- You can add more content using the "Get More Content" command in the 3D menu.
- To navigate a 3D mesh you have to have the Move tool (V) targeted.
- The X, Y and Z axes are color-coded red, green and blue.
- You can view the mesh using other surface attributes like Points or Lines.
- Cutting planes reveal one portion of the mesh and hide another.
- Cutting planes can be shifted and rotated around and in the mesh.
- You can change the color and opacity of a cutting plane.
- IBL stands for Image Based Lights.
- IBL light the 3D environment with an image color and luminance.
- You can apply IBL through the Environment.

Use my suggestions as a starting point then modify as you see fit for your unique purposes.

3D Lighting

How we feel about the world around us is often dictated by the mood of the environment. The quality of light, its direction and color highly influences that mood. As an example, candlelight can set the mood for a romantic dinner as it emanates a warm light that falls off quickly to shadow. Window light produces wonderfully soft lighting that is ideal for producing flattering portraits. Harsher lighting that produces strong directional shadows can set

the mood for an aggressive scene or it can bring out textures in a dynamic way. Light can be warm like a sunset or cold like the dark of night and the two work off one another. The lighting choices and styles used in 3D will be identical to how lighting is used in the world of filmmaking and photography. There are various light qualities that artists and photographers must pay attention to if their work is to be convincing and compelling and this chapter will explore those lighting styles and light quality.

In chapter 1 we discussed three light types that are available in Photoshop and which will be used to establish the mood of a scene. They are:

1. Infinite light to produce directional lighting from a distance like that of the sun (Figure 2.1A).
2. Point light source, which is similar to what a light bulb will produce. The Point light will illuminate 360 degrees from its point source. (Figure 2.1B)
3. Spot light is directional where its angle of illumination and falloff can be controlled. This is like spotlights used on the theatre stage. (Figure 2.1C)

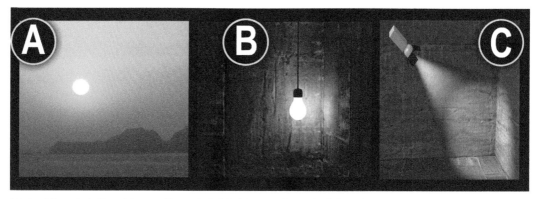

FIG 2.1 A) Example of a Distant light source, B) example of a Point light source, C) example of a Spot light source

Now let's go and explore the effects of lighting inside of Photoshop 3D by applying various portrait lighting styles to a 3D object. In later chapters we will use the following lighting techniques in some capacity.

Exploring Lighting Styles and Techniques

There are several types of lighting techniques that are used to light a subject or a scene. We are going to explore them here.

Go to the "Chapter 2 Work Files" folder and open the "3D Lighting.tif" that has the head imported from Poser 3D (Figure 2.2A). We will use this as our subject to light with an Infinite light source so that it will be easy for you see the direction in which the light is placed to achieve a particular look. By

default, the 3D bust is lit from the front but take note that a view of the actual direction of the light source is displayed in the bottom left of the frame to further illustrate how the light was positioned. Also, each lighting style has been saved in a "Preset" menu in the Properties tab for you to compare with your results. Let's go explore the various lighting techniques to consider in your 3D creations.

Side Lighting (Split Lighting)

Now let's produce a technique called Side Lighting which is also referred to as Split Lighting. Place the direction of the light to illuminate the head from the left so that the directional staff stays horizontal to the ground plane and facing 90 degrees to the front of the face as shown in Figure 2.2B. Take note that with this technique, half of your subject is illuminated by the main light source, allowing a split coming down the center of the face as the other side falls into the shadow.

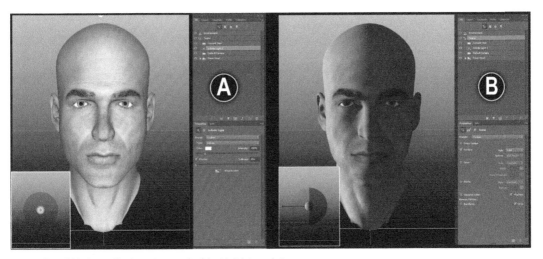

FIG 2.2 Open "3D Lighting.tif" and view the example of the side lighting technique.

 See the app for a video on side lighting.

Broad Lighting (Three Quarters Lighting)

Broad lighting is achieved by keeping the directional staff horizontal to the ground plane and rotating it so that 75% of the subject is lit. Use Figure 2.3A as a guide. The shadow should take up approximately 25% of the subject. This is also referred to as Three Quarters Lighting technique. This approach is ideal for subjects with thin facial structures.

 See the app for a video on broad lighting.

Short Lighting

Do the opposite of Broad lighting by keeping the directional staff horizontal to the ground plane and rotate it so that 25% of the subject is lit on the right side. Use Figure 2.3B as a guide. The shadow should take up approximately 75% of the subject, giving the opposite effect of Broad lighting. In a portrait situation, this is ideal for subjects who have wide facial structures.

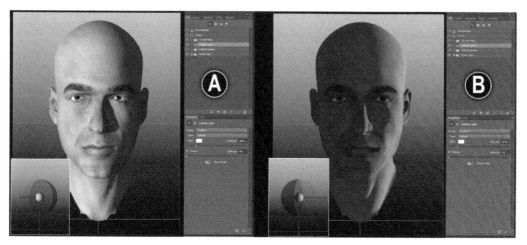

FIG 2.3 Examples of the Broad lighting and Short lighting techniques.

 See the app for a video on short lighting.

Rembrandt Lighting

To set up the Rembrandt lighting style start with the Three Quarters technique and position the directional staff at a 45-degree angle coming from the top left. This should produce a small triangular light shape under the left eye, as shown in Figure 2.4A. This approach is often considered one of the most popular and flexible. It often simulates what we see on a daily basis with the angle of sunlight falling onto a subject.

 See the app for a video on Rembrandt and rim lighting.

Butterfly Lighting (Beauty Lighting)

Create a Butterfly lighting style by placing the light directly onto the front of the face. You can quickly achieve this by targeting the "Move To View" button on the bottom of the Properties panel for the Infinite light as shown in Figure 2.4B. Next, rotate the directional bar so that it is angled approximately 45 degrees downward, to produce a butterfly wing–like shadow underneath the nose. This type of lighting is also called Beauty Lighting because it was used in the 1920s–1950s as the choice for the glamour look, using broad harsh lights. We will discuss the concept of harsh and soft lighting shortly.

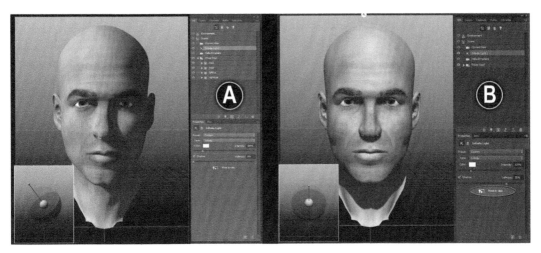

FIG 2.4 Examples of the Rembrandt lighting and Butterfly lighting techniques.

Rim Lighting

Rim lighting adds a highlight around the outer edge of a subject. Place the light to the far rear and opposite of the main light. Angle it toward the subject to produce a brighter edge of light that will add depth to the portrait. The brightness is normally a minimum of one stop greater (double) in brightness than the main light. This technique adds depth to the portrait (Figure 2.5A).

In the Properties panel Adobe has given you presets with a number of different light setups for you to explore as well. Go through them and explore the various setups that you use as a starter for any of the 3D scenes (Figure 2.5B).

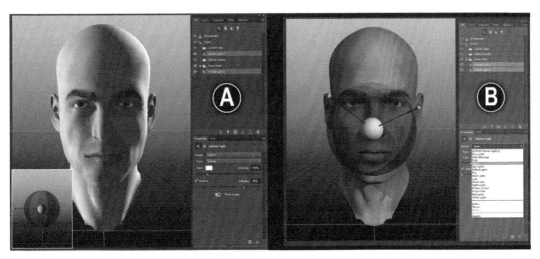

FIG 2.5 Example of the Rim lighting technique and exploring your Light presets in the Properties panel.

 See the app for a video on lighting presets.

Light Quality

The quality of light is directly related to how soft or how harsh it may be and this is controlled by using the "Shadow" slider in the Properties (Figure 2.6C). To create a greater Umbra (more shadow) and get a harsher edge, pull the slider to the left. To gain a greater Penumbra (soft area of transition from light to shadow), pull the slider to the right.

In the real world, a raw light source with no diffusion to soften it will leave harsh pits and often-unflattering details on the surface of the skin. The transition from light to shadow will also be harsh, leaving a sharp edge from where it transitions from light to shadow (Figure 2.6A). If we soften the light source using a soft box as an example, the texture on your subject will not be as noticeable and a greater Penumbra will be produced where the transitions occur between the light shadow (Figure 2.6B).

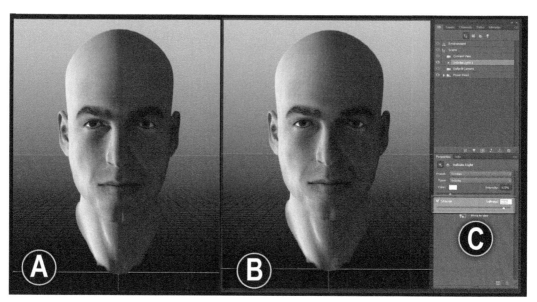

FIG 2.6 Example of hard and soft lighting results.

Step 1

Change the light type from Infinite into Spot from the "Type" drop list. Position it so that it illuminates the face of your subject from a 45-degree angle from the upper left. Set the "Intensity" to 125% to make it easier for you to see the lighting results. Make sure that the "Shadows" slider is set to "0." You are going to use only the "Hotspot" and "Cone" to control the Penumbra or edge falloff next.

Set the Hotspot to 4.8% and the Cone to somewhere around 22%. Take notice that we have a very directional light source where we can control the percentage of the Umbra and Penumbra (Figure 2.7A).

Step 2

Bring the "Hotspot" and the "Cone" closer together to reduce the Penumbra and get a harsher edge. You can achieve this by clicking and dragging on the hotspots where you see the cone angle join with the Falloff circle on the character's face. Use Figure 2.7B as an example. Now, let's look another light type that has an effect on the quality of light.

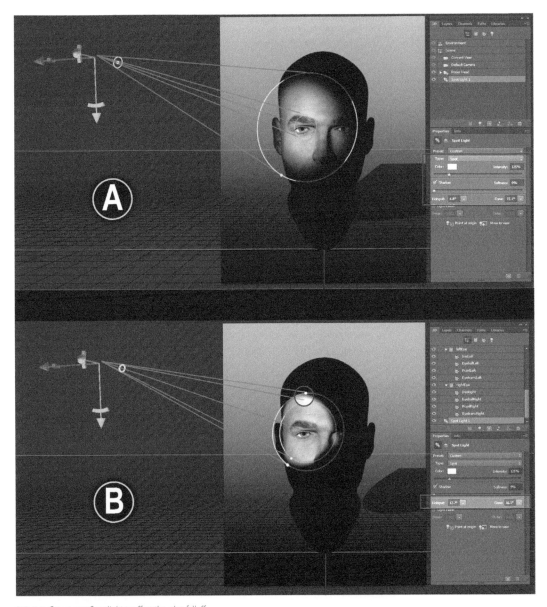

FIG 2.7 Set up your Spot light to affect the edge falloff.

Step 3

Change the light type from Spot to a Point light and place it out in front of the model and slightly to the left (Figure 2.8).

FIG 2.8 Alter the Spot into a Point light source.

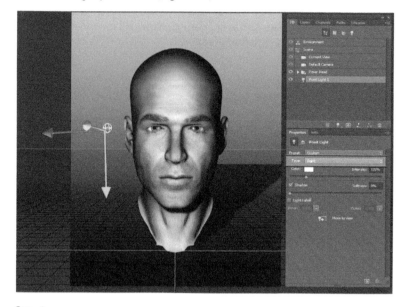

Step 4

Change the light type from Spot to a Point light and place it out in front of the model and slightly to the left. Check the "Light Falloff" box to activate it. In Figure 2.9A you will see an "Inner" circle. That is where the light is strongest. The "Outer" circle represents the distance of light falloff, or the Penumbra. In this example, you can see the "Outer" circle just barely illuminating the edge of the forehead. This is telling you that the Intensity influence of the light ends in that region.

Step 5

Now expand the influence of the "Outer" ring to see how the falloff can be expanded to provide a softer lighting choice (Figure 2.9B).

FIG 2.9 Alter the Spot into a Point light source and activate the light falloff.

Step 6

Alter the Point light back to a Spot light and position it to the top left to illuminate the bust from a 45-degree angle. Activate the "Light Falloff" for this light type as well. With this style, the "Inner" and "Outer" rings are represented with disks. Hover your cursor over it and you will see the disk display into a bright white luminance (as shown in Figure 2.10A). You can click and drag to extend or retract the Inner or Outer circles.

Step 7

Extend the "Outer" circle beyond the bust and observe the effects as the intensity is extended beyond the object (Figure 2.10B).

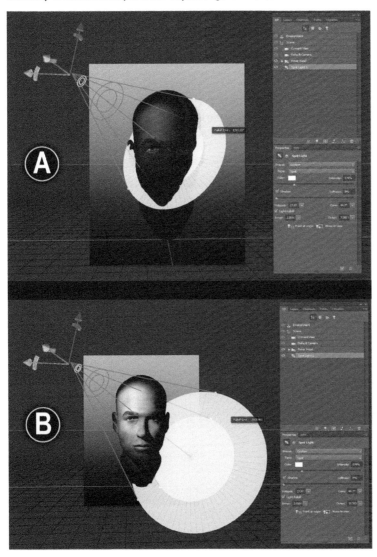

FIG 2.10 Activate and adjust the light falloff and extend the light falloff beyond the bust.

Image Based Lights (IBL)

Now it's time to explore some other sources of lighting in Photoshop 3D. We are going to explore lighting your 3D environment with an image. In addition, we are going to take a look at using 3D objects as a light source. Let's get started.

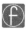 See the app for a video on lighting with a 3D object.

Step 1

Open a new file that is 5x5 inches with 200 PPI resolution. Alter the background layer into a 3D sphere (3D>New Mesh From 3D>Mesh Preset>Sphere).

Now target the "Environment" option in the 3D panel and you will see its attributes in the Properties panel. Make sure that the IBL option is checked and you will see the default image that is currently illuminating the 3D scene. Let's change this image.

Go to the Texture edit panel and target "Replace Texture." Figure 2.20 shows the default texture being used as the IBL light source; however, we are now going to change it by using the "Replace" option in the IBL texture drop list, as shown in Figure 2.11.

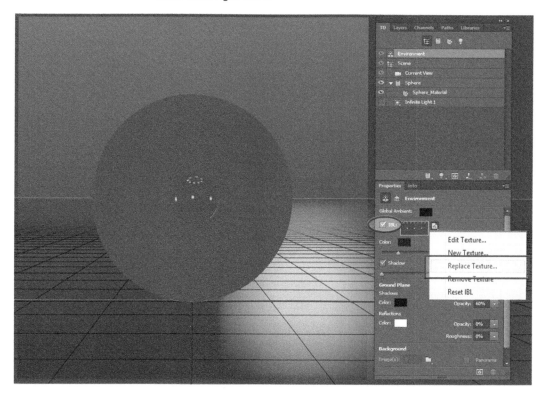

FIG 2.11 Alter the background layer into a 3D sphere.

Step 2

Next, navigate to the "Chapter 2 Work Files" folder and target "sunset pano. psd." You will now see the new image that is being used to illuminate the 3D scene. Use Figure 2.12 as a guide.

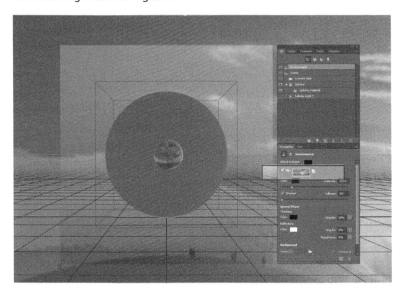

FIG 2.12 Alter background layer into a 3D sphere.

Step 3

Increase the "Intensity" of the IBL by moving the slider to the right. In this example I have 277%, but play with this and get used to it. Take visual note as to how the 3D sphere is being affected by the position of the image as well as the brightness of the light (Figure 2.13).

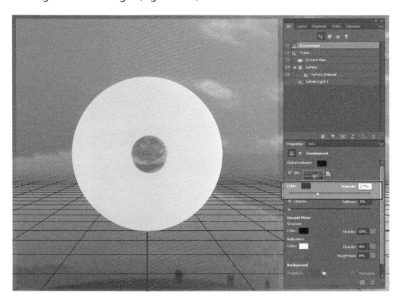

FIG 2.13 Intensify the Image Based Lights.

To get the image to reflect onto the 3D sphere, click on Sphere_material in the 3D panel, and then on the Properties panel select Reflection to increase its reflectivity (Figure 2.14).

FIG 2.14 Apply IBL image as a reflection on the sphere.

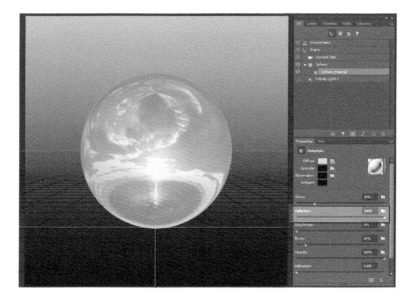

Step 4

Now, we will apply the reflection technique to a 3D bust that was imported for you from Poser as shown in Figure 2.15.

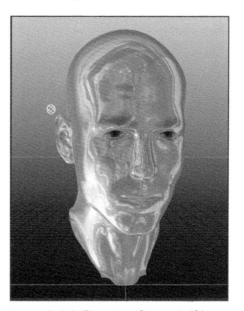

FIG 2.15 Apply the IBL image as a reflection on the 3D bust.

To begin, open "3D lighting.tif" in the "Chapter 2 Work Files" folder to view the 3D bust. In the 3D panel take note that it is made up of several 3D objects located in the 3D folder called "Poser Head." Open its drop list to view the materials for the "head" 3D object. Now select the "Head" material and apply the reflection as you have learned in steps 2 and 3.

Object Based Lighting

Object based lighting is simply using the luminosity setting in the 3D Panel to use the 3D object as a light source. For your convenience I have provided a file titled "3D lighting 002.tif" so you can open that if you like. Otherwise, follow the steps below to create the object-based light from scratch. Let's explore.

Step 1

Turn off the IBL from the 3D bust that we added in the previous exercise by simply clicking the eyeball to the left of IBL in the Environment panel. Create a medium-gray filled layer above the 3D bust. Right-click on the color fill layer and choose "Convert To Smart Object." This is a good nondestructive workflow in the event that you want to alter the colors at any time. Use Figure 2.16 as a guide.

FIG 2.16 Create new gray filled layer and remove the IBL.

Step 2

Using the 3D panel alter the gray filled layer into a 3D Postcard as shown in Figure 2.17. Click Create to finalize the process. You now have a simple 3D plane that you will use as a softbox.

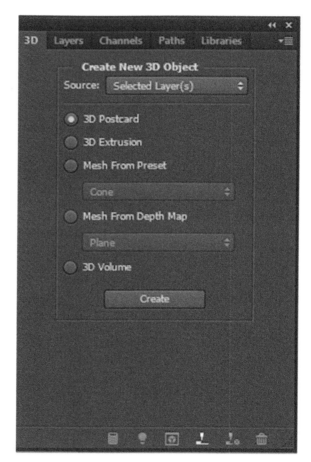

FIG 2.17 Alter new gray filled layer a 3D plane.

Step 3

In your 3D panel find and open the drop menu to your 3D plane, which in my case is called "Color Fill 1 Mesh." It may be a different name in yours. Target the Material and in the Properties tab target the color for the "Illumination." It is black by default, which means that there is no illumination. Change it to white and watch how the 3D bust becomes illuminated by the panel. Take note that the color picker panel is in Floating Point mode so you can illuminate beyond the current color or values in stops (Figure 2.18).

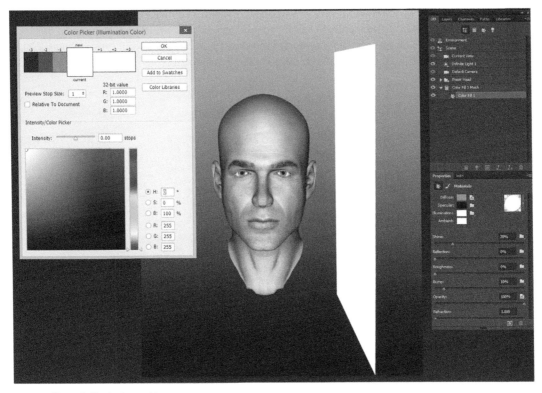

FIG 2.18 Change the Illumination to white.

Step 4

Turn off all lights in your scene so that the 3D bust goes completely black.
Now render the scene (Ctl/Cmd-Alt/Opt-Shift-R) to get the results that you see
in Figure 2.19.

FIG 2.19 Turn off all of the lights.

At first, the render will appear to have lots of noise but let it continue to render until the noise is gone. How long this will take will depend on the speed of your processor and the amount of RAM in your system. Figure 2.20 shows a more extensive render of the model.

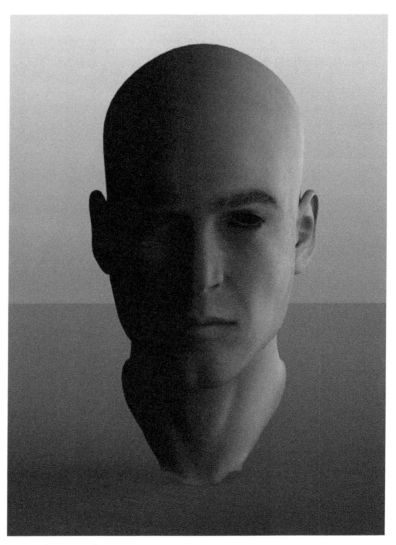

FIG 2.20 Final Render of the bust.

What You Have Learned

- Side Lighting illuminates the object from the side, leaving half in the shadow.
- Broad lighting illuminates three quarters of the face.
- Short lighting illuminates 25% of the face.
- Rembrandt lighting creates an illuminated triangle under the eye of the shaded side of the face.
- Butterfly light is so named because of the butterfly-shaped shadow that it creates underneath the nose.
- Rim light adds a brightened edge around the shaded side of the subject.
- The softness quality of light is controlled by the "Shadow" slider.
- Penubra represents that area that is the soft transition between where the light and the shadow fall.
- You can use any 3D image as a light source by applying its "Luminance" value in the Properties panel.

Simple 3D Modeling

This chapter focuses on building and composing 3D objects to create your concept. You will learn the fundamentals of how 3D objects are built in Photoshop by way of vector technology. If fact, all 3D programs are nothing more than text editors that map points on 3D coordinate space. In between these points, geometry is drawn to create the surface on which you will apply the textures to give your 3D model character. So, the type of workflow that you will rely on will use vector shapes.

And what tool do we have in Photoshop that addresses vector technology?

You have guessed it . . . the Pen tool.

In essence, Photoshop uses curvilinear shapes to build its 3D objects. To elaborate, the 3D engine in Photoshop relies on spline-based technology that creates and controls complex shapes along the path of a curve. Even though we can use painted shapes on layers to create 3D objects, the best results will come from the use of the Pen tool and vector shapes.

Chapters 1 and 2 laid down the groundwork for us to navigate and place the 3D objects, lights and camera within the 3D scene. It also established the lighting mechanisms that we have available to us in Photoshop to add mood to our scene.

I cannot say enough that you should always try to "use references" to build 3D models and we will use that approach in most of this chapter. The deciding factor in the believability of your creation will depend a great deal on the references that you choose.

In later chapters, you will learn how to texture and light the scene to complete the final vision, so make sure to save each one to be used later on. For now let's get started with custom building the 3D objects in Photoshop.

See the app for a video on 3D Housekeeping.

Modeling a Logo

Now it's time to have some real fun and build the 3D objects that give your story life. We are going to begin by learning the basics of creating custom-built 3D objects by creating a 3D logo. In subsequent exercises we will progress into more complicated designs. There are two ways to create 3D objects in Photoshop, and that is the use of either Extrusions or Depth Maps. We will explore both of these in the upcoming exercises but first let's look at Extrusions.

Step 1

Create a new document at 5x5 inches at 300 PPI. Next, create a new layer (Cmd/Ctl-Alt/Opt-Shift-N) above the background layer.

See the app for a video on 3D extrusion using a brush

Step 2

Load in the "Brushes.abr" file located in the "Brushes" folder. Choose the brush titled "Sampled Brush 21." Figure 3.1A shows the shape of the brush that you are going to use to make a 3D logo. Resize the brush so that it dominates 75% of the document and paint a black-filled shape of the brush into the blank layer that is above the background layer. Use Figure 3.1 to guide you. We will use this shape to represent a logo of sorts to make a custom 3D object.

Step 3

Now, extrude this shape into a 3D object (3D>New 3D Extrusion from Selected Layer). You will get something similar to what you see in Figure 3.1B.

This 3D object consists of the front and rear face called the "Front and Back Inflation" and the extruded shape along its side is called the "Extrusion." You will see a grid floor below your object called the ground plane that the 3D objects and lights will interact with to provide a place for the shadow and reflections to appear. We will learn more about this later.

Step 4

You can modify the length of the extrusion my focusing on the Properties panel and targeting the "Extrusion Depth" slider. Play with this to get used to the functionality of extending or shortening a 3D object's depth along the "Z" axis, as shown in Figure 3.1C.

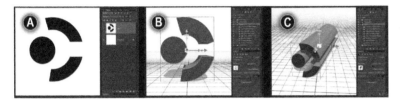

FIG 3.1 Load "Sampled Brush 21" and extrude logo into a 3D object.

Note: To see the properties for the 3D object extrusion you must have the object targeted in the 3D panel. To have the object targeted you must first have the "Move" tool (V) activated.

Step 5

Let's explore further Photoshop's capability with 3D. In the Properties panel, play with the "Twist" and explore how Photoshop twists the shape along its extrusion path. When done set it back to default shape by placing "0" for the value in Twist (Figure 3.2A).

Step 6

Reset all of the controls back to their defaults to make this exercise easier. Play with "Taper" to reduce or enlarge the back end of the extrusion. The side that will be affected is the back end that is furthest away from the original shape, as shown in Figure 3.2B.

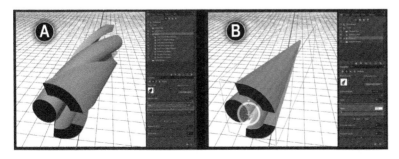

FIG 3.2 Use the "Twist" slider to twist object along extrusion path and use "Taper" slider to reduce or enlarge the opposite side of the shape.

Step 7

In the Properties panel, use the "Bend" slider to bend along the Horizontal Angle (X) (Figure 3.3A) or Vertical Angle (Y) axis (Figure 3.3B). For now, just get used to how Photoshop responds to the shape changes and do not worry about applying any specific number in the Properties panel.

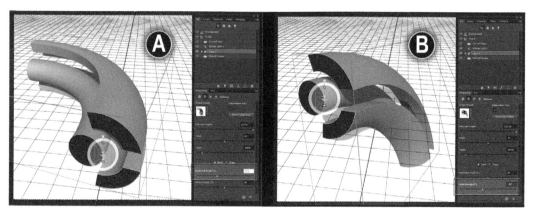

FIG 3.3 Use "Bend" slider along the "Horizontal Angle(X)" and use "Taper" slider along "Vertical Angle (Y)."

Step 8

Now, let's look at another attribute for custom 3D objects called the "Constraint." To assist you, it will help to add a black-filled color for the background to make it easier to see the constraints. So apply a "Solid Color" adjustment layer for the background that is filled with black, and then let's move on.

Constraints are the vector shapes originally used to extrude a 3D object. Remember that we could use pixels on a layer to create a 3D object just as we did with this logo. However, Photoshop will simply alter its shape into a vector shape. That is what the constraints are. The highlighted red-colored Constraint is the one that is currently selected, as shown in Figure 3.4A. To select a constraint you simply click and release directly on it. We can delete or add constraints as well. You are going to explore adding a constraint next to further modify the logo.

Step 9

Rotate the shape so that the front inflation is facing you straight on as shown in Figure 3.4B. Now use the "Elliptical Marquee" to place a circular selection in the center of the circular portion of the logo.

Note: Additional Constraints can only be added to the Front and Back Inflation, never the Extrusion.

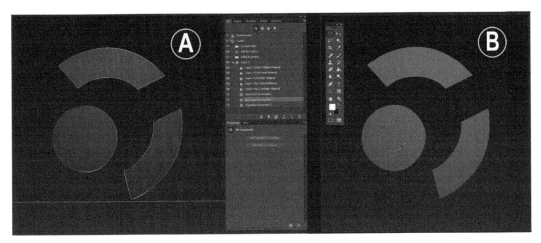

FIG 3.4 View of a selected Constraint and adding a selection to the Constraint.

Step 10

Now, add the selection as a new constraint (3D>Add Constraint(s) from>Current Selection) (Figure 3.5A). You will see a new constraint but let's use it to add a hole in the logo.

Step 11

Target the constraint on the 3D object then in the Properties panel, target the "Type" drop list and select "Hole." This will alter the shape into a hole that has been added to the 3D object. Use Figure 3.5B as a guide.

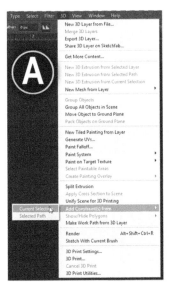
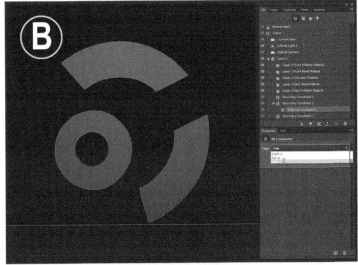

FIG 3.5 Add a selection to the Constraint and add a hole in the place of the Constraint.

Figure 3.6A displays the results of adding the new constraint. Rotate your model to become familiar with the results of adding constraints.

Step 12

Finally, we can add bevel features to any extruded 3D object. On the top of the Properties panel, target the third icon from the left to access the "Bevel" attributes. Here you can set the width and angle to get the desired effect of your choice. The "Width" sets the depth of the bevel while the "Angle" sets the edge sharpness. In addition, click on the "Contour" button as shown in Figure 3.6B and use the Curves outline to add points similar to the way you add them in the Curves command. This will add a custom bevel to your shapes. Play with this and get used to how the bevel on the 3D object reflects the shape of the curve.

FIG 3.6 Rotate to view the completed model and add a hole in the place of the Constraint.

A Simple Practical Use for 3D Illustration

Now that you have a basic understanding of how to create 3D models lets venture into more sophisticated approaches. We will begin with an obvious use of the extrusion technique to make an illustration showing different gauges of wire displaying its interior parts. In upcoming exercises, we will progress toward models that are more sophisticated in design, but for now let's keep it simple. When designing your 3D models you will often use more than one shape to build out its design. It is best to break out the various design elements into simple shapes. If we use our imagination and take wire cutters and clip the wire to look down inside it, what will we see exposed? What we will see are circular shapes within other circular shapes of various sizes. So, we will begin with that concept for the wire gauge illustration.

Step 1

Open "wire gauge" in the "Chapter 3 Wire Gauge" folder. You will see three vector layers to represent each component of the wire gauge illustration. In this example, the red represents the outer rubber housing, the gray represents the inner rubber insulation and the orange represents the copper wire. Use Figure 3.7A as a guide.

Step 2

Extrude each of the layers "copper," "insulation" and "red rubber" into a linear 3D shape as you learned in Figures 3.1–3.3. Use an "Extrusion Depth" of 3.652. Use Figure 3.7B as a guide.

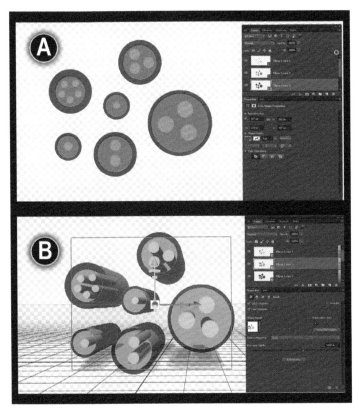

FIG 3.7 Illustrate the various components of wire and extrude shapes into 3D.

Step 3

Each 3D layer is a separate 3D environment where each one is independent of the other. So, each 3D object will not interact with the other. We need them to be part of a single 3D scene so let's accomplish that next.

Select all 3D layers then merge them into a single 3D scene (3D>Mege 3D Layers). They may not all be aligned and offset the way that we need them to

so use your 3D navigation tools to get similar to what you see in Figure 3.8A. As you can see all 3D objects are now in a single scene where lights, shadow and reflectivity will all interact with each of the 3D wire components. Although they are merged you can still navigate them individually. Just select the 3D object in the 3D panel and use your 3D navigational tool to place them as desired.

 See the app for a video on chapter 3's repositioning of 3D objects.

Step 4

Target each 3D object and apply a curve on the Horizontal (Y) axis as you learned in Figure 3.3. In addition, add a slight curved bevel to each one as you learned in Figure 3.6. Just use a simple rounded edge for the bevel, which will do the trick. Use Figure 3.8 to assist you. Let's move on to more complicated models.

Note: Keep in mind that you may need to massage each of the curve settings to get close to what you see in Figure 3.8. Yours does not need to match the example exactly. Just try to get as close as you can.

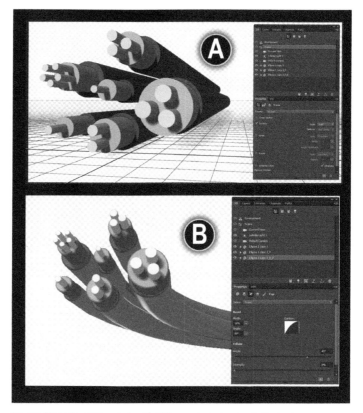

FIG 3.8 Merge shapes into a single unified 3D scene, curve shapes and add a bevel.

Building a 3D Syringe

In this tutorial, we are going to build a 3D syringe. This is an ideal exercise in that it will force you to simplify the shapes into a few simple components. We will merge the components and reposition each one to become part of the overall concept. We will use what resembles a lathe technique where you carve out shapes from a spinning object similar to what is done in woodworking or in the molding (throwing) of clay pots on a spinning wheel. Let's begin.

Step 1

If you divide a syringe into quarters and look straight on to it then Figure 3.9A is similar to what you would see. So open "syringe vectors.psd" in the "Chapter 3 Syringe" folder. You will see several vector layers representing the "injector," the "syringe," "liquid," the "needle support" and the "needle."

 See the app for a video on 3D syringe extrusion

Step 2

Begin with the syringe layer and extrude it into 3D space as shown in Figure 3.9B.

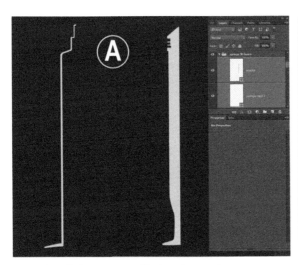 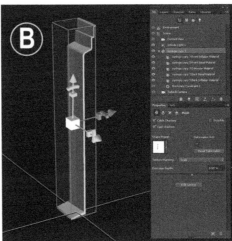

FIG 3.9 Open file "syringe vectors.psd" and extrude syringe layer.

Step 3

In your Properties panel, target the "Shape Preset" and choose the lathe option titled the "Bend X 360 Right" as shown in Figure 3.10.

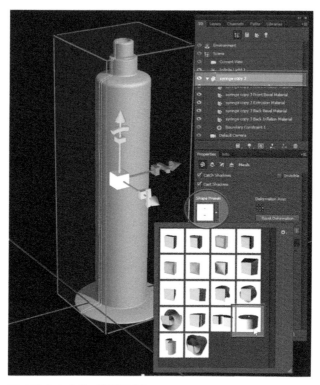

FIG 3.10 Apply the "Bend X 360 Right" preset.

Step 4

By default the syringe will probably be a little too wide so modify it so that it is thinner as shown in Figure 3.11. In this case I used an "Extrusion Depth" of .101.

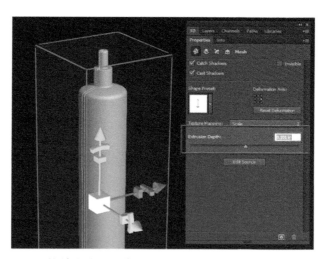

FIG 3.11 Modify the shape with Extrusion Depth.

 See the app for a video on Chapter 3's lathe and extrude adjust.

Step 5

Follow steps 2 through 4 to apply to the syringe "injector." Use Figure 3.12 as an example.

FIG 3.12 Create the 3D syringe injector.

Step 6

Now target the layers for the liquid (Figure 3.13A), needle support (Figure 3.13B) and needle (Figure 3.13C). Apply the lathe technique to all three of the vector shapes. Modify them as needed with the Extrusion slider to get close to what you see in Figure 3.14.

FIG 3.13 Create the 3D syringe injector.

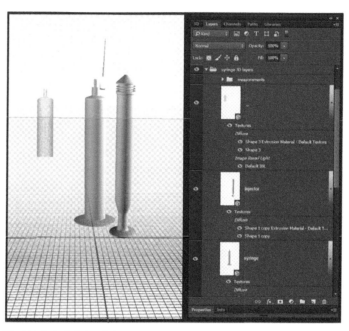

FIG 3.14 Apply the lathe technique.

Step 7

To assist with placing each object inside of each other to complete the syringe concept, select each 3D object in the 3D panel and select the Coordinates button in the Properties panel as shown in Figure 3.15. Here you can custom place objects by inputting coordinates or you can hit the "Reset Coordinates" button to place all of your objects onto the (0,0,0) coordinate onto the ground plane.

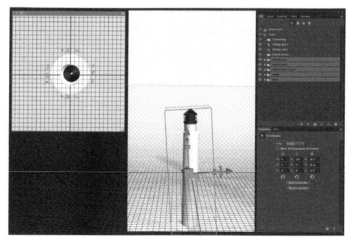

FIG 3.15 Apply "Reset Coordinate" for each object.

 See the app for a video on grouping and editing.

Step 8

Next, begin reorganizing each object to create the look of the final piece. It would help to turn down the opacity of the syringe. To do this go to the 3D panel and look for the "syringe object." In the drop list below the syringe 3D object you will see a series of Material surfaces that are instrumental in creating textures onto the objects. We will texture and discuss this in a later chapter but for now target all Materials for the syringe and set the Opacity to around 32%, as shown in Figure 3.16.

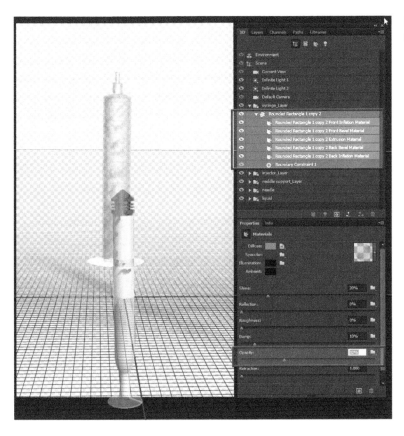

FIG 3.16 Reorganize the objects and set the syringe opacity to 32%.

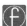 See the app for a video from Chapter 3: Make 3D objects transparent.

Step 9

Figure 3.17 shows what you should have so far. Just get as close as you can.

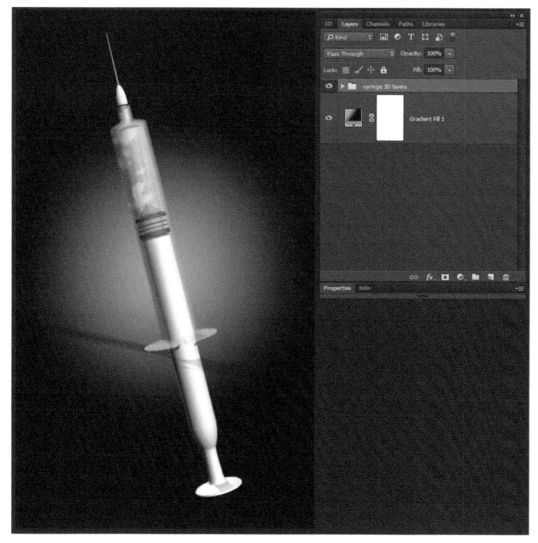

FIG 3.17 View of the final object placement

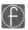 See the app for a video on Chapter 3: Resizing a document with the crop tool.

Step 10

Set up the scene with two Infinite Lights where one illuminates from the far right rear and the other from the far left rear, as shown in Figure 3.18. We will discuss lighting in detail later, so for now just position them with their intensity at 90%.

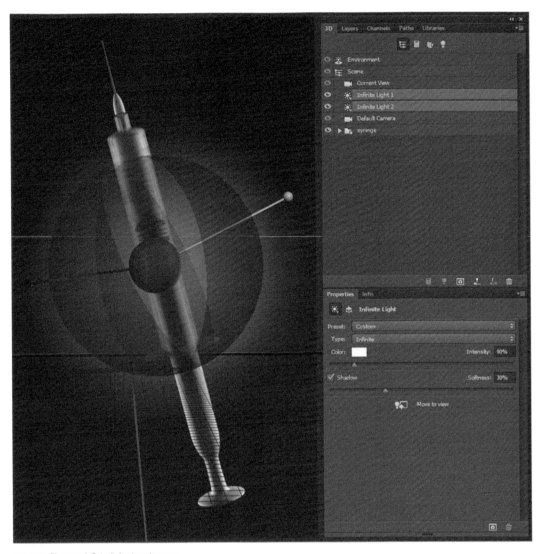

FIG 3.18 Place two Infinite lights into the scene.

Step 11

Finally, render the scene (Ctl/Cmd-Alt/Opt-Shift-R) to see how it would look at this stage of the game. Use Figure 3.19 as a guide.

FIG 3.19 Render the scene.

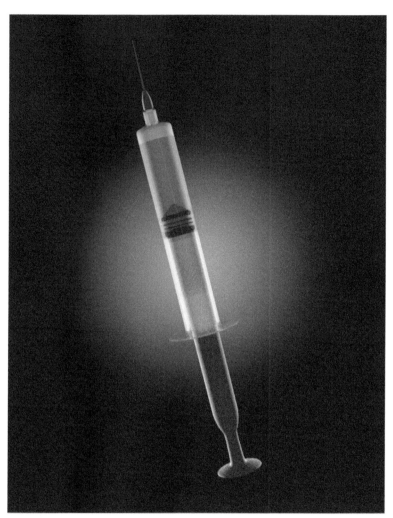

Building a 3D Microphone

Now that we have some better modeling skills, let's learn how quickly we can build a multitude of 3D objects. We will start by building a 3D microphone. This will be one of the simplest examples in building 3D objects but it will also show that you can edit in more detail after the initial creation of the object. Let's begin.

Step 1

Open the "microphone vectors.psd" inside of the "Chapter 3 Microphone" folder. You will see a layer group titled "Microphone Vectors" (Figure 3.20).

FIG 3.20 Open the microphone vectors files.

Step 2

Apply the lathe technique that you learned in Figure 3.10 to both the shape for the handle and the microphone, as shown in Figures 3.21A and 3.21B.

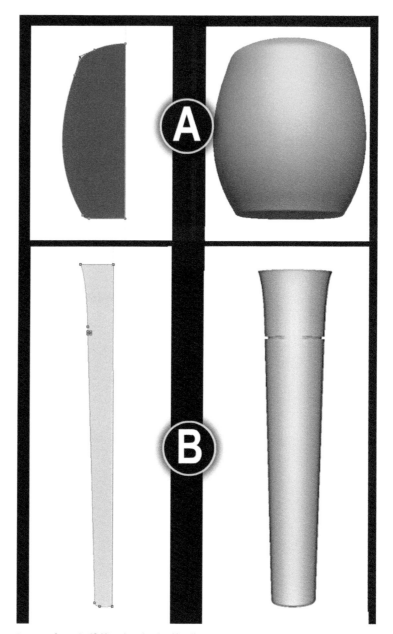

FIG 3.21 Create the 3D Microphone head and handle.

Step 3

Target both 3D layers and merge them into a single 3D scene (3D>Merge To 3D Layers) (Figure 3.22). Use your 3D navigational tools to get close to Figure 3.22.

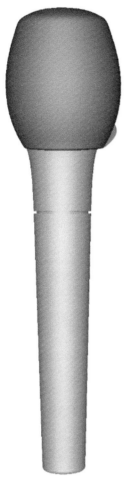

FIG 3.22 Merge the microphone 3D layers.

Step 4

This microphone will have a support band around the head. Create a circular vector shape that will be extruded to produce the microphone band. The example shows the color of the vector shape to be white, but it really doesn't matter. We just need to shape to create the band. Use your 3D navigation tools to resize and reposition the shape until you get something close to Figure 3.23A.

Next, extrude the circular vector shape and merge it with the rest of the microphone. Position it so that you get close to what you see in Figure 3.23B.

FIG 3.23 Extrude the circular band and merge the band with the microphone.

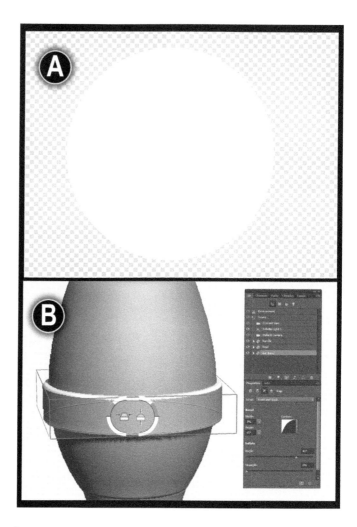

Step 5

Even after we have created the model, we can edit it at any time because the workflow is completely nondestructive.

So far, the microphone is in two 3D layers. Inside of your 3D panel where one is the head and the other is the handle, target the handle. To do this make sure that the Move (V) tool is activated and then click and release on the handle of the microphone and click the "Edit" button in the Properties panel. This will bring up the original vector shape.

Place both vector and the 3D files side by side (Window>Arrange>Tile Vertically) so that it is easier for you to see both files simultaneously as you apply the updates onto the 3D object. Use your pen tool to edit the vector shape by adding more points in an effort to add more grout and surface indentations, as shown in Figure 3.24. What you have does not have to match the example, but understand that you can edit the shape at any time. When

you are done editing your shape just hit Ctl/Cmd-S (Save) and you will see the 3D object update instantly.

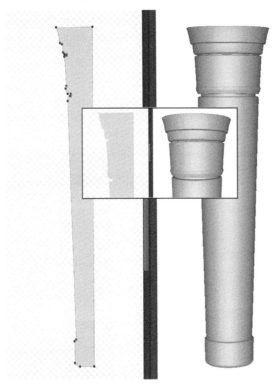

FIG 3.24 Add more surface indentation to the microphone.

Step 6

Now, render the microphone (Ctrl/Cmd-Alt/Opt-Shift-R) to get a better view of what we have so far (Figure 3.25).

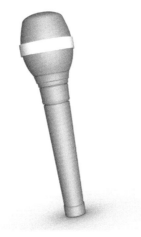

FIG 3.25 Render the Microphone.

Creating a 3D Wine Bottle and Glass

Elegant shapes work well in Photoshop 3D and the pen tool is ideal when it comes to creating elegant, fluid curves. So, it is ideal for creating the wine glass and bottle. Here we are going to create a wine bottle, wine glass, the wine inside of the glass and a ground to set them on.

Step 1

Open the document "wine & glass.tif" inside of the "Chapter 3 Wine Glass" folder. You will see three vector shapes representing the glass, wine bottle and wine (Figure 3.26).

FIG 3.26 Open "wine & glass.psd"

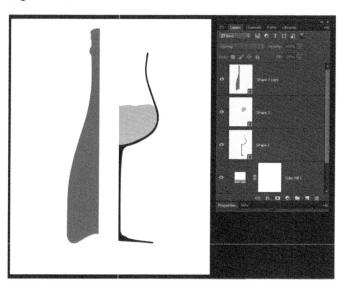

Step 2

Change the color for the Color Fill adjustment layer to a medium gray. This will help the objects stand out more so that it is easy to see the results. Now apply your lathe technique to each layer to produce what you see in Figures 3.27A

FIG 3.27 Lathe the wine bottle, wine glass and wine.

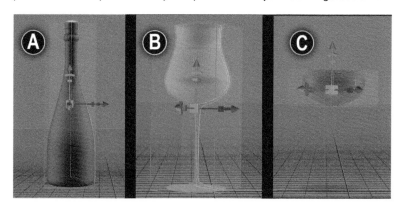

through C. Keep in mind that although the vector layers have color, when lathed they will take on a medium gray color. It doesn't matter as we will change its texture properties later.

Step 3

Let's create a table for the subjects to sit on. To do this we will create a new layer and alter that layer into a 3D plane that will interact with the other subjects. So, create a new layer (Ctl/Cmd-Alt/Opt-Shift-N). In your 3D panel you will see options for creating 3D objects, so target "3D Postcard" and click the "Create" button (Figure 3.28).

FIG 3.28 Create a 3D plane from a blank layer.

Step 4

Next, merge all of the 3D layers into a single 3D scene. Place the 3D postcard plane so that it sits flat on top of the ground plane. Position all objects on top

of the 3D postcard plane so that the glass and bottle uses it as a table. Use the "Move Objects to Ground Plane" command (3D>Move Objects to Ground Plane) to assist you. To get things set up for lights, make sure that you have a total of three infinite lights in the scene. Place the wine bottle and wine glass in the center of the table so that a quarter of the glass sits in front of the bottle toward the right. Finally, make sure that the "Camera" is targeted in the 3D panel. Now, go to the Properties panel and set the camera's focal length (FOV, field of view) to 140 mm. Use your 3D navigational tools to get something close to what you see in Figure 3.29.

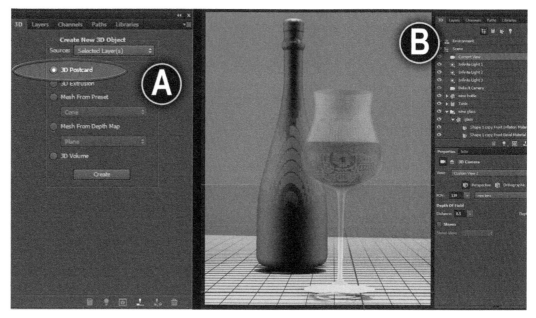

FIG 3.29 Merge the 3D layers and place objects onto the ground plane.

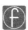 See the app for a video on wine & glass navigation

Step 5

Make a render (Ctl/Cmd-Alt/Opt-Shift-R) to see what we have so far. Let's move on to the next model (Figure 3.30).

FIG 3.30 Compose objects onto the ground plane.

Creating the Wacom Cintiq Companion

The rule in modeling is that you can create almost anything if you reduce your subject into simple shapes. That is the same approach that we will use to create the Wacom Cintiq Companion. The Companion is the computer that I used to create this entire book, so I thought it would be a good subject for an exercise in modeling. Let's give it try.

Step 1

Access the "Chapter 3 Wacom Tablet" folder and open the "pen.tif" document. Figure 3.43 shows how I derived the shape itself from a photo of the stylus.

All that was needed was to create a shape based on half of the pen for it to be lathed into a 3D object. I have provided a photo of the stylus for you if you choose to try creating a vector shape on your own. You will find it in the "stylus.tif" folder. Next, lathe the layer titled "stylus" into a 3D object to get what you see in Figure 3.31.

FIG 3.31 Create the 3D shape of the pen stylus.

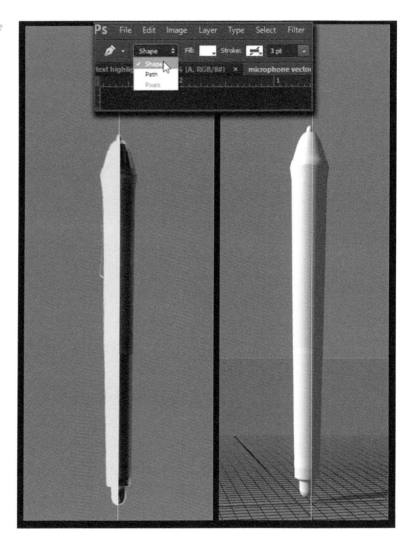

Step 2

Now, let's create the pen's button from scratch. Open "stylus.tif." Use your Pen tool (P) to create a shape that you can extrude into the 3D shape of the button that is located on the side of the stylus as shown in Figure 3.32A. If you are not confident with the Pen tool, use the "button.tif" to extrude the 3D object from the button layer.

Extrude your shape into the button. Use your eye for this one to get it to look and fit correctly onto the pen. Figure 3.32B shows the results of the extruded object. Try to get close to this example.

Step 3

Now, merge the stylus and button and position the button onto the stylus to get close to what you see in Figure 3.32C. Now render your scene. Let's go create the tablet.

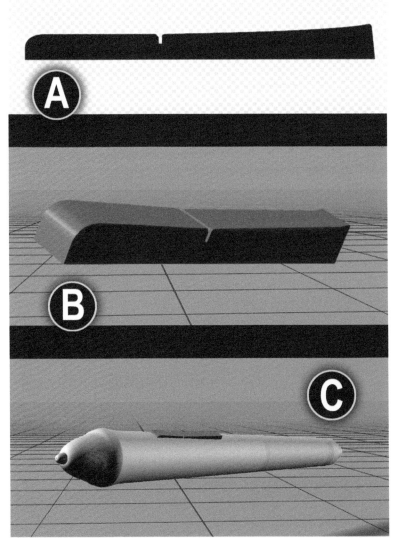

FIG 3.32 Outline the button with the Pen tool, extrude the button shape into a 3D object and merge the button with the 3D stylus.

Step 4

Open "wacom pad.tif". In the layers you will see the template for the pad titled "pad" and another for the monitor titled "monitor" (Figure 3.33). We will extrude them to have the same extrusion depth so that the monitor fits flush inside the pad.

FIG 3.33 Open the vector template for the Wacom pad.

Note: As a general rule, if you choose to use vector masks to create your shapes then alter them into Smart Objects first. The reason for this is that Photoshop works best with a single vector layer that shows the transparent areas around the subject to be extruded. If the layer has a layer mask associated with it, Photoshop will only recognize the mask as the extrusion object and you will get what you see in Figure 3.34.

FIG 3.34 Result of 3D object before altering it into a Smart Object.

The "pad" layer in the "Wacom pad.tif" (Figure 3.35A) document is already a smart object, so extrude the layer and use an "Extusion Depth" of .101 to get something close to what you see in Figure 3.35.

Do the same for the "monitor" layer. Merge the two 3D layers into one 3D scene and use your navigation tools to place the monitor inside of the Wacom pad (Figure 3.35B).

Note: Reset the 3D location for each like you did in Figure 3.25 if you feel it will help you.

FIG 3.35 Extrude the "pad" and "monitor" layers and place the viewing monitor inside the tablet.

Step 5

Let's create the reservoir next. Use Figure 3.36 as a guide to create the vector template to lathe the 3D shape. The vector shape has been provided for you as well in the "reservoir.psd" file located in the "Chapter 3 Wacom Tablet" folder.

FIG 3.36 Create the reservoir.

Step 6

Create a 7.5x9.5 document at 300 PPI and place all of the 3D objects into this new file. Create a 3D plane the way that you did in Figure 3.28 to create a table for all of the objects to sit on. Merge all 3D layers into a single 3D scene. Set the camera FOV to 110 and compose the objects as you see in Figure 3.37.

FIG 3.37 Merge and compose the Wacom pad scene.

Step 7

Now render the scene (Ctl/cmd-alt/Opt-Shift-R). Your results do not have to be exactly what you see in Figure 3.38, but try to get close to it.

FIG 3.38 Render the Wacom pad scene.

What You Have Learned

- That it's always best to work from references when possible.
- Photoshop 3D works best with vector layers.
- Photoshop 3D will alter painting objects into 3D vectors called constraints.
- The two types of modeling in Photoshop are extrusions and Depth Maps.
- The "Twist" slider will twist the object along its extrusion.
- The "Bend" slider will bend the object along its extrusion.
- To assist with aligning multiple objects the use of "Reset Coordinates" is very handy.
- Depth Maps uses dark and light values to create peaks and valleys using geometry.

Sophisticated 3D Modeling

This is a continuation of chapter 3 with an approach to building more sophisticated 3D models. Take your time and enjoy the process. You will find that many of the approaches are repetitive; however, it requires that you create using more complicated shapes. For this chapter all of your files are located in the "Chapter 4 Sophisticated 3D Models" folder. So, let's get started.

Creating a 3D Watch

In this exercise, I used the Vestal watch from their Z3 line (Figure 4.1) as inspiration for creating the 3D watch. The goal is not to duplicate it exactly but

FIG 4.1 View of the Vestal Watch.

instead to create something that is our own design using the Vestal Watch as a base. I have also provided a file with all of the vector shapes for you to follow along with this tutorial. However, you are welcome to create your own shapes if you like. So, let's go make the 3D components for the watch.

Step 1

Open the "watch vectors.psd" in the "Chapter 3 Watch" folder. Lathe the layers titled "base" and "glass" as shown in Figures 4.2 and 4.3. Use an extrusion of .226 for the base and .08 for the glass.

FIG 4.2 Lath Vector Layer titled "base."

FIG 4.3 Lath Vector Layer titled "glass."

Step 2

Use the "face" layer to extrude the shape to represent the face and dials of the watch (Figure 4.4). Don't extrude too much. Give it an extrusion setting of just a slight thickness since it will sit down into the base. In this example an extrusion of –0.173 inches is used.

FIG 4.4 Create the face of the watch.

Step 3

Use the "body" layer to extrude the shape to represent the body of the watch that the wristband will attach to. Use an extrusion of .227 inches. Add a slight inflation angle of 47 degrees with a strength 3% to give it some roundness for the front and back Inflation (Figure 4.5).

FIG 4.5 Create the body of the watch.

Step 4

Next, use the "hands" layer to extrude the hands for the watch using an extrusion of .024 inches (Figure 4.6).

FIG 4.6 Create the hands of the watch.

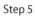

Step 5

Use the "winder" layer to lathe the winder for the watch. Use –0.264 for the Extrusion Depth (Figure 4.7).

FIG 4.7 Lathe the winder for the watch.

Step 6

Use the "wristband" layer to extrude the shape into the 3D wristband to 1.879 Extrusion Depth (Figure 4.8).

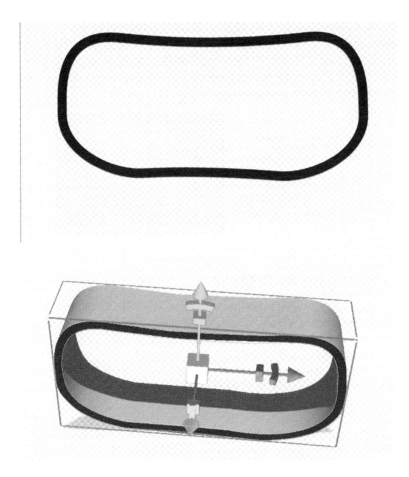

FIG 4.8 Extrude the wristband.

Step 7

For this step, keep in mind that you may need to modify the size and extrusion values a bit to get everything to look right. So, with that in mind, let's get started.

Merge the 3D layers then position the "base" so that it fits into the center and on top of the "body." Next, place the "face" so that it sits down into the "base." Later on we will texture the dials on this. Now, place the "hands" above the face giving is some slight space to cast a shadow. Place the glass above the "hands" so that it fits flush into the inner ring of the base but making sure it sits above the "hands." We need to turn down the opacity of the glass to see hands through it. To accomplish this, select the "glass" 3D object in the 3D panel and then target the Extrusion material for the glass in the submenu underneath it. In the Properties panel find the Opacity slider and slide it to around 8%. That should do it. You should now see the watch hands come into view underneath the glass.

Finally, position the band so that it runs through the watch as shown in Figure 4.9. Set the camera field of view (FOV) to 100 and position it so that you get similar to

what you see in Figure 4.9. Render it to see what you are getting. To help navigate the watch and all of its components much more easily, merge all 3D objects into a single 3D group (3D>Group All Objects in scene). By targeting the group you can now navigate all parts as if they are a single object. So keep in mind that even after merging your 3D layers you can go back any time and manipulate your objects.

FIG 4.9 The final results.

Creating an Hourglass

Hourglass designs are very simplistic in general, which makes this an ideal exercise in modeling. We are going to model the wooden stand, the glass and the sand that goes inside of the glass. In this tutorial, you will become familiar with the concept of instancing 3D objects to help you build repetitive parts. You will also be introduced to a creating depth maps that use B&W values to alter 3D shapes. Let's begin with the wooden stand.

Step 1

Open the "hourglass vectors.tif" document. Then lathe the "wooden stand" (0 Extrusion Depth), "glass" (–0.121 Extrusion Depth) "sand" (–0.1115 Extrusion Depth) and "support" vector layers as shown in Figures 4.10–4.13.

FIG 4.10 Lathe the wooden stand.

FIG 4.11 Lathe the glass.

FIG 4.12 Lathe the sand.

FIG 4.13 Lathe the support.

Step 2

Merge the 3D layers and begin repositioning the "support," "wooden stand" and "glass" as you see in Figure 4.14. Now add in a 3D sphere by right clicking on the "support" layer in the 3D Panel and chose "Sphere" from the drop list. Place it in the center gap area of the support as shown again in Figure 4.14.

FIG 4.14 Merge the 3D layers and add a 3D sphere.

Step 3

Instance the "support" objects twice so that we have a total of three "supports." Accomplish this by right-clicking on the "Support" 3D layer in the 3D panel and choosing the "Instance" option. This will create multiple instances of the same object. Instance is handy when changing any texturing on the main object will automatically be carried over onto the other two. So, if you alter the original object all of the objects will inherit the same results (Figure 4.15).

FIG 4.15 Instance the 3D supports.

Step 4

To help navigate the hourglass for the next step, merge all 3D objects into a single 3D group (3D>Group All Objects in scene). Let's move on.

Step 5

Create a new layer and make sure your background and foreground color is set so that one is medium gray and the other is black. Fill the layer with clouds (Filter>Render>Clouds) and alter it into a Smart Object. Next, apply a Gaussian blur (Filter>Blur>Gaussian Blur) to get something similar to Figure 4.16.

FIG 4.16 Create a clouds layer.

Step 6

We are going to use the cloud smart object as a Depth Map. Depth Maps use tonalities to create depth in geometry. The lower tonalities that are closer to black will create the valleys while the higher tones closer to white will create peaks. We will use this to create our sand dunes. Make sure that the smart object is targeted then go to the 3D panel to activate the "Mesh from Depth Map" radial button then choose "Plane" for the drop list. You will see that the shape resemble sand dunes. Alter the depth of the shape by stretching it up or down along he "Y" axis to get something like Figure 4.17.

FIG 4.17 Alter the Depth maps height and merge the 3D layers.

Step 7

Merge the 3D layers and position the hourglass on top of the sand. We will texture and compose it in detail later (Figure 4.18).

FIG 4.18 Final view of the hourglass

Creating a Sword in Stone

Creating content for fantasy scenes like swords and weapons are always a good way to find out how capable a 3D program is. So, let's see just how well Photoshop does in modeling swords.

Step 1

Open the "sword.tif" in the "Chapter 4 Sophisticated / Sword in Stone" folder. Use the "blade" vector layer to extrude the sword. Use the bevel feature in the Properties panel to create the edge of the sword as you can see in Figure 4.19. The bevel feature can found by pressing the Cap button (third button from the left) on the top left of the Properties panel. Use the angle and strength to get just the right look, I used the following settings: 29% for the width and 45 degrees for the angle. I also used 34 degrees for the angle under Inflate. Experiment to get something that you like better.

FIG 4.19 Create the blade of the sword.

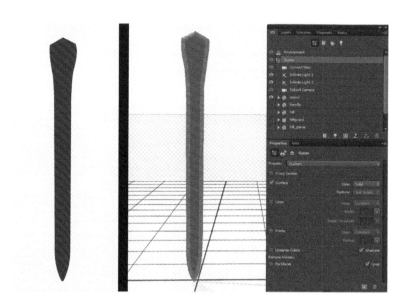

 See the app for a video on sword extrusion.

Step 2

Next, target the "handle" layer and lathe the handle vector layer to get what you see in Figure 4.20.

FIG 4.20 Lathe the sword handle.

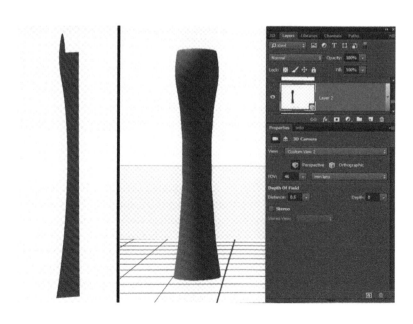

Step 3

Use the "hilt" shape layer to extrude the hand guard shape. Then alter the Inflate, Angle and Shape preferences. Figure 4.21 displays 17 degrees for the Bevel "angle", 45 degrees for the "inflate" and the inflate "Strength" is 27 degrees . Play with it and don't be afraid to get something different.

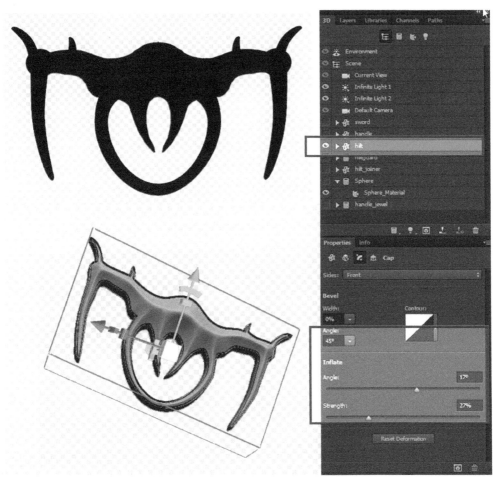

FIG 4.21 Create the hand guard.

Step 4

Target the "hilt connector" vector layer and lathe the shape into what you see for Figure 4.22. Then add and position two spheres that we will add to the ends of the hilt. To add spheres just right-click onto the hilt 3D layer in the 3D panel and select "Sphere" from the drop list.

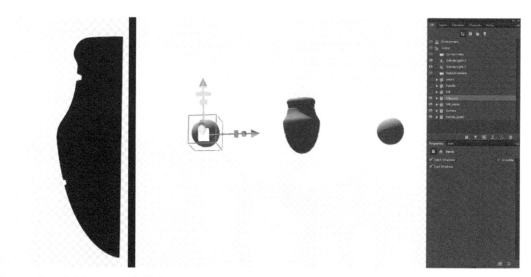

FIG 4.22 Create the hilt connector and add spheres.

Step 5

Follow the steps from Figures 4.16 and 4.17 to create a cloud filled layer to use as a Depth Map. This will serve as the start for the stone object (Figure 4.23).

FIG 4.23 Create the cloud filled layer.

See the app: Sword & Stone Displacement Map

Step 6

Create a planar depth map form the cloud layer. Then reduce the height of the peaks a bit by using the 3D widget to stretch it in toward the "Z" axis (Figure 4.24).

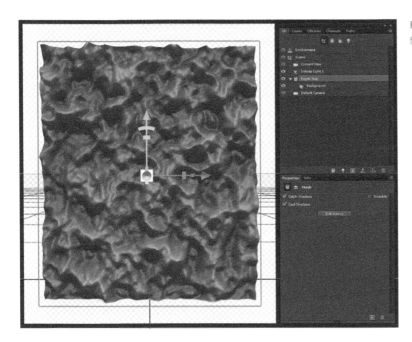

FIG 4.24 Create the stone object from the planar depth map.

Step 7

With the new planar depth selected in the 3D panel, target the "Edit button" in the Properties panel. This will bring up the original smart object clouds layer used to create the stone. We are going to create the mound in which the stone will be embedded. Create a new layer above the clouds and use a soft-edged brush and paint white into the center. This is an ideal task for the Wacom stylus to use pressure to apply the amount of what that we need. These brighter values will pull up that area of the geometry while darker values will recede them. When done hit Ctl/Cmd-S for save and watch the 3D stone change before your eyes. Play with this to get the results that work best for you but use Figure 4.25 as a guide.

Note: Hit Ctl-S (save) constantly as you make changes to see how your 3D model updates.

FIG 4.25 Create the mound for the sword.

Step 8

Now position the handle, hilt, hilt connector and blade to create the sword that you see in Figure 4.26. Place the spheres on either ends of the hilt to add detail. Add another sphere to the end of the handle. Now group all of the 3D layers that make up the sword and merge them into a single group by way of "Group All Objects In Scene" (3D>Group All Objects In Scene). Name the group "sword." Now let's make a second sword that is slightly different from this one. Simple, right?

Just duplicate the "sword" group and call it "sword 2." Since this is a duplicate and not an instance we can modify the shapes within it to be unique from the original sword. Go into the "blade" and "hilt" and modify them with the "Edit" button in the Properties panel. This brings up the original vector layer so that you can edit it to give it unique characteristics. Finally, position both swords into the protruding stone as you see in Figure 4.26. Now let's change the document dimensions. Target Crop tool (C) and in the options bar set the dimensions to 7.5x9.5, and compose the document similar to what you see in Figure 4.26.

FIG 4.26 Compose the mound for the sword.

 Check out the app to see a video on the Sword & Stone completed.

Step 9

Render the document to get close to what you see in Figure 4.27.

FIG 4.27 Render the sword and stone.

Creating Custom 3D Binoculars

This exercise will use instancing and duplicating techniques to create our 3D field binoculars. The goal here is to place most of our efforts into building just one scope and then instance it to create the other half.

Step 1

Open "binoculars.psd" and apply the lathe technique to the shapes in the "binocular layer. Use an extrusion depth. Don't forget to adjust the "Extrude" slider in the Properties panel to get what you see in (Figure 4.28). Let's move on to the lens.

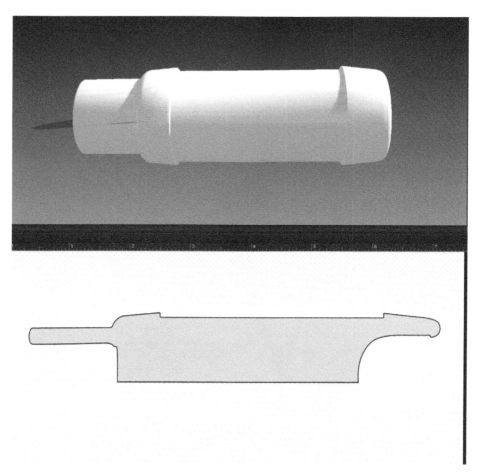

FIG 4.28 Lathe the binocular layer.

Next, lathe the lens vector shape from the "lens" layers (Figure 4.29A). In this example I used -0.043 for an Extrusion Depth. In the Properties panel look for the Diffuse color attributes and change the color to a type of turquoise blue. We will get more into texturing in chapter 4, but for now feel free to alter the color of the object. Target the two 3D layers in the layers panel and Merge them (3D>Merge 3D Layers). In the 3D panel target the Lens Object (rename if you have to), right click on it and choose "Instance Objects." The instanced object is a child of the original. So any texture of surface modification to the parent will also affect the child. Place one inside the front end and the other inside the back of the binocular as shown in Figures 4.29B and 4.29C. Keep in mind that you might need to modify the size a bit to fit inside the scope.

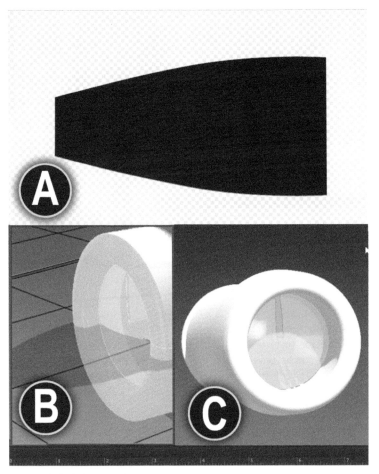

FIG 4.29 Lathe the lens vector shape.

Step 2

Extrude the "binocular detail" vector layer and give it a slight bevel. In this example, 0.114 inches was used for the Extrusion Depth. Instance this to get a total, so 6 duplicates. Merge the duplicates with the binocular (3D>Merge 3D Layers) and place them around the sides where you have three placed along the length on either side of the scope as you see in Figure 4.30A.

Just in front of the lens is another small piece of detail, which is a support ring, to hold the lens in place. Create a shape using your Pen tool to match what you see in Figure 4.30B. Lathe it into a 3D object to create the ringed shape that will sit in front of the lens, then merge it with scope. Adjust the extrusion length so that it can fit properly close to what you see in Figure 4.30C. In this example, the Extrusion Depth came to 2.045 inches.

FIG 4.30 Extrude the "binocular detail" and the lens.

Step 3

We are going to create the bridge connector for the binocular. So, target the "bridge connector" vector layer and extrude it to 2.114 inches. To add a little visual detail, give it a rounded bevel for both the front and back inflation then merge with the main 3D layer. Instance the connector and place one near the front and the other opposite to it near the back end of the binocular (Figure 4.31).

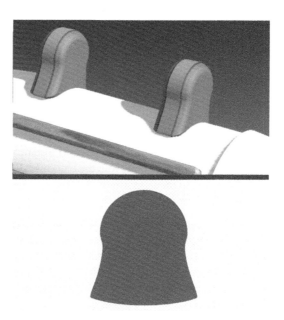

FIG 4.31 Extrude the "bridge connector" and the lens.

Step 4

Target the "scope detail 2" vector layer and extrude it. Give a bevel as well for both the front and rear inflation. Merge the object with the main 3D layer and position it around the rear eyepiece as shown in Figure 4.32. Now it's time to group all of the 3D objects for the scope into a single group so go to 3D>Group All Objects In Scene. Then rename the group "scope 1" to keep organized.

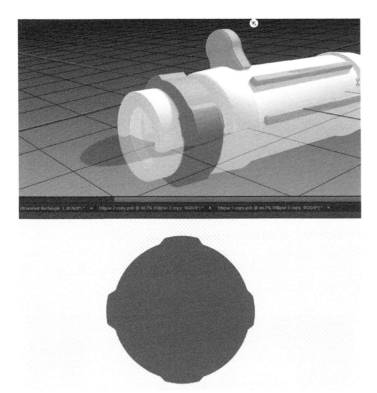

FIG 4.32 Extrude "binocular detail 2" and place onto the rear eyepiece.

Step 5

It's time to modify the bridge that will join to two scopes into a single binocular. There will be a rectangular gap to place the focusing wheel into so we will create the bridge in such a way in that we will duplicate the shape in three places then modify one to create the gap. Let's get started.

Target the "bridge 1" vector layer and extrude it out slightly and merge with the main 3D layer. Position it toward the front of the lens so that the rounded edge line up with the bridge connectors as shown in Figure 4.33. Instance the "bridge 1" and position the second so that it sits to the rear of the binocular, leaving a gap in the center. Utilize the 3D widget to easily slide it on its Z axis by targeting the tip of the blue arrow. Again, use Figure 4.33 as a guide.

FIG 4.33 Extrude, instance and place the binocular bridge.

Step 6

Duplicate the bridge connector toward the front of the binocular and position it so that it takes up the center gap. Edit the 3D shape by cutting out a portion of the center to achieve an gap to place the focus dial into. Use Figure 4.34 to assist you.

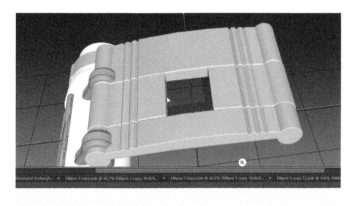

FIG 4.34 Duplicate and modify the bridge.

Step 7

Use the "focus dial" vector layer and extrude the focus dial from it. Merge with the main 3D layer and place the dial as you see in Figure 4.35

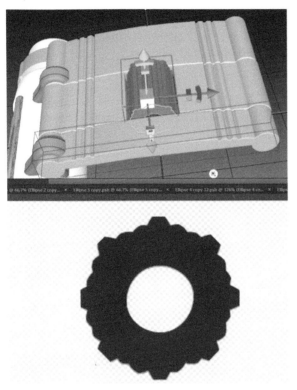

FIG 4.35 Create and place the focus dial into the binocular.

Step 8

In your 3D panel, target the "scope 1" group and instance it. Place it to the other side so that the bridge connectors fit flush with the bridge. That's it. Figure 4.36 displays the finished model. We will texture this in the next chapter.

FIG 4.36 Instance and position the "scope 1" group.

Modeling a Corkscrew

I found this corkscrew in a kitchen drawer. I have had it for years; it's my favorite and the most effective one that I have ever purchased. When looking at it I thought that it would be a challenging one to model in Photoshop and I had to include it. So, I photographed it and we will model it next. In this exercise we will learn about practical uses of the Twist command to get screw-like effects. Let's have some fun.

Step 1

Open the "corkscrew.psd" inside of the "Chapter 4 Corkscrew" folder and take a look at how the corkscrew has been simplified with a few vector layer shapes (Figure 4.37).

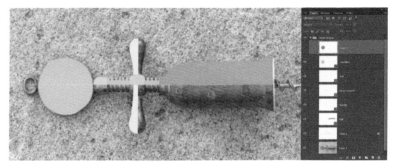

FIG 4.37 Open "corkscrew.psd."

Step 2

Lathe the bolt, hinge support, handle and bell vector layers. When done, extrude the medallion layer. Figure 4.38 shows what you should have.

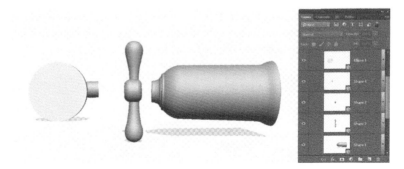

FIG 4.38 Open "corkscrew.psd."

Step 3

Let's make the screw that the handle is attached to. Create a rectangular vector shape on a new layer then extrude it into a 3D shape. In the Properties panel target the "Twist" slider and place it to the far right. Figure 4.39 has it at 1392 degrees. Get close to what you see in the example. So far, it looks close but the edges are not quite flat enough as they bow inward. The next step will solve that problem.

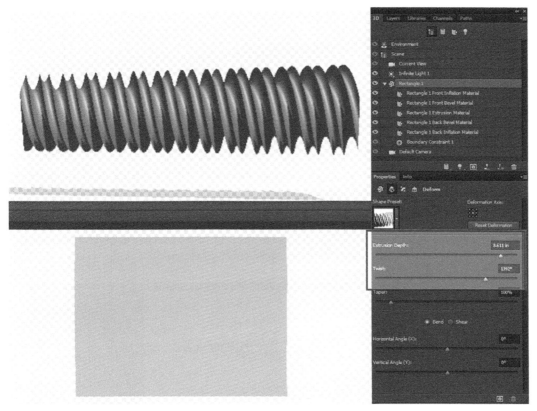

FIG 4.39 Use the Twist slider to create the handle screw.

Step 4

Edit the original shape using the Warp Command (Edit>Transform>Warp) to bow out the ends to compensate for the inside curving (Figure 4.40). Save the shape to update the model.

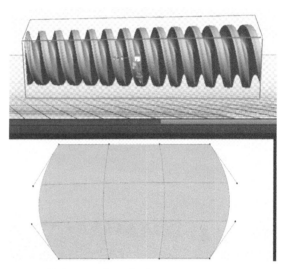

FIG 4.40 Edit the screw to flatten the edges.

Step 5

Next, we are going to create the corkscrew that inserts into the cork of the wine bottle. Create a shape in a new layer that resembles what you see in Figure 4.41. It's a simple circle on top of a rectangle with bowed sides. You can use the Warp command (Edit>Transform>Warp) to bow out the sides. If you use multiple layers for this then don't forget to merge them into a single smart object. Now extrude it into a 3D object and apply a twist to get something close to Figure 4.41.

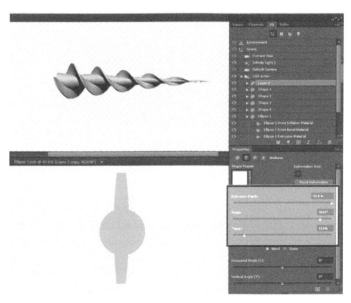

FIG 4.41 Edit the corkscrew.

Step 6

Merge all of the layers into a 3D scene and position them to get close to Figure 4.42. Then merge everything into a 3D group (3D>Group All Objects In Scene).

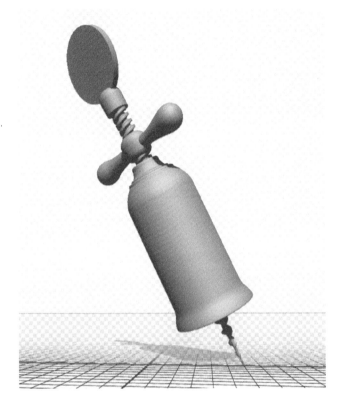

FIG 4.42 Create the corkscrew.

We are done and ready to move on to texturing the 3D objects.

What You Have Learned

- Sophisticated models are a combination of many individual parts.
- It is best to lay out your vector shapes in layers as a template for creating the 3D vision before creating the actual 3D object.
- Depth Map is a great option for creating a landscape.
- The two types of modeling in Photoshop are extrusions and Depth Maps.
- To create a 3D landscape, Use the Clouds command will get you started.
- The bevel command is ideal for creating bladed weapons.
- Instancing completed 3objects can save you time later.

3D Texturing

This is where we bring our model to life. A great place to get textures is www.
cgtextures.com. They are royalty-free for both personal and commercial use.
Textures do not always have the need for higher detail from an SLR, which
makes them ideal for capture with cellphones and point-and-shoot cameras.

Whenever you are on the road, capture all kinds of textures like oil slicks, brick walls, peeling paint and tree bark just to name a few. Build an extensive library of textures so that you always have some inspiration at hand.

We will make some custom textures as well but photographic textures are the best for getting realistic details.

When using a 3D package the process of adding details to the surface of geometry is called surfacing or texturing. In Photoshop, we are going to use the Materials to add the color, highlights and bump textures to the models that we built in chapter 3. Let's begin.

Take a look at Figure 5.1 and let's get familiar with the Materials attributes located in the Properties panel. This panel will become available to you whenever you target a 3D objects surface. Let's get more familiar with it by definition for now and then we will see the practical applications in the tutorials afterwards.

Below are several attributes and their descriptions that you will see listed in the panel.

Diffuse: You can apply color, image or video to the surface of your 3D object.

Specular: With this attribute, you can apply changes to extreme highlights on your model. You can alter its color and luminance values, an image or video.

Illumination: This affects the brightness of model's surface. This can be used to illuminate the scene's surroundings from a model's surface using color, luminance values, images or videos.

Ambient: This is where the shadow areas of a model are affected by the color or luminance set here. Keep in mind that in order for this to work the "Global Ambient" has to be set to something other than black as a color. You can change this by targeting the "Environment" attribute in the 3D panel, then in the "Properties" panel target the "Global Ambient" color swatch located in the top of the panel to change the overall ambient effects for the entire scene. In a way it behaves like an on or off switch for the "Ambient" texture attribute.

Now the following texture attributes have sliders where you can vary the texture effects in percentages from 0 to 100.

Shine: This allows the surface to produce brighter hotspots from the light.

Reflection: This allows the surface to reflect neighboring 3D objects or light sources.

Roughness: This adds distortion to reflections so that they are not exact mirrors of the object or scene that they are reflecting.

Bump: This adds bump-like details to the surface of your objects.

Opacity: This gives transparency to 3D objects.

Refraction: This works alongside Opacity where it causes light to bend when it enters transparent objects. You get distorted views of images inside or behind transparent 3D objects.

Below the slider attributes you will see two folders titled "Normal" and "Environment."

Normal: This is a type of bump map that use red, green, and blue color coordinates to define the surface of the object.

Environment: This is another way to illuminate the 3D scene using the color and luminance values from an image. In addition, if the "Reflection" is turned up for a model's texture then the environment image will reflect in its surface.

Now, let's go apply some of these attributes.

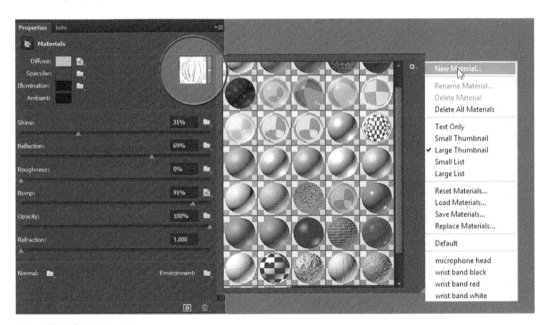

FIG 5.1 View of the texture panel.

Texturing the Wire Illustration

Now that we are more familiar with our material panel let's surface the first model that we built, which is our wire illustration.

Step 1

Open the "cables.psd" (Figure 5.2A). Let's give the surface of the wire a shinier look. Target all of the surfaces for the red wire and set textures for Shine at 73% and reflection at 29%. Keep the rest at default and you should see the surface take on a new look, as shown in Figure 5.2B.

FIG 5.2 Apply shinier surface for the red wire.

 See the app for a video on cable texturing

Step 2

Let's add some rubber texturing to the insulation that's surrounding the inner wire. Target all surfaces for the "rubber" and load in an image map using the "rubber.jpg" texture into the bump as shown in Figure 5.3. To load in the image just target the yellow folder on the right side of the "Bump" slider and target "Load Texture." Navigate to the "Chapter 4 Wire Gauge" folder where you will find the image. This will use the image to add the texture for all attributes for the rubber insulation.

FIG 5.3 Add rubber texture to the insulation.

Figure 5.4 shows the initial results from adding the texture. Next, we are going to modify the size of the image map to get results that are a little more convincing.

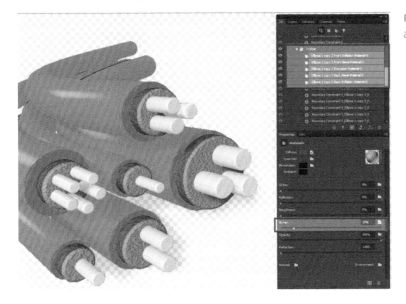

FIG 5.4 View of the initial result of adding the bump texture.

Step 3

Access the "Edit UV Properties" from the Bump drop list. UV Properties adjust the width and height of our textures. "U" represents the horizontal and "V" represents the vertical dimensions. So, we are going to reduce the size of the Rubber texture by setting those attributes to 10%, the tile amount to 10 and offset to 24.5%, as shown in Figure 5.5. Play with these figures to get used to how things are being changed.

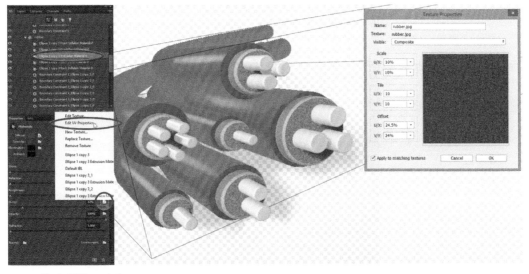

FIG 5.5 Edit the "UV Properties."

Step 4

Next, follow the same steps that you did in Figures 5.3 through 5.5 for the inner wire. Adjust the "Texture Properties" for the extrusion as you see in Figures 5.6A and the Texture Properties for the "Inflation" as you see in Figures 5.6B

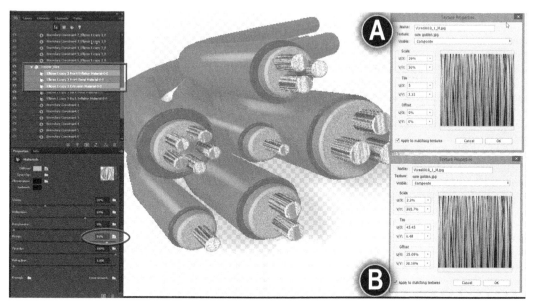

FIG 5.6 Apply textures to the wire.

Now, let do a render (Ctrl/Cmd-Alt/Opt-Shift-R) to see the final results (Figure 5.7). The render happens in a single pass but take note that at first it leaves behind noise. As you allow it to render longer that noise will be cleaned up, leaving a detailed high resolution image. So for the best results be patient and give it time so that is can do its job.

FIG 5.7 Render the final results.

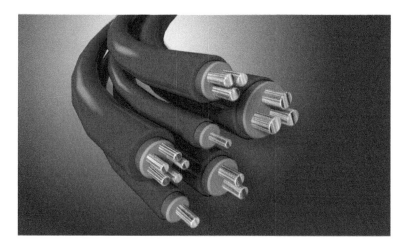

Surfacing the Syringe

Inside the syringe is a glowing concoction of mystery fluid; it could be used for a medical illustration. In this tutorial we will set the refraction index for the fluid and glass.

See the app for a video on this syringe.

Step 1

Open the syringe document that you created in chapter 3. Let's surface the syringe housing first so that we can see through it to the green glowing liquid inside.

Turn off all of the 3D objects with the exception of the "Syringe_Layer" in the 3D panel. Target the "Extrusion" material and set the following properties (Figure 5.8).

> Shine: 34%
> Reflection: 78%
> Opacity: 25%
> Refraction: 1.33

As a note on refraction, the 1.33 represents the refractive index that I set for glass. 1.33 is normally what you set for water but I wanted subtler effects here.

Refractive indexes are a measurement as to how light is affected when it enters into certain types of environments like water, oil or glass. Air has a

FIG 5.8 Set the surfacing properties for the syringe.

refractive index of "1." Below are indexes for some of the most common situations that you will have as part of your 3D surfacing:

Vacuum: 1.00000
Air: 1.00029
Ice: 1.31
Water: 1.33
Sugar Solution: 1.49
Glass: 1.5–1.9

Ok, enough of the technical stuff and on to the creative fun.

Once you create a surface material you can save it to the Materials Preset library to use at a later date. Target any material on a 3D object in the 3D panel. Now focus on the top-right side of the Properties panel and target the material preset icon to see various presets that Adobe has provided for you. To save your custom material, hit the gear icon on the top right to get a drop list. Then target "New Material" and save it under your desired name (Figure 5.9).

FIG 5.9 Save the material as a preset.

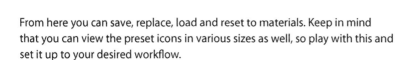

From here you can save, replace, load and reset to materials. Keep in mind that you can view the preset icons in various sizes as well, so play with this and set it up to your desired workflow.

Step 2

Now target the material for the extrusion of the "injector_Layer" in the 3D panel. In the Properties panel target the folder next to the Diffuse option and choose "Edit Texture," as shown in Figure 5.10.

FIG 5.10 Edit an existing texture.

Figure 5.11 displays a lined pattern called a UV Map. If you peel off the surface from an object and lay it down onto a flat sheet of paper then this is how the surface of your model will look. The UV map displays the polygons used that create the actual syringe object.

Place the 3D object and UV Map side by side. Activate your Brush (B) and navigate it over the UV map. Take note that a crosshair symbol displays where the brush is located on the injector. This will help you decide where to apply

any painting or compositing techniques to surface your object. Move your stylus from right to left and notice that the cross hair moved up and down the injector object. This tells you that the map will be wrapped onto the injector in a cylinder-like manner.

FIG 5.11 Display of UV map or injector.

Step 3

To give the tip of the injector a black rubber-like effect, fill the area, using your Rectangular Marquee to assist you, on the UV that represents the rubber tip with black, as shown in Figure 5.12.

FIG 5.12 Rotate to view the completed model.

Step 4

Target the needle object and give its extrusion material 62% Shine and 74% Reflection. For the needle support object that connects with the needle, we will leave it at default (Figure 5.13).

FIG 5.13 Surface the needle.

Step 5

Now, target the "Extrusion" for the liquid object. For the "Diffuse" give it a bright blue of your choice then give the "Illumination" more of a turquoise/green. Set the Material sliders for the following:

Shine: 20%
Opacity: 20%
Refraction: 1.33
Use Figure 5.14 as a guide and let's move on.

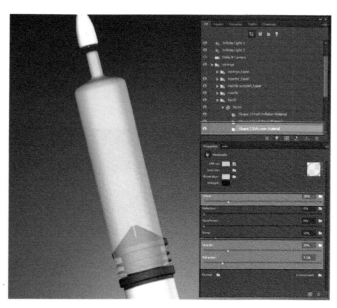

FIG 5.14 Surface the liquid.

Step 6

Locate the Extrusion material for the syringe and load in the "Measurement.tif" file into the Diffuse. Free Transform (Ctl/Cmd-T) it until you get similar results to Figure 5.15. Take note that the effects are less than desirable because the image map takes on the Opacity level of the syringe, which is 25%. You will instead need to create an Opacity Map to get numbers to show up solid. Let's move on.

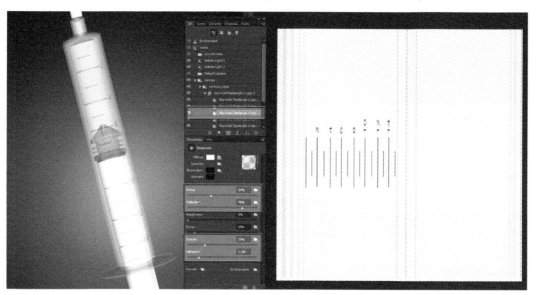

FIG 5.15 Apply "Measurement.tif" to syringe Diffuse.

Step 7

For Opacity maps, any value close to black makes the model more transparent. Any value closer to white will take on full opacity. We want the measurements to have full opacity (white) while the syringe receives some transparency (dark gray). Double-click on the measurement smart object to edit its original content and use Ctl/Cmd-I for inverse to make the measurements white. Save the result to update the Smart Object. Now give a fill layer of dark gray for the background. Save it out and observe the results. You should see something close to Figure 5.16.

FIG 5.16 Apply the Opacity Map.

 See the app for a video on repositioning 3D objects.

Step 8

Create a render and enjoy the results (Figure 5.17).

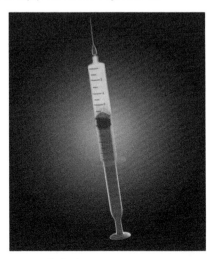

FIG 5.17 Render the syringe.

Surfacing the Microphone

As simple as the microphone was to model, you will find that applying a simple approach to texturing it will bring it to life. We are going to apply a texture that has a fine toothed surface. We will use noise to assist us in creating a custom texture for the microphone handle. Then we will use a photo texture to give the head of the microphone a realistic wire mesh appeal. Let's begin with texturing the handle.

FIG 5.18 Create a new file and create a medium gray layer, add noise to the smart object, add Gaussian Blur to Noise and save file.

Step 1

We do not need a super high-res image, so create new file that is 3x3 inches at 200 PPI. Unlock the background layer and fill it with medium gray (Edit>Fill>50% Gray) and alter it into a Smart Object (Figure 5.18A).

Step 2

Next, add noise with an amount close to what is shown in Figure 5.18B to get some larger grain effects.

Step 3

Next, add a slight Gaussian Blur to take the harshness off the noise, as shown in Figure 5.18C. Save the file and call it "handle bump.tif."

Step 4

Now, apply "handle bump.tif" texture to the "bump" material for the handle of the microphone. Give a finer grain look by reducing the size of the texture by adjusting the Texture Properties so that the scale for "U/X" and "V/Y" is 5% with a tile of 20 as shown in Figure 5.19A.

Step 5

You should see something like Figure 5.19B.

FIG 5.19 Apply "handle bump.tif" to the bump material and modify its size.

 See the app for videos on Microphone and Microphone Preset.

Step 6

Now, render to see how the textures appear on the microphone. Take note that we are getting a much smoother looking surface (Figure 5.20A).

Step 7

Go to the "Chapter 4 Microphone" folder and add the "mesh.tif" to the "Diffuse" material for the "Extrusion" for the head of the microphone. The mesh may be a little large at first so adjust the Texture Properties to match what you see in Figure 5.20B. Next, make the handle a little darker so that it begins to look like a professional mic.

FIG 5.20 Render the microphone to review the texture result and modify Texture Properties for the head of microphone.

Step 8

We could save the handle as a custom texture and apply it other areas of our model but there is a quicker way that you are going to love. We are going to use the 3D Eye Dropper to copy and paste our textures into other areas. In the Tools panel target the 3D Eye Dropper, as shown in Figure 5.21A.

 Check out the app for a video on the 3D Eye Dropper.

Step 9

Once targeted, use it to click and release on the handle to sample that texture. Now, click and release onto the microphone band surrounding the head of mic to transfer the texture there (Figure 5.21B). Next, let's modify it.

FIG 5.21 User the 3D Eye Dropper to copy texture from the handle and paste texture onto the mic band.

Step 10

Edit the band texture that you just pasted. Currently the texture is an instance of the microphone's handle, so save it as another name so that you do not replace the original texture on the handle. When done, add a Motion Blur (Filter>Blur>Motion Blur) to give it a brushed metal look. User Figure 5.22A as a guide.

 See the app for a video on modifying texture

Step 11

Now edit the Texture Properties to modify the effect to look more convincing. In the Texture Properties set the "U/X" Scale to 400% and the "Tile" for U/X to .25. That should do the trick. Play with these settings and get used to what they do (Figure 5.22B).

FIG 5.22 Apply Motion Blur to the texture and modify the Texture Properties.

Step 12

Let's do a render: Ctl/Cmd-Alt/Opt-Shift-R (Figure 5.23).

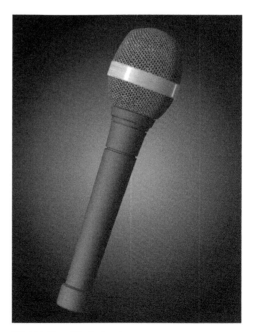

FIG 5.23 View of the final render

Adding a Logo to the Microphone

Oftentimes the process of texturing on an object inspires the addition of more detail to complete the piece. This is an ideal case where the microphone is looking pretty good but just needs a little something to complete it. Here you will learn that you can keep adding more 3D and texture details even after the fact to complete your vision. And the ideal thing to add in this case is a logo to brand the mic. Let's finish up.

Step 1

Open the Logo that you created in Figure 3.4 in chapter 3 and merge it with a 3D rectangle with a rounded corner rectangle to serve as a backdrop for the logo. Give the logo a rounded edge for the bevel to depart from its original edge (Figure 5.24A). Use the 3D Secondary view (View>Show>3D Secondary View) to help you align the objects. Take note that the secondary view also shows the dimensions of the 3D object to aid you with 3D printing. We will cover that in a later chapter but for now let's move forward.

Step 2

Group the two objects into a single logo (3D>Group All Objects In Scene) then merge the logo with the microphone (Figure 5.24B). After you merge, your scene will more than likely be different than what you see here but don't worry about it as we are about to discover another way to assist you in piecing your objects together. Let's move on.

FIG 5.24 Create the microphone logo and merge the logo with the microphone.

Step 3

In your secondary view you can change the view to help you align 3D objects by seeing them from other angles. So switch it to the "left" view for now (Figure 5.25A).

Step 4

Move the logo to the head of the microphone and rotate it to make its sides parallel to the mic. Use Figure 5.25B to assist you.

FIG 5.25 Switch the view on the Secondary View panel and extrude the circular band.

Step 5

Now alter the secondary view to the "Top" view (Figure 5.26A). We are going to switch views next.

FIG 5.26 Change secondary view and switch 3D Views.

FIG 5.26 (Continued)

Step 6

On the top right corner you will see an icon that when targeted it will place the secondary into the main Photoshop Interface and vice versa. Switch the views to assist you in lining up the logo more precisely (Figure 5.26B).

Step 7

Next, render the logo. It has more character now and is a lot more interesting than before (Figure 5.27).

FIG 5.27 Render the Microphone.

Surfacing the Wine Bottle and Wine Glass

Here we will add a label to the wine bottle and set surface attributes for the wine glass and wine.

Step 1

Open the material for the "Extrusion" of the wine bottle and set the document side by side to the wine bottle document (Window>Arrange Tile Vertically). You will see the UV Map overlay at 100% located at the bottom of our Properties panel. Set its "Opacity" to 10% so that it does not visually get in the way of you positioning the label. Open the "lable.tif" from the "Chapter 4 Wine Glass" folder and align it on the UV as shown in Figure 5.28A. Hit Ctl/Cmd-S to see the results of your alignment. Also, place a vertical golden strip made from a rectangular vector shape to color the cap on the bottle. As you can see, the textures need to be transformed a bit, so let's accomplish this next.

 Check out the app for the video "Wine & Glass"

Step 2

Using Free Transform, alter your label to get close to what you see in Figure 5.28B.

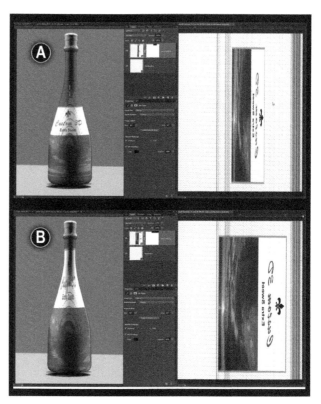

FIG 5.28 Place the label and colors for the lid on UV coordinates.

Step 3

Now, alter the yellow strip to color the cap to get close to what you see in
Figure 5.29.

FIG 5.29 Position the color for
the cap.

Step 4

Set the "Shine" material attributes for the bottle to 20% to give is a very slight
sparkle (Figure 5.30).

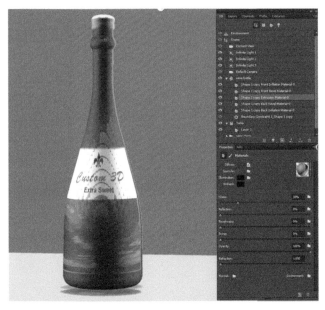

FIG 5.30 Set the surface for the wine bottle.

Step 5

Now we are going to add some texture to the ground so that it resembles sand on a beach. Load the "ground.tif" into the "Bump" option for the "table" object (Figure 5.31).

FIG 5.31 Give the table a bump texture.

Step 6

Alter the Texture Properties to match what you see in Figure 5.32.

FIG 5.32 Alter the bump using Texture Properties panel.

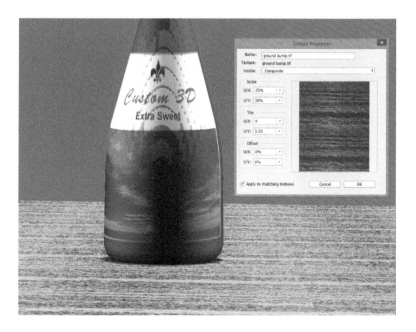

Step 7

Next we are going to focus on the wine. Set its color to a deep burgundy and give it the following attributes:

Shine: 54%
Reflection: 85%
Opacity: 32%
Refraction: 1.149

Use these Figures as only a starting base but explore on your own as well to get something more dynamic (Figure 5.33).

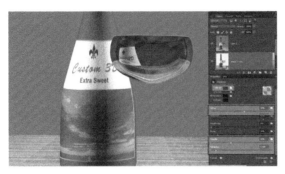

FIG 5.33 Set the Material attributes for the wine then create a render (Ct//Cmd-Alt/Opt-Shift-R) to a quick look at what you are achieving so far.

Shine: 41%
Reflection: 43%
Opacity: 7%
Refraction: 1.059

Step 8

For the glass, give it the Material attributes as shown in Figure 5.34.

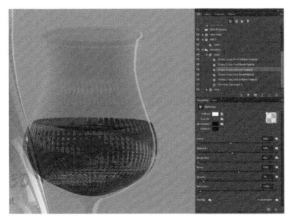

FIG 5.34 Outline the stylus with the Pen tool.

Step 9

Let's finalize the concept of the wine bottle and wine glass on the beach. On the bottom of your Properties panel, target folder for the background and load in the "sunset" image to add a nice concept to the scene (Figure 5.35).

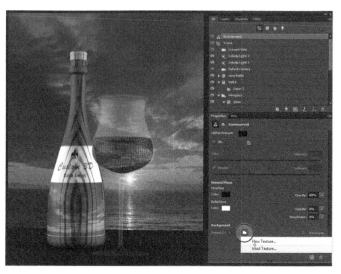

FIG 5.35 Add a background.

Step 10

Create a partial render of the glass by selecting a portion of it with your Rectangular Marquee tool and then render it (Ctl/Cmd-Alt/Opt-Shift-R). Use Figure 5.36 as a guide.

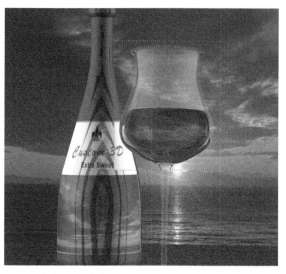

FIG 5.36 Outline the stylus button.

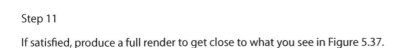

Step 11

If satisfied, produce a full render to get close to what you see in Figure 5.37.

FIG 5.37 Render your scene.

Texturing the Wacom Cintiq Companion

This entire book was created using the Wacom Cintiq Companion. This tablet computer is a game changer in how artists create in the studio and on the fly. We are going to begin with surfacing the Wacom stylus and then follow with the tablet. In the process, we will add additional surface details in combination with image textures. All files for this exercise are found in the "Chapter 4 Wacom Pad" folder.

Step 1

Open the Diffuse texture for the Stylus. Notice that wherever your cursor sits on the UV map, a cross hair symbol appears on the corresponding location on the 3D object (Figure 5.38A). Add a Color Fill Adjustment layer set to

50% gray. Now, change the color of the UV Map to white to make it easier to visually track our efforts, and use the UV map to locate the position of the pen tip, the rubber grip and the eraser. Make the pen tip black. Use the technique to produce a noise texture that you learned in Figures 5.11–12C to apply to the area for the grip, and then finally make the eraser black. Use Figure 5.38B to assist you, save the texture to update the stylus and let's move on.

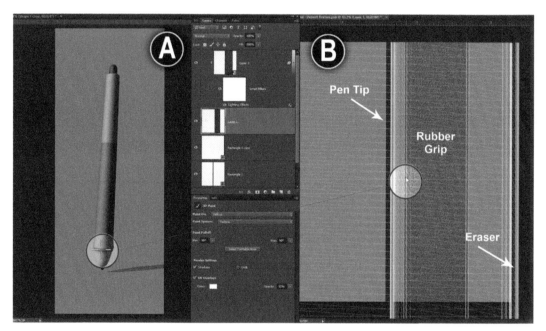

FIG 5.38 Result of the 3D object before altering it into a Smart Object.

Step 2

In using image maps in Materials that control surface luminance, color and contrast, the black value will not allow the material to have an effect while the white value will allow the effect to happen. This is exactly how layer masking works as well, so let's apply for the surface of the "eraser" and "pen tip."

Use the Diffuse texture and modify it so that the tip and the eraser of the stylus will take on a shiny quality. So, turn off all of the vector layers with the exception of the ones that modify the pen tip and eraser. Alter those to white and make sure that the background is black to get what you see in Figure 5.39.

Save this as "shine map.tif" and apply it to the "Shine" material. This will override the slider for the most part but play with it to get subtler effects. Let's move on.

FIG 5.39 Create a shine map for the eraser.

Step 3

Next, create a rectangular 3D plane to be use as the table. Add the "marble.tif" from the "Chapter 5 Wacom Tablet" folder to the Diffuse to texture the table's surface. Modify the Texture Properties to "offset" it so that the lighter marble veins passes through the stylus (Figure 5.40A). This will help lead the viewer's eye toward the primary subject.

FIG 5.40 Create a localized render.

Step 4

Give the table the following surface attributes.

> Shine: 36%
> Reflection: 62%
> Roughness: 6%

Next, select a localized area around the stylus to include some of the table and render it so that we can quickly get an idea of the final look and feel of the scene (Figure 5.40B).

Step 5

Add "graphic.tif" to the Illumination for the "Front Inflation" of the "glass viewing area" (Figure 5.41A). You should see the color and brightness coming

FIG 5.41 Add the graphic to the Illumination material and to the Diffuse material.

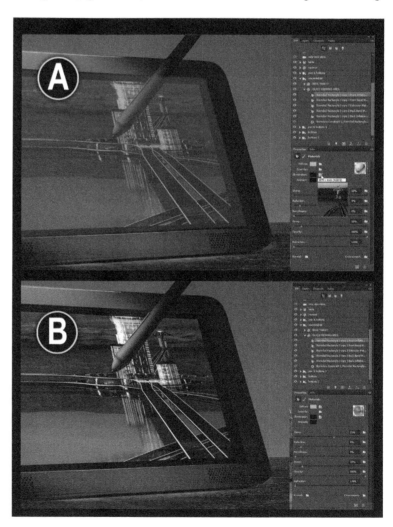

through on the surface. What you are seeing here is the brightness and color manifesting themselves, just as a monitor behaves as it transmits light. Let's add an image to the Diffuse to see how that will enhance it.

Step 6

Add "graphic.tif" to the Diffuse and take note that you a getting enhanced results with better detail (Figure 5.41B). Let's move on to the reservoir.

Step 7

Apply a Shine of 20% to the reservoir to give its surface some character (Figure 5.42).

FIG 5.42 Add shine to reservoir.

Step 8

Because the control ring is designed to push into the surface of the tablet, we are now running into limitation as to how much detail we can model into the pad's surface. In this case, it is easier to apply the graphic "tablet surface" to

the Diffuse for the tablet's "Front Inflation" to represent the control ring. Take note that the circular dial is made up of vector shapes (Figure 5.43) with Layer Style properties applied to them.

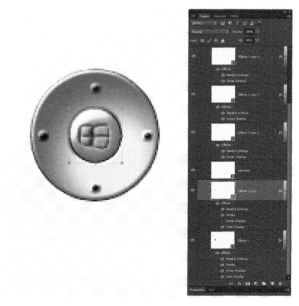

FIG 5.43 Add decal to table surface.

Figures 5.44A–C show the settings for Bevel & Emboss (Figure 5.44A), Inner Shadow (Figure 5.44B) and Color Overlay (Figure 5.44C). You are welcome to modify these or make your own. For now, use this to study how they were created.

FIG 5.44 View of the Layer Style properties.

FIG 5.44 (Continued)

Step 9

To add a tad bit of extra detail, create 3D buttons from the "button.tif" file
(Figure 5.45A) and add them to the Companion, as shown in Figure 5.45B.
Give them the same dark gray color as the tablet.

FIG 5.45 Create 3D buttons and add buttons to the Companion.

Step 10

Finally, render the final piece (Figure 5.46).

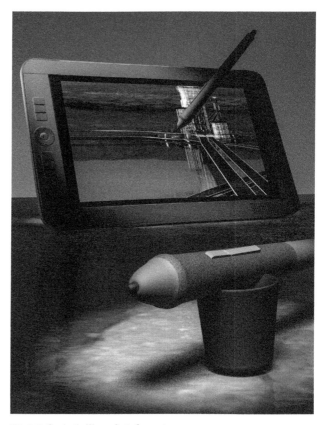

FIG 5.46 Render the Wacom Cintiq Companion.

Surfacing the Watch

We are so used to seeing watches that the 3D model without its textures makes this piece fairly unconvincing. Watch what can happen when we pay attention to extra details in surfacing the watch. Access the "Chapter 4 Watch" folder to get the reference images for this tutorial.

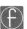 See the app for a video on this watch.

Step 1

Target the "Bump" material for the "Extrusion" of the "wristband" object and apply the "wristband texture.tif." In the Texture Properties, set the "U/X" for the Scale to 5% and the "U/X" for the Tile to 20. You should have something similar to Figure 5.47A.

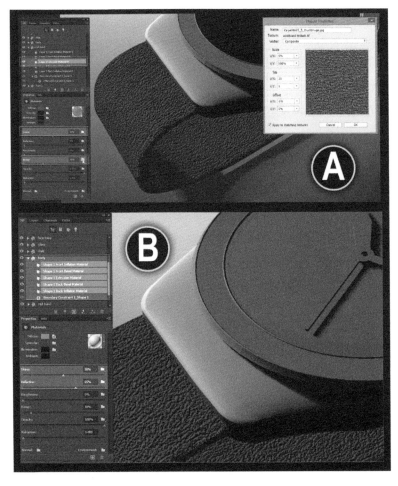

FIG 5.47 Apply bump to wristband, surface the body of the watch and surface the "face base."

FIG 5.47 (Continued)

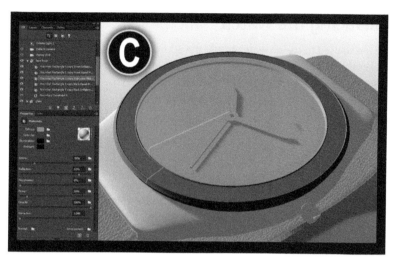

Step 2

Surface the body of the watch with the following attributes (Figure 5.47B).

 Shine: 50%
 Reflection: 65%

Step 3

Next, apply the following setting to the "face base" (Figure 5.47C).

 Shine: 20%
 Reflection: 83%

Step 4

Now, apply and line up the "dials.tif" to the UV map for the Diffuse material for the "Front Inflation" of the "dial" object, as shown in Figure 5.48 A–B.

FIG 5.48 Texture applied to the watch.

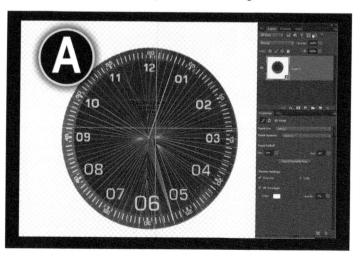

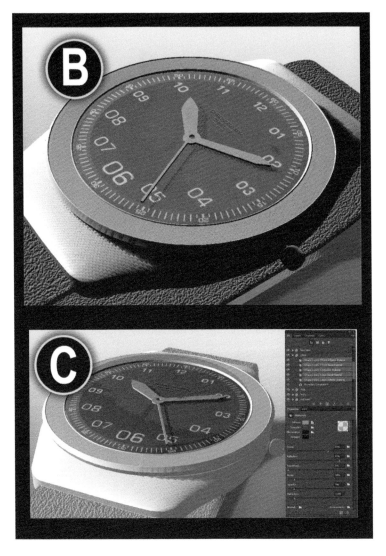

FIG 5.48 (Continued)

Step 5

Apply the following Material attributes to the glass (Figure 5.48C).

Shine: 65%
Reflection: 83%
Opacity: 9%
Refraction: 1.2

Step 6

Access the UV map for the Diffuse of the "hands" of the watch. Add white-filled vector shapes to match the UV map as shown in Figure 5.49. Add a dark stroke to it as well. Use Figure 5.49 as a guide.

FIG 5.49 Texture the watch "hands."

Step 7

Use the following material attributes for the "winder" (Figure 5.50).

Shine: 50%
Reflection: 65%

FIG 5.50 Texture the watch "winder."

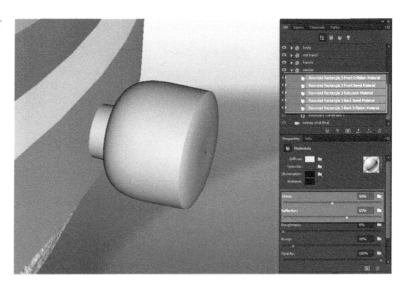

Step 8

Finally, render it to see how well the texturing brings the watch to life (Figure 5.51).

FIG 5.51 Render the watch.

Texturing the Hourglass

Here we will use both photographic and custom textures to bring detail into sand and wood areas. We will begin by adding a background. All files can be found in the "Chapter 4 Hourglass" folder.

Step 1

Open the "hourglass" file that you modeled from chapter 3. Add the "sky. tif" to the background and add the "world map.tif" to the bump material of the "globe." Remember that this was instanced, so you should see the effect happen across three globes. We will add more detail in just a bit but let's change gears and quickly change the format of the composition to something more vertical to give the image stature. Use the Crop tool, and in the Options panel give it a dimension of 7.5x9.5 inches (Figure 5.52).

FIG 5.52 Give the image a vertical format.

Step 2

Target the Diffuse material for the "dune" object so that we can texture that to look like sand. We are going to use the noise technique that we did in Figure 5.19. However, this time exclude the Gaussian Blur to give the sand a sharper look. Apply the texture to the "sand" and for the Scale in the Texture Properties, set it to 5% and the Tile to 20% (Figure 5.53). This will give us a look of very fine sand.

FIG 5.53 Surface the sand.

Step 3

Next, add the same texture to the "Diffuse," Shine and Bump material for the "sand" (Figure 5.54).

FIG 5.54 Add image to Diffuse, Shine and Bump for the sand inside of the glass.

Step 4

Next, add the "world map.tif" to the "Diffuse" for the globe (Figure 5.55).

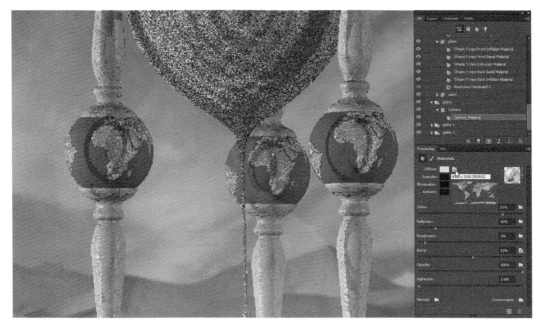

FIG 5.55 Texture the globe.

Step 5

Add the "wood texture.tif" to the "Diffuse" channel for the Extrusion of the "top platform" and the "pillar" (Figure 5.56).

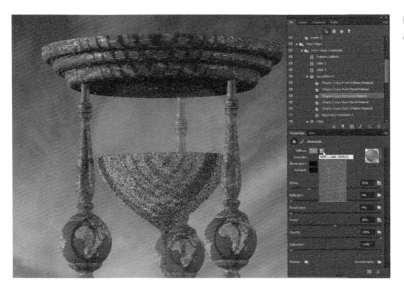

FIG 5.56 Surface the "top" platform and "globe."

3D Texturing

Step 6

Use Figure 5.57 to surface the glass. When done, let's do a render.

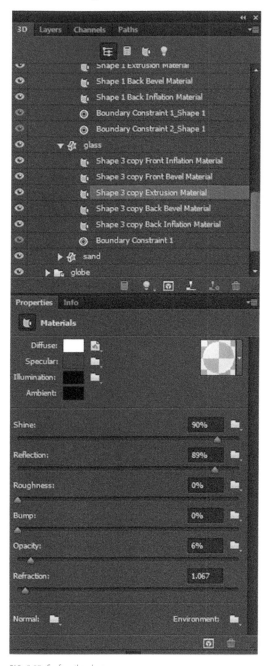

FIG 5.57 Surface the glass.

160

Step 7

Render the scene. Figure 5.58 shows the result of the render. Keep in mind that your result could look slightly different, however, that is ok. Just get as close as you can.

FIG 5.58 Render the hourglass.

Step 8

Now that we have everything surfaced the way that we like it, merge the 3D objects for the hourglass and create four instances of it to scatter them through the dunes to the left of the primary hourglass. Get close to what you see in Figure 5.59. Don't worry about the lighting now as we will address that in chapter 6. Pretty fun stuff, huh?

FIG 5.59 Merge and instance the hourglass.

Bringing Life to the Sword

In this tutorial we are going to texture the primary blade in the foreground. What you will learn will allow you to texture the second blade on your own.

 See the app for this video: Sword & Stone

Step 1

Open the "sword and stone.tif" that you created in chapter 3 and apply "red sky" to the background (Figure 5.60).

FIG 5.60 Add sky to background.

Step 2

Add the "mud.tif" to the Diffuse of the mud material. In the Texture Properties,
set the Scale to 350% and the Tile to 28% (Figure 5.61).

FIG 5.61 Add surface to Diffusion.

**163**

Step 3

Now add the "water.tif" to the "Diffuse" and the "Bump" for the "water" object. Use Figure 5.62 as a guide.

FIG 5.62 Compose the mound for the sword.

Step 4

Let's place an engraving in the sword to give it its own unique personality. Target the "sword" in the 3D panel and for both the Front and Back Inflation add the "sword bump.tif." Now, set the slide intensity for the bump to 56% and let's move forward (Figure 5.63).

FIG 5.63 Add bump to sword.

Step 5

Let's give the blade an etched look to give a sharp appearance, and let's use a texture that we already created. Use the microphone handle texture and give it a slight Motion Bur (Filters>Blur>Motion Blur), as shown in Figure 5.64.

FIG 5.64 Add edge to the sword.

Step 6

Now it's time to surface the hilt with a weatherworn look. I photographed the side of a rusting tanker car and thought it ideal for this exercise. Target all of the material attributes for the hilt and set their Shine to 91% and Reflection to 64%. In addition, add the same texture to the Shine so that where the brighter areas lie will become more glossy looking. Next, in the Texture Properties, set your values to match what you see in Figure 5.65.

FIG 5.65 Add a weatherworn look to the hilt.

Step 7

Let's add texture to the spheres on either end of the hilt. Add the "hilt texture.tif" to the "Diffuse" and "Bump" then apply surface properties, as seen in Figure 5.66.

FIG 5.66 Apply texture to "hilt detail."

Step 8

For the handle of the sword, use the "sword wrap.tif" for the Extrusion. Also, add this texture to the "Bump." Access the Texture Properties and match your settings to what you see here (Figure 5.67).

FIG 5.67 Surface the handle.

Step 9

Now apply the same texture procedures to the second sword and render the scene (Figure 5.68).

FIG 5.68 Texture the second sword and render the scene.

Surfacing the Binoculars

These binoculars will take on a camouflage look with a texture that we will custom create. All files for this exercise are found in the "Chapter 4 Binoculars" folder.

 See the app for this video: Binoculars

Step 1

Create a new document at 5x5 inches with 200 PPI resolution. Set your foreground color to sandy yellow and the background to an olive color. Duplicate the layer and fill it with a cloud texture (Filter>Render>Clouds) to start the camouflage effect (Figure 5.69A).

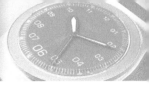

FIG 5.69 Create a new file and fill the layer with clouds, create the camouflage, create the Smart Object and transform the layer.

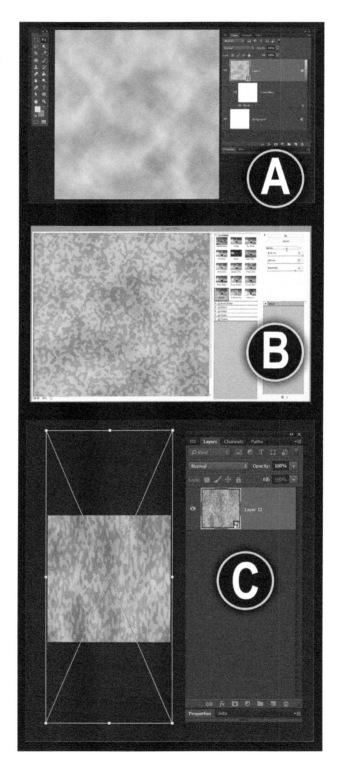

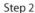

Step 2

To get the camouflage effect apply a Sponge filter (Filter>Artistic>Sponge) with the settings that you see in Figure 5.69B.

Step 3

Merge all layers into a Smart Object and stretch the texture so that when applied it doesn't look too uniform, as shown in Figure 5.69C.

Step 4

If you remember, we instanced the scope so applying the texture to the original will automatically surface the other, so add the camouflage to the Diffuse and watch the other become populated with the same effect (Figure 5.70A).

Step 5

For the "lens detail" that holds the glass optics in place, apply the following as you see in Figure 5.70B.

FIG 5.70 Texture the scope, Surface the lens detail and Texture the focus ring and bridge connectors.

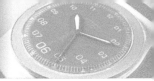
FIG 5.70 (Continued)

Step 6

Next, alter the color of the "bridge connectors" and the "focus ring" to deep gray (Figure 5.70C).

Step 7

Let's make some adjustments to the "scope detail" that represents the eyepiece focus ring as shown in Figure 5.71. As you can see, the texture was truncated due to the resizing of this object early. This is not a problem since we can adjust its texture properties. Let's accomplish that next.

FIG 5.71 View of eyepiece focus ring with shorter texture

Step 8

Access your Texture Properties for the Diffuse and set the size to 250% for the Scale and 4% for Tile (Figure 5.72). Let's move on.

FIG 5.72 Enlarge texture.

Step 9

The bevel for the eyepiece focus ring can be improved. So target the "scope detail 2" in the 3D panel that represents this object and target the icon for the Bevel properties. Make a custom bevel shape close to what you see in Figure 5.73.

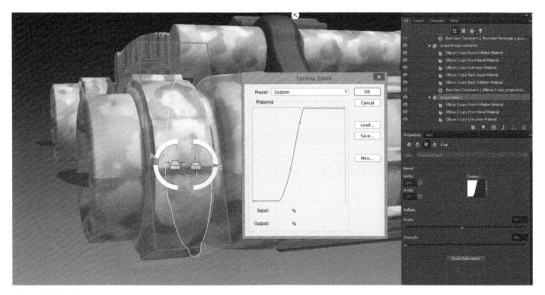

FIG 5.73 Edit the Bevel properties.

Step 10

There are other areas with similar problems as step 9 so instead of entering into the Properties panel we will use the 3D Eye Dropper to copy and paste what we modified on the eyepiece focus ring. So target the 3D Eye Dropper tool as shown in Figure 5.74.

FIG 5.74 Target 3D Eye Dropper Tool.

Step 11

Click and release on the **modified extrusion**, as shown in Figure 5.75.

FIG 5.75 Target modified extrusion.

Step 12

Now, Alt/Opt click on the areas that need to receive the adjusted texture (Figure 5.76).

FIG 5.76 Paste modified extrusion.

Step 13

Now render the binoculars (Figure 5.77). So far so good. Let's move on to lighting our scene.

FIG 5.77 Render the binoculars.

Texturing the Corkscrew

To get the most realistic renders, photographic textures will take on an important role. In this exercise we will use images taken from a Nokia 5012 cellphone camera of the texture on the original corkscrew and apply them to the 3D object.

Diffused lighting is often best to capture detailed textures. Today we do not have to rely on professional SLR (Single Lens Reflex) cameras to capture a great texture. The cellphone cameras and point-and-shoot cameras have come a long way and they are just as capable of capturing a good texture that is more than sufficient for 3D texturing. Figure 5.78A shows our subject in direct sunlight. The problem is that the direct sun will give a harsh result by washing out the details that reside in the mid tonal-range areas. By having softer or diffused light sources, the details in the mid-tonal areas will continue to be present to bring out the much needed detail for your 3D model. So, for Figure 5.78B I placed a white bedsheet between the direct sun and the subject to soften the light. Finally, I used my Nokia 5012 cellphone, which records a 20-megapixel file, to capture the image. The texture that you are using in this exercise is the one captured with my camera. Also, all files can be found in the "Chapter 5 Corkscrew" folder. So, let's get started by making a seamless tiled texture.

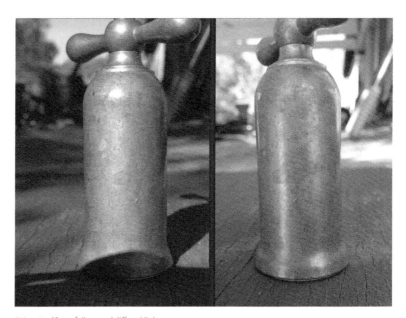

FIG 5.78 View of direct and diffused light.

See the app for this video: Binoculars

Step 1

Open the "corkscrew.tif" document. This is our original file captured with the cellphone camera. There is good texture in it but the highlights are a distraction so we will get rid of them.

Step 2

Duplicate the layer and use the Clone Stamp tool (S) to sample textures from one location to replace the highlight areas. Use Figure 5.79B as a guide.

FIG 5.79 Replace the highlighted areas with texture.

Step 3

To further even-out the tones and to add more texture, duplicate the original texture and position it as the top layer. Now change the layer blend mode to "Darken." This will only allow the richer details to show up while the brighter values have no effect on the image. Add a layer mask and edit the mask so that the detail is restricted to the left side of the image. Now, duplicate this layer and flip it horizontally (Edit>Transform>Flip Horizontal) and position it so that the right side gains more detail (Figure 5.80).

FIG 5.80 Replace the highlighted areas with texture.

Step 4

Improve the contrast and detail by adding a Curves adjustment layer to increase the overall contrast, as shown in Figure 5.81. When done, flatten the image and save it as "corkscrew.tif."

FIG 5.81 Apply a Curves adjustment to enhance detail.

Step 5

I have provided the original photo called "corkscrew photo.tif" in case you would like to customize your textures, but for now apply the "medallion.tif" found in the "Chapter 4 Corkscrew" folder to the "Front & Back" inflation of the medallion handle. In addition, apply the image to "Bump" material. Let's now surface the rest of the corkscrew (Figure 5.82).

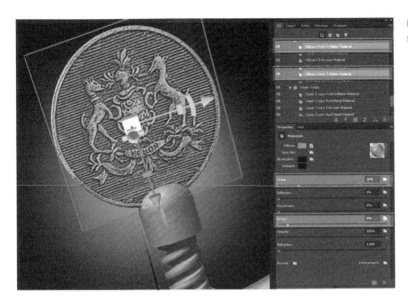

FIG 5.82 Apply the medallion image to corkscrew handle.

Step 6

Finally, apply your new seamless texture to the "Diffuse" for all of the material attributes for the rest of the 3D objects with the exception of the spiraling point. For that, make its surface color white and keep the "Shine" at 20%. For the remaining objects, give them the surface attributes that you see in Figure 5.83.

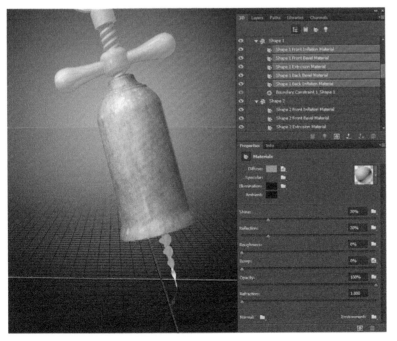

FIG 5.83 Use "corkscrew photo.tif" to texture the model.

Now apply a render to see the final results (Figure 5.84).

FIG 5.84 Render the Scene.

I hope that you enjoyed this chapter. Now we are onto lighting the 3D scenes.

What You Have Learned

- All texturing is applied via the properties panel.
- An object must be targeted in the 3D panel to view its Materials.
- You can add video as well as images to a Material.
- You can modify the size and location of a texture with the "Texture Properties."
- The Bump channel uses B&W information to add texture detail to the surfaces.
- The Opacity varies the transparency based on the values applied to an object.
- Smart objects are ideal for creating textures.
- The Eye Dropper is ideal for copying and pasting materials from one location to another.

Creative 3D Lighting

Understanding 3D Lighting

In this chapter, you will learn various ways to use lighting to bring out the very mood that you are trying to convey in your scene. Your most successful 3D scenes simplify light techniques by using very few light sources. Remember the old adage, "less is more"? This is especially true when using 3D lighting. Setting the stage with a single light will lead to suggestions for how other lights could enhance your ideas.

Getting Started with Lighting Presets

In the start of this chapter, we will rely on the Infinite light then we will progress to a combination of light types. In addition, we will apply presets that Adobe has given us as a starting point and modify them to meet our purposes. So, let's get started and set up the lighting environment for the wire gauge.

Step 1

Open the "wire gauge.tif" that you saved in chapter 4. Figure 6.1A shows two Infinite lights where one illuminates from the top right with a slightly yellow hue and the other is set up as a rim light illuminating from the bottom left that has a bluish hue. Set your lights similar to what you see here for now. Keep in mind that this is an initial setup to help you view the object better for the next step and the intention is to change it later on. Let's go to the next step.

Step 2

To focus the viewer's attention on the exposed wire, we are going to set up a shallow depth of field with the current camera. Target the "Camera" in the 3D panel. In the Properties panel set your depth of field to match what you see in Figure 6.2. Keep in mind that how you set up your scene will affect your choice for setting the "Distance" and "Depth." So, a nice trick is to hold down the Alt/Opt key and click and release on the location of the object that you want to be in focus. From there you can modify your settings. Play with this to get something close to what you see in Figure 6.1B and let's move on.

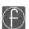 Check out the app for a video on Depth of Focus

Step 3

We are going to give this image a more dynamic lighting situation to make it more visually interesting. Target just one of your lights so that you can see the light attributes in the Properties panel. So focus your attention there. In the Preset drop down list, target "Mardi Gras." Now it looks more festive and not as mundane. Figure 6.1C shows how the preset arranged three Infinite lights with blue from the left, green from the bottom right and a yellow light from the top.

Note: Any light setup can be saved. Just choose "Save" from the Preset drop list.

Step 4

Taking a closer look, the default light style for this preset is harsh, as is evident in the sharper edge quality of the shadows as displayed in Figure 6.2A. So, let's soften it.

Step 5

Target all of the lights and set the "Shadow" slider in the Properties panel to 80%. That should do it (Figure 6.2B).

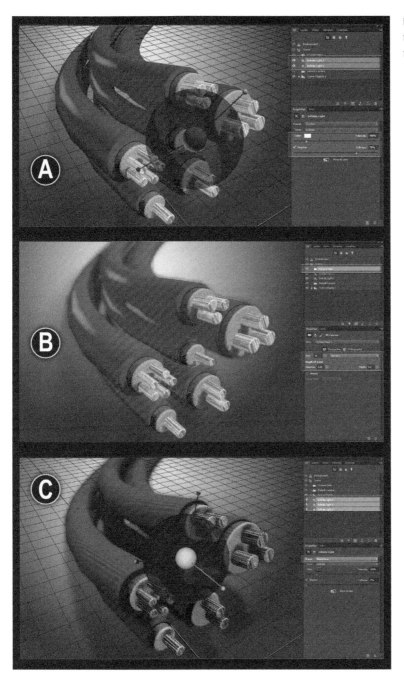

FIG 6.1 Set up initial light formation, set the depth of field and choose the Mardi Gras light preset.

FIG 6.2 Soften the shadows of the Mardi Gras light preset.

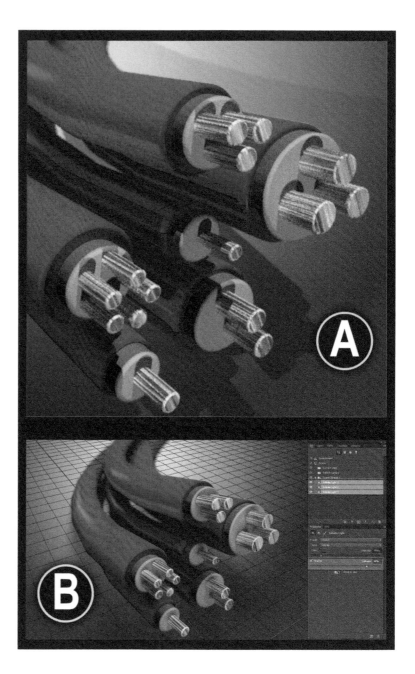

Now give it a render and view the final results (Figure 6.3).

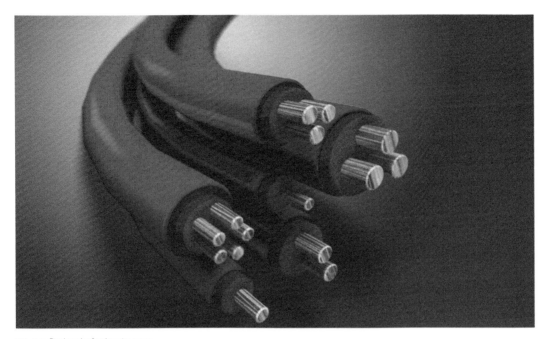

FIG 6.3 Final render for the wire gauge.

Set Up the Lights for the Syringe

Step 1

Open the "syringe.tif" file that you created in chapter 4. Apply the "CAD Optimized" light preset and let's explore what this does.

Turn off all of the lights except for the Point Light, which is the first in the list. Observe how this provides a broad side lighting.

Step 2

Turn on the "Infinite Light 1" to see a rear light source. This one is ideal for lighting the transparent glass and liquid (Figure 6.4B).

Step 3

Turn on the "Infinite Light 2" to see a fill light source. This one is ideal for adding light in the shadow areas (Figure 6.5A).

FIG 6.4 Preview "Infinite Light 1."

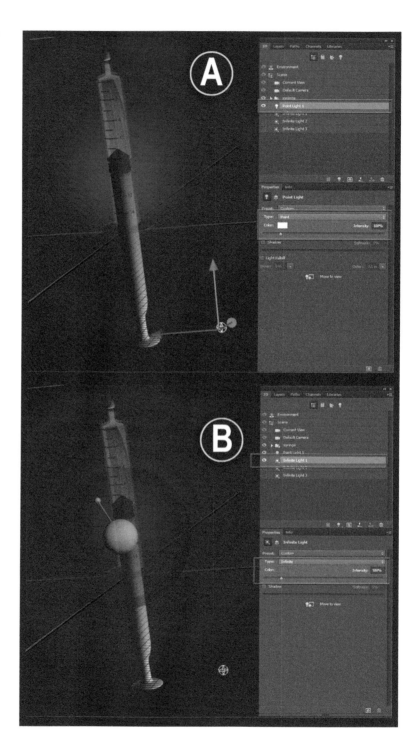

Step 4

Turn on the "Infinite Light 3" to see a rim light source from the bottom. This one is ideal for adding light contour around the side of sides of the syringe (Figure 6.5B).

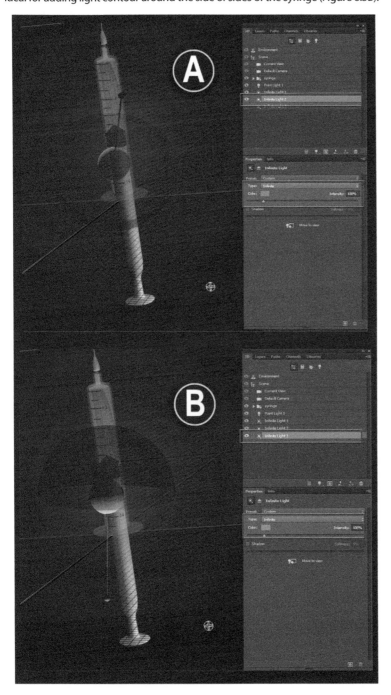

FIG 6.5 Preview "Infinite Light 2" and "Infinite Light 3."

Step 5

Now go to your layers panel and add a Gradient adjustment layer underneath the 3D layer. Use the circular option gradient option and use red for the highlight and black for the background edges similar to what you see in Figure 6.6. That will help add attention to the subject. Now create a render to see results of this light combination. Use Figure 6.6 as a guide.

FIG 6.6 Render the syringe.

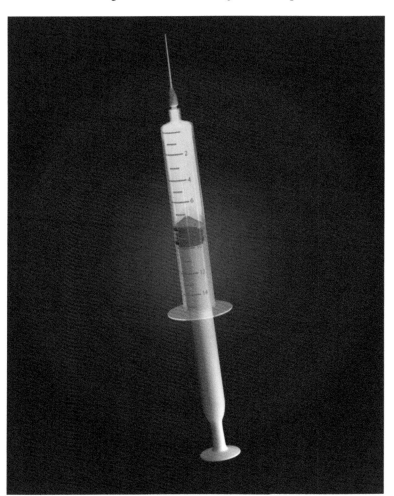

Lighting the Microphone

Step 1

Open the "microphone.tif" from chapter 4. Set up two Infinite lights as shown in Figure 6.12. Alter the color of the rim light illuminating from the left rear to a red hue and set the "Softness" slider for the shadows to 76% to get a subtler light transition (Figure 6.7).

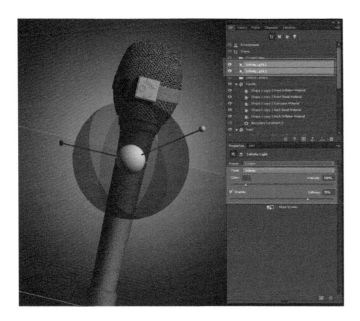

FIG 6.7 Adjust the color and shadow attributes of rim light.

Step 2

Target the "Infinite Light 2" which is your main light and set it to illuminate from top right corner at a 46-degree angle. Give it more brightness of 171% to get the microphone and texture to jump out more as you see in Figure 6.8. Keep in mind that the intensity amounts were derived from constant experimentation. So play with it and get something that you feel works great.

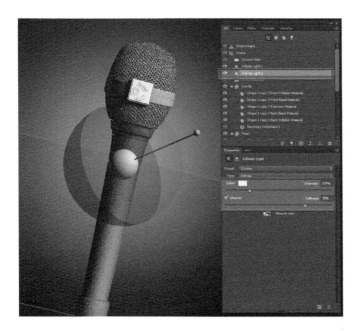

FIG 6.8 Adjust the color and shadow attributes of rim light.

Step 3

That's it on this one. Now do a render to see the results (Figure 6.9).

FIG 6.9 Render the microphone.

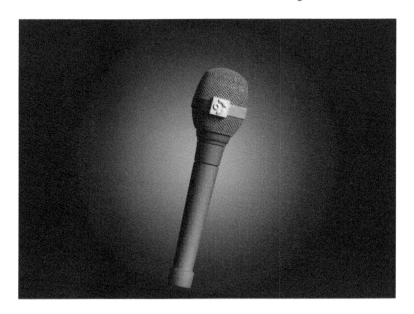

Sunset Lighting for a Romantic Evening

The wine bottle and glass reminds of a setup for romantic date. So, we will create the mood with a thoughtful lighting setup. We will use a combination of spot and infinite lights to give it a personalized look. The goal is to keep the bottle in the shadow while adding a spotlight to the label. For the glass itself we will backlight it and provide a rim light on the bottle to match the sunset. Keep in mind that transparent objects are best lit from behind when photographing them so we will approach the lighting of this object as if we are photographers. Let's begin.

Step 1

Open the "wine glass.tif" from chapter 4. Set a Spot light to the far right of the bottle and adjust its "Hotspot" and "Cone" angle to create a circular illumination on the label of the bottle. Get close to what you see in Figure 6.10A.

Step 2

Add an Infinite light (Infinite Light 1) as a rim light coming from left-rear to warm up the left edge of the bottle as shown in Figure 6.10B.

Step 3

Add an Infinite light (Infinite Light 2) as a rim light coming from right-rear to warm up the right edge of the bottle as shown in Figure 6.10C.

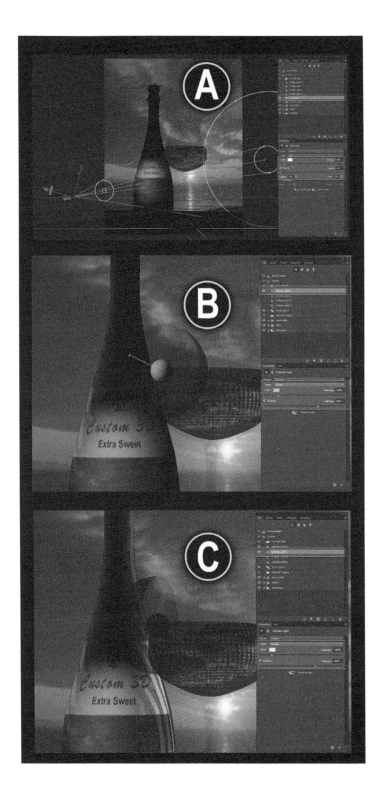

FIG 6.10 Illuminate the label using a Spot light, add rim light to the left, and add rim light to the right.

Step 4

Add an Infinite light (Infinite Light 3) as a rim light coming from the direct rear to illuminate the wine inside of glass (Figure 6.11A).

Step 5

Add an Infinite Light (Infinite Light 3) as a top light coming from the direct rear and above to illuminate the surface of the wine inside of glass (Figure 6.11B).

FIG 6.11 Add rim light to the rear and add top light to light the surface of the wine.

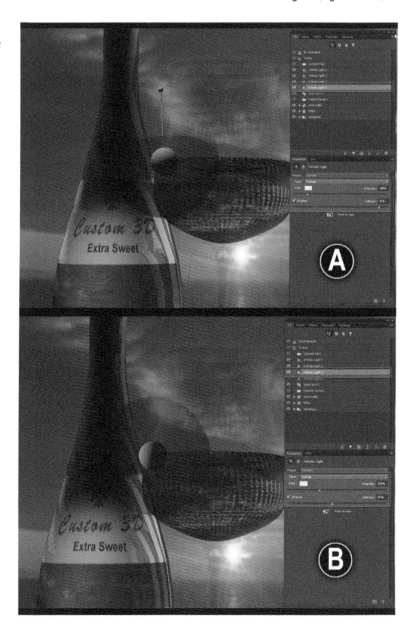

Step 6

Now let's render the scene. Keep in mind the renders will take longer for objects that have transparent surfaces and refractions applied. Be patient and you will be rewarded (Figure 6.12).

FIG 6.12 Render the wine glass.

Rendering the WACOM Table and Pen

With the Wacom tablet, the goal is to create a stylized lighting setup that gives the composition depth. So, we will rely on a light source that gives us more control. We will rely on the Spot light. Let's get started.

Step 1

Open the "Wacom Tablet.tif" file that you created in chapter 4. Figure 6.13A shows the current setup with Infinite lights as the primary light source. This

works but it's a little uninteresting. Let's make it more dynamic using Spot lights.

Step 2

Setup a Spot light so that it illuminates the pad from the far top-left corner as shown in Figure 6.13B.

Note: Hold down Alt/Opt to be placed into the 3D Roll tool and vice versa.

FIG 6.13 View of the 3D navigational tools and set up Spot light in top left corner.

Step 3

Adjust the angle of the Spot light so that its influence falls off the bottom left and the top right edge of the tablet in a manner that you see in Figure 6.14A.

Step 4

Now, do the same for the pen and reservoir in the front right (Figure 6.14B).

FIG 6.14 Apply Spot light to scene and apply Spot light to stylus and reservoir.

Step 5

Adjust the angle of the Spot light so that its influence surrounds mostly the pen as you see in Figure 6.15.

FIG 6.15 Restrict angle of Spot light to stylus and reservoir.

Step 6

Target the Environment attribute in the 3D panel then click the color swatch for "Global Ambient." Set the color to slightly lower than a medium gray. This will brighten up the areas of the scene that have darker tonalities like the shadows on the table. This will add some brighter tones in that region so that we can see the reflection when we render the file (Figure 6.16).

FIG 6.16 Set "Global Ambient" to a dark gray value.

Step 7

Now render the Wacom Cintiq Companion tablet (Figure 6.17).

FIG 6.17 Render the Wacom Cintiq Companion.

Texturing the Watch Using IBL

In this tutorial, we are going to use IBL (Image Based Lights) as a way to give character to the watch. We are not just going to use it to light the scene but as a way to texture our subject as well.

Step 1

Open up the "watch.tif" from chapter 4. Turn off all of the lights so that what you see is a shadowy shape (Figure 6.18). This is the result when new illumination is provided.

FIG 6.18 Use the Pan tool to reposition the Cube Wrap.

Step 2

Target the IBL checkbox and load in "sunset IBL.tif" for the image that will be used to light the scene. Making sure that the Environment attribute in the 3D panel is targeted and use your 3D Rotation tool to rotate the image to get the color rendition on the watch that you like (Figure 6.19). Remember that the IBL wraps the image around your entire 3D scene and uses its tonal values and hues to illuminate the scene. Due to the experimentation on your end, your colors may not match up with what you see in this example but get something that you like and let's move forward.

FIG 6.19 Add an Image Based Light.

Step 3

We are going to use a light to bring out the detail on the watch, so add a single Infinite light to light the watch diagonally from the top left (Figure 6.20).

FIG 6.20 Add Infinite light.

Step 4

Now that you have the main light set, let's add another technique to blend the colors so that they integrate a little better on the watch.

Open up the IBL image again. Unlock the layer and make it a smart object to make it nondestructive. Now add a Gaussian Blur of 55 to smooth the colors

into one another. Since we are more interested in the colors on the watch instead of the detail, this will help give the final result a smoother look as you see in Figure 6.21.

FIG 6.21 Add Gaussian Blur to the IBL image.

Step 5

Now give it a render (Figure 6.22). It looks great! Let's have some more fun.

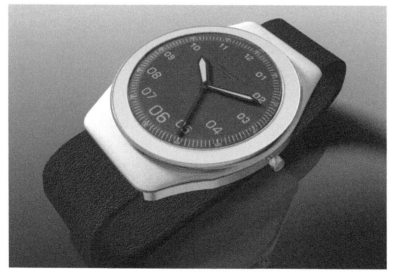

FIG 6.22 Render the watch.

Lighting the Hourglass

When we build models to integrate them as part of a photographic scene we need to pay attention to the lighting style, color, its quality and direction. In

situations like this, we rely on IBL so that our 3D model has a fighting chance of looking believably integrated. In this exercise we will design the lighting to match that of the sand dune so that the scene becomes a unified experience.

Step 1

Open the "hour glass.tif" from chapter 4. We are going to match the nature of the light from the photo in the background. The first thing we are going to look at is the placement of the shadows and note their direction and position. The direction of the light source in the sand dune is emanating from the far left toward the lower right so we are going to mimic that effect here. The background photo gives us the clues that we need. Simply look at the placement and length of the shadows in the photo. Take note of the color of brighter values to discover what color dominates the image. In this image, the color that dominates is more of a bright orange. In addition, the scene has a slight diffused light quality due to the sun being lower in the sky where atmospheric haze softens the effect of the light. We will keep all of that in mind as we create. Let's get working.

Start by adding the one light style in Photoshop that resembles sunlight and call it "rim light 001." Add an Infinite light. Angle it so that the light comes from the far left corner toward us so that the shadows on the 3D objects match that in the scene. Set its color to white with an intensity of 376% to get a strong, directional sunlit effect. In addition set the "Softness" for the "Shadow" to somewhere around 90% to get the diffused light effect. Use Figure 6.23 as a guide. Next, we are going to blend this light with some color.

FIG 6.23 Apply Infinite light to the scene.

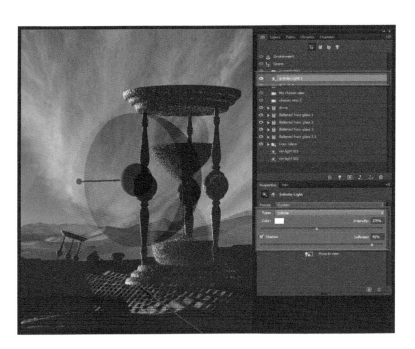

Step 2

We are going to broaden the shape of the rim light across the hourglass by adding a second light. However, this time we are going to alter its color to a bright orange to mix this with the original light. I have found that in CG software adding multiple lights with color variations from the start gives me less control over that color. I have found that establishing the main light with a neutral value to get the brightness that I need and then mixing colors into it from an additional light gives me greater control. So, add another Infinite light and call it "rim light 002." Alter its color to a bright orange. Then offset the angle slightly so that the rim light effect is a little broader across the side of the hourglass. The light intensity does not need to be as harsh since we are using this light to color the subject so set the "Intensity" slider to around 260% and the "Shadow" slider to 70% and let's move on (Figure 6.24).

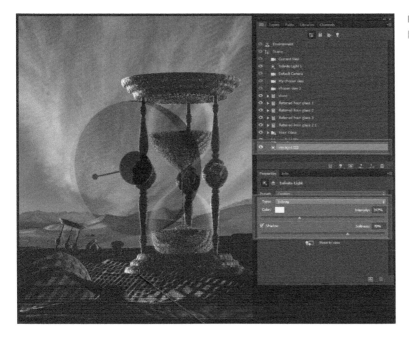

FIG 6.24 Add an additional Infinite light as a color mixer.

Step 3

Next, add another Infinite light to add rim light to the opposite side of the hourglass as shown in Figure 6.25. Since it will be used to fill light into the other side, set the default color as white, the "Intensity" to around 156% and the shadow to around 71%. We kept the color white since the next step will add mix more color with it.

FIG 6.25 The 3D mesh.

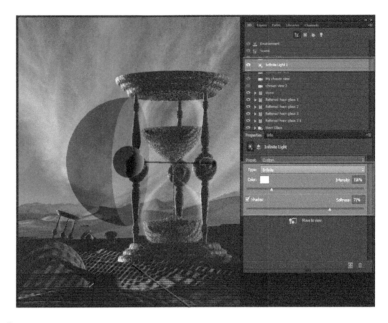

Step 4

Now, for the final ingredient, In the Environment attribute add in an IBL. Use "sky.tif" as the image to illuminate the scene. The background image is not illuminating the entire scene. Set the "Intensity" to around 60% since we don't need it as the primary light source. We are using it only to paint color back into the 3D environment (Figure 6.26). Also, notice that the IBL has added a nicer luminance effect along the left edge where we placed the two rim lights.

FIG 6.26 Add "sky.tif" to IBL.

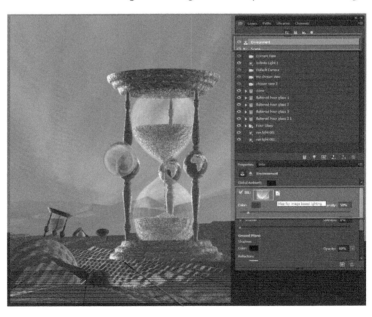

Step 5

Finally, render your scene and enjoy (Figure 6.27).

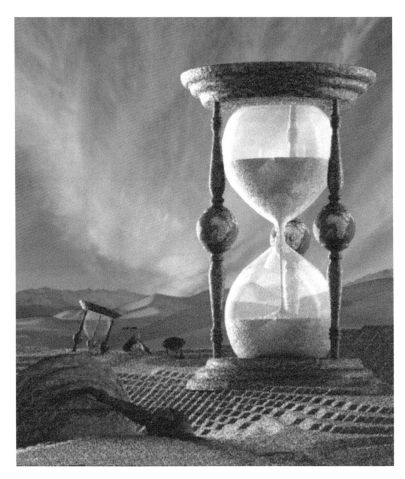

FIG 6.27 Render the hourglass.

Lighting the Swords in Stone

In this tutorial, we are going to rely mostly on an Image Based Light to bring the swords to life. Currently, they are interesting but the primary character being the front sword is not jumping out to the viewer. Let's give it a stronger presence.

Step 1

Open the "sword in stone.tif" that you created in chapter 4. Begin by adding an Infinite light coming from a 45-degree angle from the right to match the lighting direction of the background image. Make its color a light orange as shown in Figure 6.28. Give it a slightly higher than 100% intensity and set the "Shadow" to around 55%.

FIG 6.28 Add Infinite light to the scene.

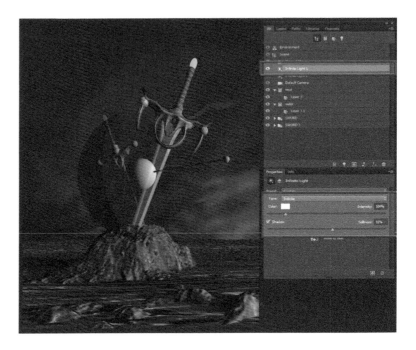

Step 2

To give the sword a slight depth, add a rim light coming from the left-rear. Give it a bright orange with a Shadow "Softness" of around 55% (Figure 6.29).

FIG 6.29 Add a rim light coming from the left-rear.

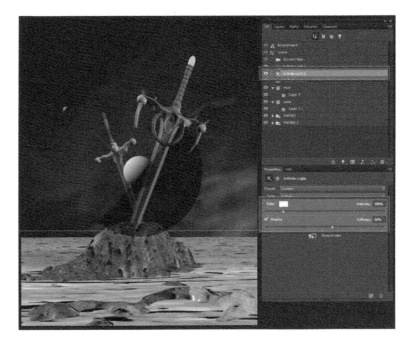

Step 3

Next, add in an IBL that will bring the sword to life. Add the image "red sky 002.tif" to the image to illuminate the scene. Notice that the file has a yellowish fill on a third of the image. This is to create the highlighted effect on the sword itself. In essence, the reflectivity of the sword's surface is providing a means to reflect the yellow portion of the image on its blade. Use the Rotation tool and rotate the IBL to position the yellow hue onto the blade of the sword. Get something close to Figure 6.30.

FIG 6.30 Add "red sky 002.tif" as an IBL.

Step 4

In experimenting with the IBL positioning from step 3 you may have noticed that the hilt of the swords may take on a more reflective quality that competes with the blade of the sword. To rectify this just turn down the "Reflection" for the hilts in both swords to around 6% and render it. You should see something close to Figure 6.31.

FIG 6.31 Render the final scene.

Lighting the Binoculars

Sometimes you might want to light a subject for a client who wants to illustrate his or her product. So, no fancy backgrounds or lighting, just showcase the model with all of its detail. An effective way to show the detail is to use side lighting. The Binocular is ideal for this type of situation.

Step 1

Open the "Binocular.tif" from chapter 4. Create a Rembrandt light style coming from the top right. This will highlight the front face and top bridge of the subject as you see in Figure 6.32. In addition, set the Reflection for the ground plane to 45% to add a nice compositional interest to the scene.

FIG 6.32 Add Rembrandt light style to the scene.

Step 2

There are details on the bottom of the subject that we need to bring attention to. So, add a rim light coming at a 45-degree angle from the bottom-left to accent the underbelly of the binocular (Figure 6.33).

FIG 6.33 Add rim light to show details underneath the subject.

Step 3

To make sure that we can view all areas in the shadow areas we will illuminate them using the default image that came with the IBL. Set its intensity to 70% and Shadow "Softness" to around 75% (Figure 6.34).

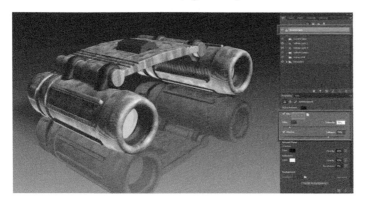

FIG 6.34 Use the default IBL to open up detail in the shadows of the binocular.

Step 4

To add a little interest, add bluish color to the "Luminance" of the lens then render the final scene (Figure 6.35). That works well. The client should be happy.

FIG 6.35 Add Luminance hue to the lens and render the scene.

Commercial Lighting for the Corkscrew

The corkscrew is another prime example of a commercial style lighting setup. A very common lighting style of product of this type is for the photographer to use a softbox similar to what you see in Figure 6.36. The lightbox is a tent that houses a photo strobe that fires light through the white screen. We are going to setup this situation to simulate such a lighting effect.

FIG 6.36 View of a photographic softbox.

Step 1

Open the "corkscrew.tif" from chapter 4. Make sure that the IBL, using the default image to light the scene, is turned on (Figure 6.37).

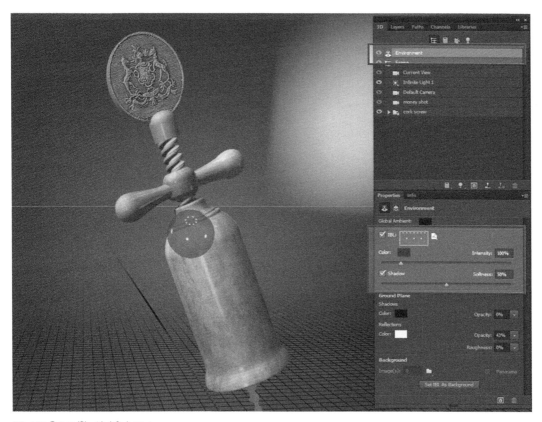

FIG 6.37 Turn on IBL with default setup.

Step 2

This is where we create our softbox. Create a new layer and fill it with white. Access your 3D panel and target "3D Postcard" and click the "Create" button to make a new 3D object. Now, merge this object with the corkscrew. Position the 3D Postcard as you see in Figure 6.38 so that the flat side of the panel faces the corkscrew.

To turn the postcard into a lightbox, target its material then target the color swatch for "Illumination" and set the RGB values for 32-Bit color to 1.5. Click "OK" and render the scene.

FIG 6.38 Create softbox and set the Illumination value.

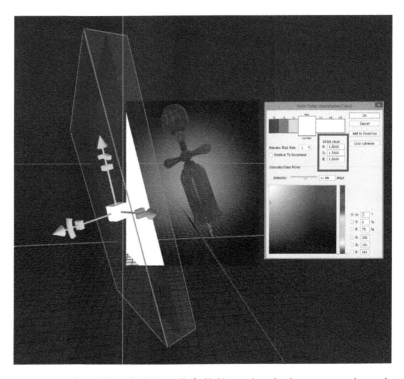

Create a render (Ctl/Cmd-Alt/Opt-Shift-R). Now take a look at your render and observe how the illumination gives a soft and even lighting result (Figure 6.39). Also, the corkscrew reflection adds a handsome effect. Let's add a little more detail.

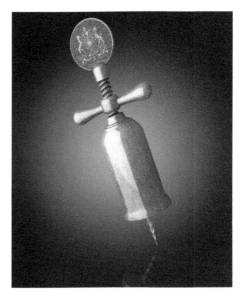

FIG 6.39 Render the scene.

Step 3

Duplicate the postcard and modify the Illumination settings for the 32-Bit value around 0.0195, as shown in Figure 6.40. Position the panel to the far right so that it will add a fill to the shadowy side of the corkscrew. This panel represents a fill or bounce card to add detail. Now render the scene.

FIG 6.40 Explore the various surface options.

Step 4

Now, render your scene again and notice the additional fill light that gives the corkscrew a more polished look (Figure 6.41).

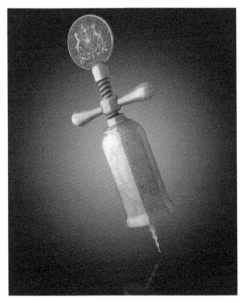

FIG 6.41 Render the scene.

What You Have Learned

- IBL can be great for texturing a 3D object.
- Mixing color using more than one light gives you better control over your lighting setup.
- You can use a 3D postcard to simulate a lightbox effect.

Once again, feel free to experiment with any of the lighting setups that you learned to produce something unique.

Creating a Planetary Scene

From this chapter on we are going to pull it all together into completing
tutorials that represent a single unified concept. Here, we are going to create a
fun concept of a Sci-Fi planetary scene of ringed planets and meteors. You will
be introduced to spherical Depth Maps as the basis for creating the meteors.
You can find all of the work files in "Chapter 7 Planet" folder so let's get started
by creating the space and star scene in which to compose our planets.

Creating the Star Scene

We are going to begin by giving our planetary scene its backdrop with a
blanket of stars. After, we will add additional stars of various styles along with
a cloud-like nebula to add visual interest. Let's have fun.

Step 1

Let's begin with a generic star pattern and add additional colored stars using a star brush. Create a new document at 3x3 inches with 200 PPI resolution. Make sure that the background is white. Use this document to create and experiment with a new brush. Keep in mind that Photoshop recognizes black color information in the document and ignores white when custom creating brushes. Target your Brush tool (B) and select a basic round brush. Set your foreground color to black and paint three solid black dots, as you see in Figure 7.1A. Now we will create a brush using these dots. Use the Rectangular Marquee tool (M) to select the three dots then define them as a new brush preset (Edit>Define Brush Preset). Title the brush "star brush default." This will now be saved to Photoshop's preferences where every time that you open the program you will have the brush available to you. Once you know the shortcuts for using your mouse you can apply them to your Wacom stylus. Now, let's add a shortcut to the top button of the Wacom stylus that will help your productivity.

FIG 7.1 A) Create a star brush. B) Set brush sizing to top button on stylus. C) Set "Shape Dynamics" for the star brush. D) Set "Shape Dynamics" for the star brush.

Check out the app for this star brush video.

Step 2

Open your Wacom Properties and make sure that in the "Application" section in Photoshop is targeted. If not, add it by clicking the "+" symbol to the far right of "Applications." We are going to set the top button to resize your brush. For PC click Modifier and choose "Alt-Right Click," and for Mac choose "Opt-Control-Left Click" (Figure 7.1B). This is one of the few instances where the shortcuts are different between the two platforms.

Once the modifiers are defined, let your stylus hover about a half inch above your pad then hold down the top button while dragging left to right to resize the brush. Note that if you use a standard round brush and you drag up or down the brush feather will be adjusted. If you drag in an upward motion you will get a feathered edge and a downward motion gives you a hard edge.

Step 3

We are going to set the Brush properties to that we can paint stars. Set the Shape Dynamics to 34% and the Angle Jitter to "Pen Tilt" from the drop list as you see in Figure 7.1C.

Step 4

Next, set scattering to 306% and check the "Both Axes" check box so that your brush will scatter on both the "X" and "Ý" axes as you see in Figure 7.1D.

Step 5

Let's create a basic star pattern. Create a new document at 7.5x9.5 inches. Create a new layer and fill it with medium gray. Next, add some noise (Filer>Noise>Add Noise) and set the Amount to around 163% to get some larger patterns (Figure 7.2).

FIG 7.2 Create a new document then create noise patterns in new layer.

Step 6

To allow the next step to obtain varying sizes to the stars, apply a small Gaussian Blur around .7 pixels (Figure 7.3).

FIG 7.3 Apply Gaussian blur to stars.

Step 7

Now let's add some stars. Apply a threshold as shown in Figure 7.4 to gain a star pattern that will scatter throughout the composition. Use your imagination and remember that we are going to add more so don't allow the threshold to apply too many. In this example, a threshold level of 224 is set but experiment with this and get close to Figure 7.4 and click "OK." Let's keep moving.

FIG 7.4 Apply a threshold to create stars.

Step 8

Alter the star layer into a Smart Object so that we can work nondestructively and let's enlarge and soften them a bit. Enlarge the stars by applying the Maximum command (Filter>Other>Maximum). In the Preserve drop list, target "Roundness" to keep the stars circular. Now, increase their size by dragging the "Radius" slider to the right. In this example the Radius is 1.7 but experiment with this as well and click "OK" (Figure 7.5).

FIG 7.5 Enlarge the stars using the Maximum command.

Step 9

Now, apply a slight Gaussian Blur of 2.7 pixels to give the appearance of them fading from a great distance (Figure 7.6).

FIG 7.6 Apply Gaussian Blur.

Step 10

Create multiple blank layers and use the star brush that you created to add various colors of stars with various sizes, as shown in Figure 7.7. Choose whatever color you like, but colors that contrast well against one another work best. For example, reds with blues or yellows with cyans seem to work well. Don't worry about blurring these out because adding a nebula cloud will accomplish that for us.

FIG 7.7 Create stars with the Star Brush on various layers.

Step 11

Let's add some brighter stars that take on the appearance of being closer to our view. Create a new layer and fill it with 100% medium gray (Shift-F12>Fill with Medium Gray). Apply a Lens Flare (Filter>Render>Lens Flare) and change the layers' blend mode to "Hard Light" so that the medium gray disappears, leaving us with a nice luminous colored light. Reduce the layer size to represent larger brighter stars and duplicate the layer to place them throughout the composition. Use the Hue and Saturation command (Ctl/Cmd-u) to alter the colors for each layer as you relocate them. Merge them together to save on memory, but don't forget to change the blend mode back to Hard Light. Duplicate the layer and use Hue and Saturation (Image>Adjustments>Hue & Saturation) to alter the color to something different (Figure 7.8).

FIG 7.8 Use Lens Flare to create more stars.

Step 12

Finally, simulate nebula clouds by adding clouds. Place the "clouds 010.tif" into a new layer. Alter it into a Smart Object and change its blend mode to Hard Light. Reduce its opacity to around 77% to recede it into the background a bit, as shown in Figure 7.9. Use Free Transform (Ctl/Cmd-T) to help you resize and place the clouds as you see fit.

FIG 7.9 Add clouds to the scene.

Step 13

The clouds for this scene have more detail than is desired so add a Gaussian Blur to soften them a bit. Next, we are going to tone down the background a bit with the help of another cloud image. So, add "cloud 011.tif" to a new layer above the "cloud 010." Alter its blend mode to "Vivid Light" so that it baths the background in a purplish blue. Duplicate the layer and change its blend mode to "Multiply" to add a deeper value to get close to what you see in Figure 7.10. This will tone down the background and make the planets stand out. Now, let's go build the 3D planetary bodies.

FIG 7.10 Add "cloud010" to two new layers.

Create the 3D Meteors

We are going to begin building the meteors using spherical Depth Maps. Remember, Depth Maps use B&W values to determine the height and depth of an object, where dark values determine the depth and bright values determine the height. So, let's begin by using the clouds command.

Step 1

Create a new layer and fill it with Clouds (Filter>Render>Clouds). Next, apply Difference Clouds (Filter>Render>Difference Clouds) to give more texture. Then apply Difference Clouds again to get similar to what you see in Figure 7.11A. Alter this texture into a Spherical Depth Map. To accomplish this, go to the 3D panel, target "Mesh from Depth Map" then select "Spherical" form the drop list and click "Create." You will see something similar to Figure 7.11B. This is too aggressive so let's modify it.

FIG 7.11 Create the Meteor by using Spherical depth maps.

Step 2

Target the 3D meteor object in the 3D panel and rename it "meteor." In the Properties panel, target "Edit" so that we can open the file that creates the surface depth. Place both the Depth Map document and meteor document side by side so that we can see the effects of our changes.

Create a gray filled layer and place it beneath the cloud layer. In Depth Map mode, the gray tonality represents no influence. In other words, the shape will not rise or fall where gray is placed on its surface. So, reduce the opacity of the cloud layer to around 10% so the values are reduced closer to gray to reduce the peaks on the meteor (Figure 7.12B). Now, save (Ctl/Cmd-S) the file to see it update to get something like Figure 7.12A.

FIG 7.12 Modify the meteor.

Creating the Planet

One of the best ways to create planets is to use stone-like textures on spherical 3D objects. So we will use a marble texture for our planet.

 See the app for this video: Create ring & planet

Step 1

We are going to create our planet from a photographic texture of marble. So, place the "planet.tif" in a new layer and alter it into a spherical 3D object to get what you see in Figure 7.13.

FIG 7.13 Create the planet for photographic texture.

Step 2

Theoretically, planet rings are a result of debris from colliding planets. The debris might look similar to the surface makeup of the planet it orbits. So, to simulate this let's use the same texture that we used for the planet to create the rings.

Place the "planet.tif" in a new layer and alter it into a smart object. Add noise of around 40 % as shown in Figure 7.14. This is just enough noise to help us create the linear effect of the rings without destroying the color.

FIG 7.14 Add noise to "planet.tif" to begin creating the rings.

Step 3

To get the rings started add a Motion Blur (Filter>Blur>Motion Blur) with
the blur angle at "0" and the Distance at 2000 to get an absolute linear effect
(Figure 7.15).

FIG 7.15 Apply Motion Blur to get lines for the rings.

Step 4

Reduce the size of the ring vertically as shown in Figure 7.16. Cut away sections of the rings to get gaps. Use a layer mask and the Rectangular Marquee tool (M) to accomplish this.

FIG 7.16 Cut away sections from the ring layer.

Step 5

Next, make the ring layer into a Smart Object and apply Polar Coordinates (Filter>Distort>Polar Coordinates) to alter the linear pattern into a circulate shape, as you see in Figure 7.17.

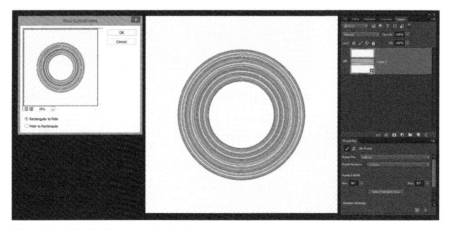

FIG 7.17 Apply Polar Coordinates to alter the ring shape to circular.

Step 6

Use your 3D panel and alter the ring into a 3D Postcard by clicking the "3D Postcard" radial button and clicking "Create." Rename the layer "ring" if you like to avoid any confusion. Next, merge the planet and the ring into a single 3D layer. Duplicate the planet and use it as a second planet and place it just behind the ringed version. Reduce its size to get close to what you see in Figure 7.18. Now group them and title it "green planet."

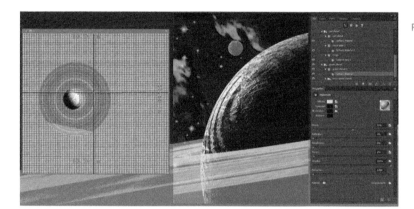

FIG 7.18 Merge 3D layers.

Step 7

Duplicate (not instance) the ringed planet 3D layer (Figure 7.19). Title it "red planet." Access its Diffuse texture and replace it with "planet red.tif" (Figure 7.20). Do the same for the rings and replace its Diffuse with "ringed red planet." Position the red planet behind the green planet and to the upper right. Target the camera and set the field of view to 450 mm. The secondary view displays the position of the red planet so adjust its size to get close to what you see in Figure 7.19.

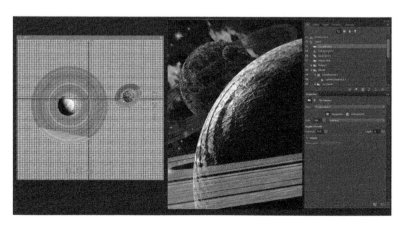

FIG 7.19 Add top light to light the surface of the wine.

FIG 7.20 Replace textures for the
planet and ring.

Step 8

Next, merge the meteor into the 3D scene. Stretch it and place it into the
foreground so that it pierces the planet ring. Replace the Diffuse texture with
"meteor.tif," which is an image taken from the cliffs along a beach with a camera.
Its rocky look will serve as an ideal texture for the meteors. Use the same texture
for the "Bump" and increase its strength to 19%. Now, duplicate the meteor
several times, alter the shape and size to redistribute into the scene as you see
in Figure 7.21. This will add some additional interest to the composition.

FIG 7.21 Replace the meteor Diffuse
material with "meteor.tif."

Step 9

The suns will rise from behind the red planet to cast a rim light around the
edges of the planet so make sure your Infinite light direction is similar to
Figure 7.22. Also, warm it up a bit with a yellowish hue.

FIG 7.22 Setup Infinite light coming from the top-left corner.

Step 10

Add a Spot light to create a type of bounced light effect to fill in the large meteor's shadowy side. Adjust the angle and cone degree of the Spot light so that its influence affects mostly the foreground meteor coming from an angle, as you see in Figure 7.23. This light will serve as a fill light, so give it a similar greenish color to the surface of the planet. In this example the Intensity is 170%, but use your judgment for your creation.

FIG 7.23 Apply Spot light to the foreground meteor.

Step 11

Next we are going to simulate a sunrise coming from behind the red planet. Use the lens flare technique that you learned in Figure 7.8 for creating the foreground stars. Duplicate the layer to intensify the effect but this time apply a black filled layer mask and paint on the mask with white to reveal the brighter highlight around the edge of the planet where it would be strongest. Using layer masks as the source to paint on or apply color is a useful nondestructive technique. Use Figure 7.24 as a guide.

FIG 7.24 Apply sun and highlights to the scene.

Next, add two green filled layers with both layer blend modes set to Overlay. Apply a black filled mask to both and paint with white on the mask to reveal a green highlight along the edge of the planet where the light would fall to illuminate. Oftentimes a single layer will not do it justice, so duplicate it and apply the technique again as needed.

To add an additional edge highlight apply the same technique with a yellow filled layer that has a layer blend mode set to Screen.

Step 12

Add a little more highlight detail along the outer edge of the green planet. We are going to use a cloud image to assist us with this and use its bright texture for the highlights. So place the "cloud 012.tif" into a new texture and change its blend mode to "Screen" to brighten the effects against the green planet. Give the image a black filled mask and edit the mask to use the cloud highlights to add subtle, atmospheric light texture for brightened edges.

Now, to consolidate the colors add a gradient from yellow to green that starts from the top left and leads bottom right, as you see in Figure 7.25. Alter its blend mode to Screen. You should get a more intensified color throughout the scene.

FIG 7.25 Add gradient to colorize composition.

Step 13

Render the scene to get close to what you see in Figure 7.26.

FIG 7.26 Render the scene

Step 14

As a final touch, merge the render. Target the very top layer. Make a new layer on top of all the other layers (Ctl/Cmd-Alt/Opt-Shift-E). Alter the blend mode of the new layer to Multiply. It will give a richer tone and color. Adjust the Opacity to 30% so that we can gain a little more shadow detail on the planets without making the overall details too dark. Render your scene to get close to what you see in Figure 7.27.

FIG 7.27 Merge the layer and set the blend mode to multiple.

What You Have Learned

- You can use tonal value to create Spherical Depth Maps.
- You can alter a Depth Map by altering its value using layers to assist you.
- The Polar Coordinate is ideal for making rings from linear shapes.
- You can use a 3D Postcard to simulate a ring for the planet.

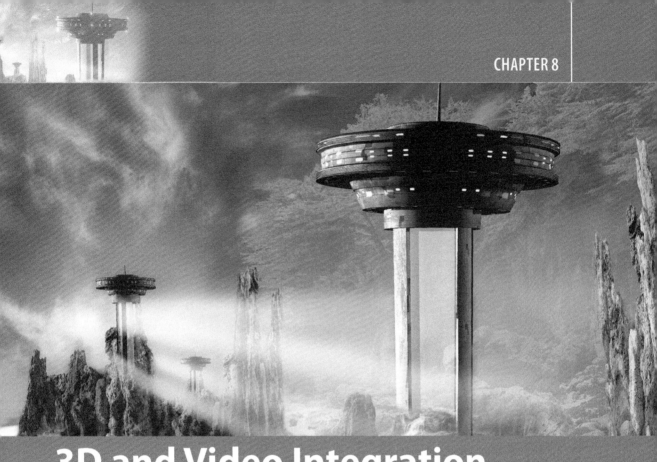

3D and Video Integration

Now we are ready to add another media to the mix and that media is video. As we have already discovered, Adobe has aggressively designed Photoshop to accommodate a variety of skill sets such as painting, graphic design, photography, 3D and video. We are going to discover a creative workflow for including video and 3D into a scene that was created using photo compositing techniques in Photoshop. This book focuses on 3D instead of compositing, so I have provided the final composited image called "background.jpg" for us to focus on integrating both the 3D tower and the video. In the first section of this chapter, you are shown how to build the 3D tower from scratch; however, you can find the completed object in the file called "3D Tower.tif" that you can use to follow along, starting at Figure 8.1, if you choose. I have also provided the completed composited image for you,

into which you will build the video content for the final result. In a nutshell, we are going to build 3D futuristic towers (Figure 8.1) to integrate into a scenic composite that will include several moving waterfalls, where the waterfalls will be created from a QuickTime video. All files can be found in the "Chapter 8 Waterfall" folder. Let's get started.

FIG 8.1 View of the completed tower

Building the 3D Tower

So, let's start by creating the towers to integrate into our futuristic scene. As before, we will use vector content to create the 3D objects.

Step 1

Open the "chapter 8 vector shapes.tif" document. Begin with the "saucer" layer (Figure 8.2A) and extrude it with the lathe option to get what you see in Figure 8.2B.

FIG 8.2 Build the saucer object.

Step 2

Let's add a cylinder-shaped detail to the bottom of the saucer from which the support stilts will join into the saucer. In the 3D panel, right-click on the saucer object and choose "Add Cylinder." Resize the cylinder so that it fits inside the base of the saucer as well as slightly protrudes out from it in a vertical manner, as shown in Figure 8.3.

FIG 8.3 Add a cylinder base to the saucer.

Step 3

Repeat step 2 to make another cylinder to fit just inside the first one. However, this time resize this new one to fit slightly inside of the first, as you see in

Figure 8.4. Next, apply the "Glass (Frosted)" preset to the "cylinder" material. As a note, change the material icon view for the Materials to "Large List" so that you can see an icon view with the title of the material. Then choose "Glass (Frosted)."

FIG 8.4 Add a new cylinder, elongate it and reduce its opacity.

Step 4

Target the "Support" layer and extrude it (Figure 8.5A) to create the stilts that will support the saucer. Merge it with the tower and extrude it to about the

same length of the extended cylinder (Figure 8.5A). Position the stilts so that they surround the transparent cylinder, as you can see in Figure 8.5B.

FIG 8.5 Extrude and merge the stilts with the saucer.

Step 5

Now, apply the "rust panel.tif" (Figure 8.6A) to the Diffuse material for the saucer and the first cylinder that you added to place the stilt support into. Adjust their "Texture Properties" to 25% for both U/X and V/X. Do the same for the long stilt supports themselves, using the "rust green.tif" (Figure 8.6B). Adjust its "Texture Properties for the U/X to 50% and the V/X to 40%. Let's keep going.

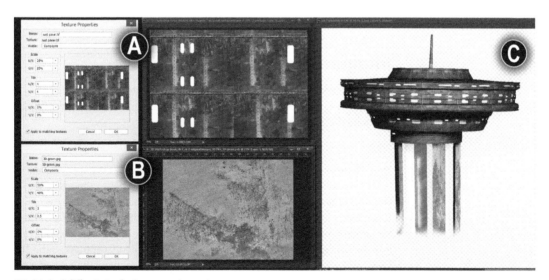

FIG 8.6 Apply Diffuse texture for the saucer and supports.

Step 6

The sunlight will be coming from the rear and we must match the light direction for the tower, to match the composited scene. Since the main light is the sun setting in the background, we will use a single Infinite light to illuminate the tower. Make sure that you have an Infinite light and adjust its angle to get close to what you see in Figure 8.8 where it creates a rim-light style coming from the far left side. Set the "Intensity" to 291%.

To match the color of the scene, open the "background.jpg" image and take a look at the yellowish lighting style. Next, match the yellowish color of the infinite light to match what will be the overall lighting in the composited scene. Remember that you can always go back and make lighting adjustments even after you merged the 3D scene (Figure 8.7).

FIG 8.7 Match the 3D light direction and color to the scene.

Integrating the 3D Tower

This is where we will fuse the tower into our composite. Your "background. jpg" should already be open from the previous step, and now we are going to integrate the 3D tower.

Step 1

Your 3D tower will be integrated into the composite above the scenic layer. It will help to have the ground plane positioned to just below the top of the waterfall. Change the camera's field of view to 50 mm, then Instance the tower twice so that you have three in your scene. Position one tower into the foreground next to the waterfall to be the main focus, and the remaining two into the background as shown in Figure 8.8. Now apply a layer mask to the 3D layers and use your Brush tool (B) to paint with black to blend the base of 3D towers into the landscape.

FIG 8.8 Integrate the 3D tower with the composite.

Step 2

Make a new layer above the 3D tower. Use your Rectangular Marquee to create a long horizontal rectangular selection filled with an orange hue. Alter it into a Smart Object and use Free Transform (Ctl/Cmd-T) and Distort (Edit>Transform>Distort) to create the sunrays, as you can see in Figure 8.9. Duplicate the layer to produce several rays.

FIG 8.9 Add sunrays.

Step 3

Next, add a Gaussian Blur to each sunray layer to get close to what you see in Figure 8.10. In this example a radius of 6.1 is used, but experiment to get a result that you like best.

FIG 8.10 Add Gaussian Blur to sunrays.

Step 4

Light rays fall off in intensity as they move to the foreground and we will duplicate that here. To simulate this, place all of the sunlight layers into a group titled "sunrays" and edit the group with a layer mask to soften the effect in the foreground, similar to what you see in Figure 8.11. In essence, use your Brush (B) to paint with black on the mask where the areas of sunlight will be closest to the foreground. This is ideal for use with the Wacom stylus, where you can use pressure sensitivity to control the opacity of the sunlight. However, if you do not have a stylus, then adjust the Opacity of the brush to around 25%. This will help you make subtle changes. Be sure to watch the video in the app called "Integrate 3D into 2D" in chapter 8. It will help to shed more insight on this workflow.

We are going to add a glow to the sunrays and use the help of a Color Fill adjustment layer. So, add a Color Fill adjustment layer of orange above the sunray group and change its blend mode to "Overlay" to get an intensified glow effect. Target its mask and inverse it (Ctl/Cmd-I) to hide its effects. Now use a soft-edged brush to paint in the glow over the sunrays. Use your judgment as to how intensified you would like the effect to be and let's move forward.

FIG 8.11 Group sunlight layers and add a mask to dissipate their effect in the foreground. Then add some intensified light.

 See the app for this video: Integrate 3D into 2D

Step 5

Let's unify the color in the scene a bit by using a gradient adjustment layer. Create a graduate of colors from blue for the sky then toward orange for the sunset and then back to blue again for the lower canyon and waterfalls (Figure 8.12). Position the adjustment layer at the top of the other layers and change its blend mode to Softlight to give a gentle blend.

FIG 8.12 Add gradient adjustment layer to enhance the scene.

Step 6

Now, add a little more light details onto the tower. Just fill a new layer with medium gray (Edit>Fill>Fill with 50% Gray). Alter its blend mode to "Hard Light" to get rid of the gray and apply a Lens Flare (Filter>Render>Lens Flare) to obtain an intensified light. Reduce its size so that it will work as a running light along the side of the tower. Duplicate the layer several times and place them in various locations on the tower, as shown in Figure 8.13.

FIG 8.13 Add running lights on the tower.

Step 7

Finally, merge all of the layers together that represent the tower and landscape. Leave light rays unaffected. Use Figure 8.14 to assist you.

FIG 8.14 Merge the tower layers with the landscape.

Adding the Video

Now we are going to make the water move. When the imagery was chosen, having a moving waterfall was in mind. So the still image of the waterfall used here was also taken as a motion video. So we will composite that video into the scene as if it is a standard image on layer, then we will use the standard transform tools to mold it to our vision.

Step 1

To make this closer to video resolution, reduce the document size to a resolution of 150 PPI instead of 300. Use Figure 8.15 as a guide.

FIG 8.15 Reduce the file size.

Step 2

Locate "waterfall.mp4" in Bridge and drag and drop it onto the composite document above the scenic layer but below the sunrays layer. We kept the sunrays in their own layer so that it will continue to light the scene even after we bring in the video (Figure 8.16).

241

FIG 8.16 Drag and drop video into
the composite.

Step 3

Use Free Transform to match up the waterfall to the one in the center of the composite (Figure 8.17).

FIG 8.17 Transform the waterfall.

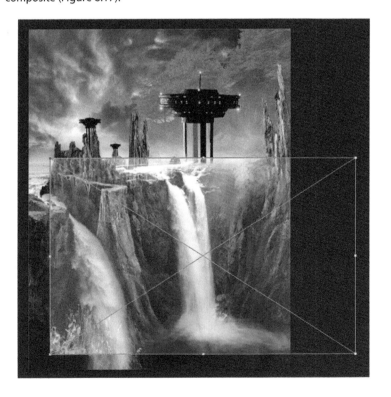

Step 4

To fine-tune it, add Warp (Edit>Transform>Warp) to alter its positioning on the canvass (Figure 8.18). Apply a black filled layer mask to hide the waterfall. Now, use your Brush (B) to paint with white on the layer mask to reveal only the falling water.

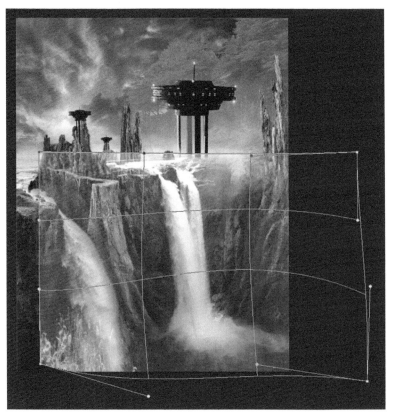

FIG 8.18 Apply Warp to the video to fine-tune its positioning.

 Check out the app for this video: Integrate waterfall

Step 5

Duplicate the waterfall and apply to the same Warp technique to the waterfall on the left side of the cliff (Figure 8.19).

FIG 8.19 Apply the Warp command to the duplicated waterfall.

Step 6

Group the waterfalls together and title the group "waterfalls." The color of the video is too blue so add and a Hue and Saturation Adjustment layer as a clipping mask to the group. To accomplish this, hold down the Alt/Opt key and place your mouse in between the adjustment layer and the layer group. Then click and release so that the effects of the Hue and Saturation apply only to the group. Reduce the saturation to minimize the blue color-cast (Figure 8.20).

FIG 8.20 Group the video and apply Hue and Saturation to the group.

Step 7

Open up your timeline (Windows>Timeline). You will not see your video layers yet because you need to tell Photoshop to create them. To do so, notice that there is a button in the center of the timeline that says "Create Video." Click it and you will see all of your layers ready to be animated. Once done, you will see them listed in color-cast boxes. In this case, the integrated video will have the greatest length, which is 30 seconds, so extend all layers to match it. To adjust each of their lengths, place your cursor on the very right edge of the video layer and drag it so that each one ends at the same length of 30 seconds. Also, keep in mind that inside the "lightrays" layer group are additional layers, so you must make sure that they are extended to 30 seconds as well. Use Figure 8.21 as a guide.

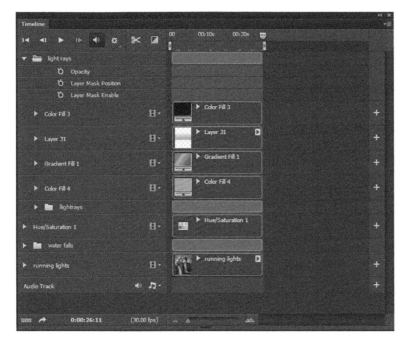

FIG 8.21 Prep the timeline for video export.

Step 8

Now export your video (File>Export>Render Video). Figure 8.22 shows the settings that you will more than likely use.

Set the name of the file that you are exporting. Define the folder to export to. Use "H.264" as the format to create your video. Leave everything else at default. As a note, play around with the "Render Options" for 3D quality so that you can get a feel for the results that you like best. When done you should get something like the video that I have provided for you, titled "Chapter 8 Waterfall Video Final.mov."

You should have something close to what you see in Figure 8.23.

FIG 8.22 Set up Infinite light coming from the top left corner.

FIG 8.23 Final view of composited image.

 See the app for a video on rendering.

> **What You Have Learned**
>
> - You can apply an Adjustment Layer as a Clipping Path to a layer group
> - You can apply a mask to a 3D layer to show or hide localized effects.
> - It's a good idea to reduce the document size when adding video to conserve memory.
> - You can treat video as if it was a standard image on a layer.
> - You can use any of Photoshop's transform tools on a video.

Importing Third-Party 3D Objects

In this tutorial, we will work with two types of 3D objects. One will be a custom-built city and roadway created in Photoshop and the other a starship built in LightWave 3D. From first appearance, the scene will look sophisticated but it is easier than you think. The sophisticated look will come from the help of photographic illumination maps used on very simple shapes. By combining those shapes, they will give the impression that the scene was built using lots of 3D detail. Let's begin by importing a textured LightWave model and add more details by painting onto it in Photoshop. All files for this chapter can be found in the "Chapter 9 Cityscape" folder.

Importing and Painting onto a 3D Model

We are going to begin by giving our cityscape scene its backdrop. Next we will import the LightWave 3D object and use the Brush tool in Photoshop to add a worn grunge look. Also, I have provided the completed model for you to use in the "Chapter 9 Night City" folder titled "3D ship with blast marks.psd." You are welcome to use this and skip down to "Creating the 3D Cityscape" if you prefer.

Step 1

If you are using the Wacom Stylus make sure to modify the shortcut so that the top button resizes the brush, as you learned in chapter 4, Figure 4.25 (Figure 9.1). Don't forget to review the video tutorial on this in the app for chapter 4, titled "sword and stone displacement map." Let's move on.

FIG 9.1 Set the brush resize for the top button of the Wacom Stylus.

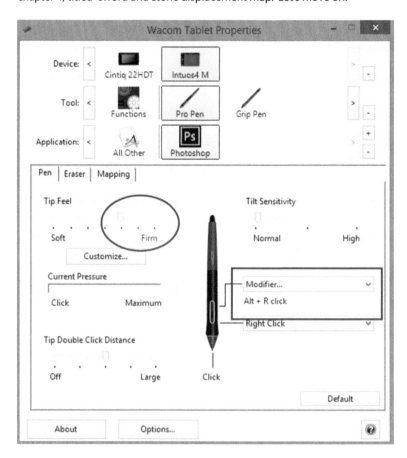

Step 2

Now we are going to do something that we have not done before and that is import a third-party 3D object. Let's import the object into a new document. Create a new document at 5x5 inches. Import the "star ship.obj" object (3D>New 3D Layer from File) from the "3D Ship" folder.

You will first get a dialogue box asking for your choice dimensions for the file (Figure 9.2). In this example, I set it to inches so set yours to inches as well. It will not affect this exercise as it is restricted to 3D printing purposes, so in a nutshell don't stress about it.

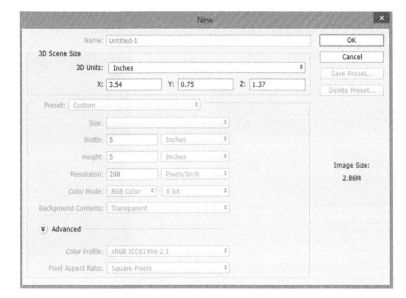

FIG 9.2 Import the 3D object.

When the model is imported, you should see something similar to Figure 9.3.

FIG 9.3 3D object dimensions on import.

In the 3D panel, you will see a series of 3D objects and materials that were created in LightWave 3D. Photoshop has imported in such a way that it has divided the model into parts. This is going to be a common challenge when importing 3D objects from third-party programs, but there is a procedure to consolidate the geometry. To do this go to "3D>Unify Scene For 3D Printing," as this command will merge everything into a single 3D object (Figure 9.4). This will also facilitate the painting process in that you will only now paint on a single surface.

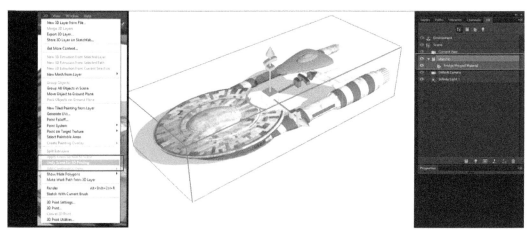

FIG 9.4 Unify the 3D objects.

Step 3

Make sure that your Brush tool (B) is selected to see its properties. In the Properties panel, target "Projection" under the Paint System. This mode will make it more intuitive to paint onto the model as it faces us from any angle (Figure 9.5).

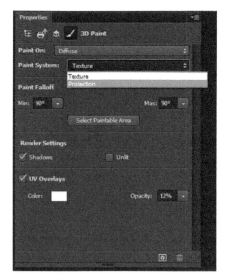

FIG 9.5 Use Projection as the Paint System.

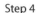

Step 4

We are going to add some blast and grunge detail to the ship so import the "Blast Brushes" from the "Brushes" folder. Apply blast marks of varying sizes and locations on the ship, first using a deep brown color. Reduce the brush size a bit then add on top of the initial blast mark. From this initial detail we will pull motion streaks caused by encounters from space debris (Figure 9.6).

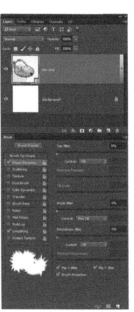

FIG 9.6 Apply blast marks.

Step 5

To add a little extra detail let's give the effect of the grunge trailing down the length of the ship due its forward movement in space. We will use the Mixer brush for this since it's far more effective than the Smudge tool in speed. It's a good idea to apply your changes in their own layer, so create a new layer to apply your technique. Make sure that on the Options panel you have "Sample All Layers." Target your Mixer brush (B) and smudge areas of blast marks linearly down the ship in the opposite direction that it moves. Feel free to use more than one layer to keep organized. Figure 9.7A shows the results of the painting on the ship. Figure 9.7B shows how it will be viewed on the UV map. Apply this technique all over the ship and when done save the file and let's move forward to creating the 3D cityscape.

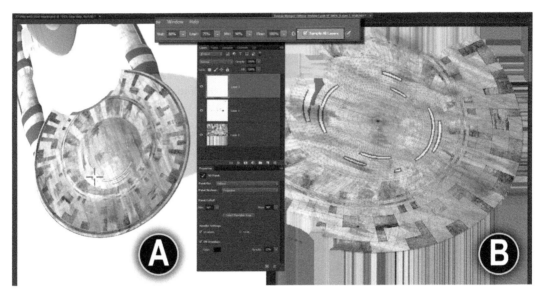

FIG 9.7 Smear blast marks down the ship.

Creating the 3D Cityscape

Often, sophisticated shapes are simply the results of smaller basic shapes brought together to add detail to the overall look of a concept. That is just the approach we will use to create the cityscape. We are going to begin with one large vector mushroom-like shape for the main focus of attention that we will sculpt into a more detailed look. Let's go have some fun.

Step 1

For your convenience I have provided the vector graphics for you in a single document titled "roadway.tif," so open the file. You will notice that the layers are titled "upper" and "lower" to represent which one will overlap the other. Extrude them slightly into 3D space. Figure 9.8A shows the roadway that will sit on Figure 9.8B. Figure 9.8C is a close-up view of the roadway.

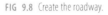

FIG 9.8 Create the roadway.

Step 2

Give both roadways a slight bevel and change the color for the bevel's Diffuse color, as well as the Self Illumination, to a bright yellow, as shown in Figure 9.9. Next, target both 3D layers and merge the 3D layers together (3D>Merge 3D Layers).

FIG 9.9 Bevel and merge the 3D roadway.

Step 3

Open the "background.jpg" document. We will use this to build our scene (Figure 9.10).

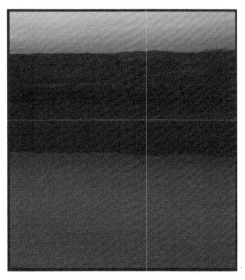

FIG 9.10 Open the "background.jpg" document.

Step 4

Place the 3D roadway on top of the background layer (Figure 9.11). You will see two guides crossing in the document. Where they meet is where you should compose the circular loop of the roadway. Make sure that both roadways are sitting slightly above the 3D ground plane so that we can cast a reflection of the freeway. Now, make sure that you target the Environment layer in the 3D panel and set the Reflect to 66% in the Properties panel. Change the Camera's field of view to 221 mm and position the camera so that you are looking down at the freeway from a 45-degree angle. Most likely you will need to pull the camera back a bit to compose the composition, similar to what you see in Figure 9.11. Remember that your results do not have to match exactly what you see in the example, but do your best to get close and let's move on.

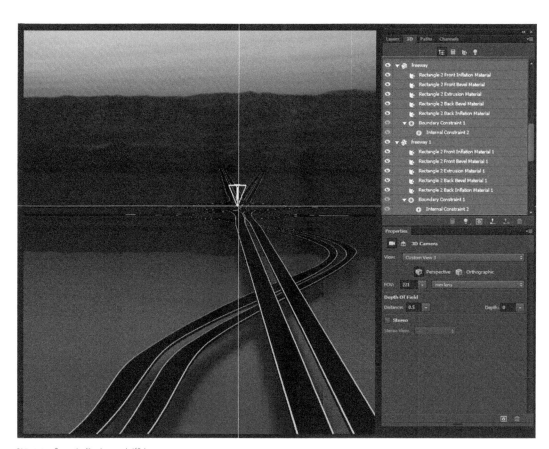

FIG 9.11 Open the "background.tif" document.

Step 5

Now we are going to create the centerpiece of attention which is the mushroom-like building to be placed in the center of the looped section of the freeway. So, open the "mushroom building" document. You will see the initial shape for the building augmented with a variety of simple vector shapes to add more detail. Be sure the check out the video "ch 9 mushroom building vector.mov" on this.

Extrude this using the 3D lathe technique. Next, texture it by importing the "illumination 001.tif" into the Self Illumination material. For the Self Illumination Properties use 3% for the U/X and 20% for the "U/Y," as shown in Figure 9.12.

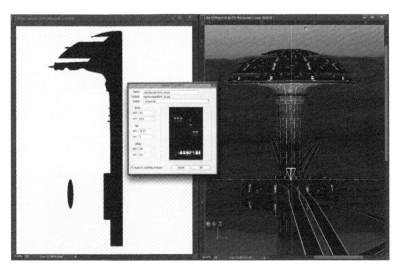

FIG 9.12 Open the "background.tif" document.

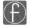 See the app for "ch 9 mushroom building vector.mov."

Step 6

Open the "skyscraper.tif" and use the "skyscaper" layer to extrude a building from this half-circle shape, as shown in Figure 9.13. As you did in step 4, apply the "night windows.jpg" to the "Self Illumination" material. Use 15% for the U/X (horizontal) and 9.2% for the U/Y (vertical) for the UV Self Illumination Properties. Place it into the main 3D document and merge it with the other 3D layers. Place it next to the mushroom building at the base so that it merges slightly into the stem of the building, as shown in Figure 9.13.

FIG 9.13 Create new building and add to the base of the mushroom building.

 See the app for a video on positioning the freeway and buildings.

Step 7

Duplicate the skyscraper from step 5 and place it on the opposite side of the stem, as shown in Figure 9.14. Keep the existing UV Properties.

FIG 9.14 Duplicate the new building and add to the opposite side of the mushroom building.

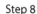

Step 8

Duplicate the building from step 6 again and place it in front next to the other two, as shown in Figure 9.15. Make it shorter in size and use "night windows 2.jpg" for the Self Illumination material. Keep the existing UV Properties.

FIG 9.15 Duplicate the new building again, place it and retexture.

Step 9

Let's add one more hint of detail to the mushroom building by adding a circular array of antennae. Open the antennae document and notice the circular shape made up of several circular shapes (Figure 9.16). Extrude them into the antenna and place it into the 3D city document. Then merge them with the main 3D scene. Next, center them on top of the mushroom building as you see on the 3D view of Figure 9.16.

FIG 9.16 Add poles on top of mushroom building.

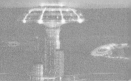

Step 10

Merge into a single 3D group all of the elements that make up the 3D skyscraper scene, to include the mushroom building and the other 3D skyscraper additions. Rename it "city." Instance the group and rename it "city 2." Use your 3D navigational tools to position it into the background near the end the roadway leading into the rear of the main city. Use Figure 9.17 as a guide.

FIG 9.17 Group the city and instance it to use as a second for the background.

Finalizing with Lighting and Effects

We are going to complete the scene by adding the rest of the lighting. We will light the top for the dome to reflect the color coming from the sky. We will also add some effects to the tops of the antennae.

Step 1

Add a Spot light on top of the mushroom building dome and restrict the angle of light so that it mostly illuminates the top or dome. Change the color of the light to match the magenta-red color of the sky and adjust the Intensity to around 300% at your discretion. Don't forget that you can click on the color of your choice in the sky when you change the color of the light. Use Figure 9.18 to assist you.

FIG 9.18 Light the dome of the mushroom building.

Step 2

Next, add an Infinite light and change its color to the magenta-red that you used for the Spot light to illuminate the dome. Angle so that the direction of the light comes from the rear-left of the composition. Next, add some lens flares, as you learned in chapter 7, to the top of the antennae to add a visual effect to the architecture. Use Figure 9.19 to assist you.

FIG 9.19 Add additional light to the architecture.

Step 3

Finally, we are going to use another approach to adding 3D content to your scene. Sometime you will come up against a challenge with not having enough memory to merge more 3D objects together. If that is the case, keep them in separate 3D layers and just match the camera and lighting parameters of the main scene. In this example, add the starship to the scene but do not merge it. Duplicate it to make another shop to add to the far background. Set the camera FOV for both to match the main scene, which should be 221 mm, and adjust the ground plane "Reflection" so that it also matches the main 3D scene at "66%." Finally, add a single Infinite light for both ships with a magenta-red to match the angle of the main scene to illuminate from the rear-left. Now render the scene and you should have something similar to Figure 9.20.

FIG 9.20 Render the final scene.

Remember, experiment and come up with other possibilities as well. Let's move on to the next chapter.

What You Have Learned

- A more sophisticated look can be created by adding multiple basic shapes.
- Using photographic images as Self Illumination maps is another great way to get a more sophisticated look.
- You can save on memory by not merging 3D objects and keeping them in their own layers.
- You can use a 3D Postcard to simulate a ring for the planet.

3D Text

When I began this book I was intent on not including 3D text. Why? Because I had seen so many examples of the use of Photoshop 3D on YouTube and Facebook as 3D extrusions. My tech editor insisted that I include a tutorial on the use of 3D text from a different point of view. So, I figured if I am going to include 3D text then I am going to create something cool, simple and dynamic. So, using the phrase "3D Power," we will create a concept that shows the after effect of energy burning texture into a metallic like surface. The approach will be simple so that we will produce a visually interesting result. To top it off we will add video as a reflective source on the face of the 3D text so that it stands out prominently from the background. The end result will be a video output. All files to follow along with this tutorial are in students files for the "Chapter 10 3D Text" folder. Let's have fun.

Creating the Text

Text, like 3D objects, is nothing more than vector information. That means there is great flexibility if you ever need to make changes after you have created your 3D extrusion. Even after the fact, you can change your fonts and your 3D objects will update on the fly. In this example, I used a font called "Racer Regular." In anticipation that some might not have it on their system, you will find a rasterized version called "Rasterized text.tif." in the chapter 12 student files. Keep in mind that if you use the rasterized version then the Warp Text in the Options panel will not be available for you in step 2, so instead use the "Warp" command (Edit>Transform>Warp) to accomplish the slight distortion to give the text a bolder look.

If you would like to work in vector then just choose any font you like, or one that comes close to it. I recommend something with a bold look. If you are a member of Adobe's Creative Cloud then feel free to use "Typekit." Just access your Creative Cloud app (Figure 10.1A) and target the "Assets" heading. At the bottom click on "Add Fonts from Typekit" button. This will bring you to the Typekit webpage (Figure 10.1B) and from there you can browse and import the fonts that you would like to work with.

FIG 10.1 Use Typekit to help you choose a font.

Step 1

Create a new document at 12.3 x 9.75 inches and 200 PPI resolution. We will work larger for now. We will use these dimensions so that when we reduce it to 72 PPI to create our video we get something close to 720 x1080.

Step 2

Use your Text tool (T) and type out "3D POWER" in all caps. Use "Free Transform" (Ctrl/Cmd-T) to resize the text to dominate two thirds of the document. On your Tools panel click on the "Warp Text" option and target the "Bulge" style. In this example, 5% for the "Bend" is used. Make sure the "Horizontal" radial button is checked, then click "OK" (Figure 10.2).

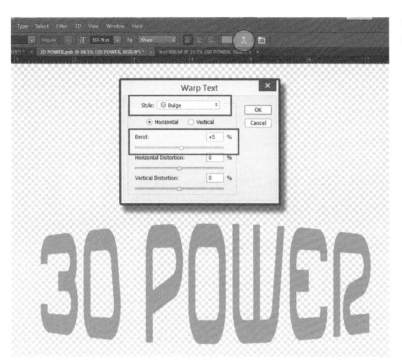

FIG 10.2 Create text and apply an effect.

Step 3

Next, give the text a 3D extrusion of 12.5 inches for the "Extrusion Depth." Also, apply a vertical bend of 115 degrees. This style of extrusion adds depth that will blend the object with the wall that we will create next. Use Figure 10.3 as a guide.

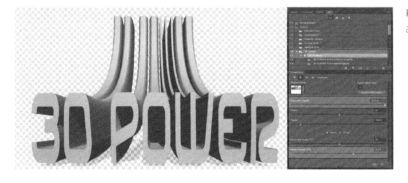

FIG 10.3 Extrude the text into a 3D object.

Step 4

In a new layer use your Elliptical tool to create a horizontal liner chair comprised of 13 circular vector shapes. Next, extrude it into a 3D object and give it an "Extusion Depth" of 12.5 inches. Rename the 3D layer to "pipes 1." Use Figure 10.4 as a guide.

FIG **10.4** Extrude vector shapes into a 3D object.

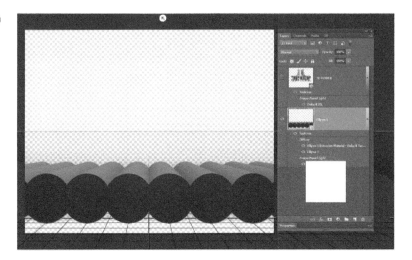

 See the app for a video on creating a vector chain.

Step 5

Merge the two 3D layers into one 3D scene. Place the "pipes 1" onto the ground plane (3D>Move Object to Ground Plane). If necessary, use your 3D navigational tools so that the pipes come from the background toward the viewer. Now position the text just above the floor and set the camera FOV to 52 mm. In this example, the camera is placed at X(-.05), Y(.74), Z(4.38), but get close to this so that the camera looks up slightly toward the text to give a monolithic feel. Also, you may need to enlarge "pipes 1" just a bit to get something close to Figure 10.5.

FIG **10.5** Position and resize 3D objects.

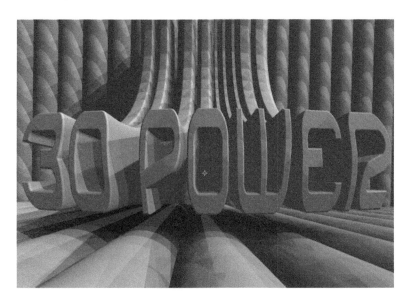

Now we will create a wall structure for the 3D text to integrate with, using the "pipes 1" 3D object. So, just duplicate it and use your 3D navigational tools to rotate it so that the tubes travel vertically. Photoshop will rename it to "pipes 11." This will be our wall. Use your 3D Slide tool to place it further to the background so that the curved extrusion of the text just touches the sides of the wall. Again, feel free to resize the 3D object to get close to what you see in Figure 10.5.

Creating the Lighting and Texture

Now we will add the mood and texture to give the scene a feeling of burnt grunge atmosphere. We will use the bump and lighting settings mostly.

Step 1

Temporarily turn off the 3D text object by clicking the eyeball to the left of the 3D layer. This will help us to set up the lighting and texture easily. Apply the "neutral burnt.jpg" image to the bump for both of the "pipe 1" and "pipes 11" 3D objects. Set the scale of the Texture Properties to 25% (Figure 10.6A). This image is instrumental in giving the 3D object the bubbly-like burnt texture.

Now make sure that you have a single Spot light source in your scene. Position is so that the light points straight down onto the wall and floor to create a falloff similar to what you see in Figure 10.6B. In this example, the Spot light has an Intensity of 76%, Shadow of 95% and a Hotspot of 24.7 degrees, and the Cone angle is set to 47.7 degrees. Position the light high above the scene to illuminate straight down on the scene. Experiment with positioning and angles to get something close to what you see in Figure 10.6.

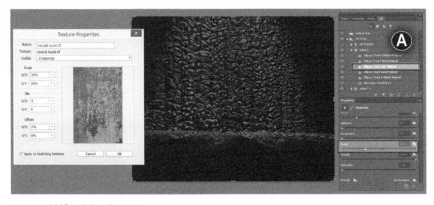

FIG 10.6 Add Spot light and texture.

 Check out the app for a video on 3D text.

Step 2

Turn on your 3D text layer. At this stage the face of the text should fall mostly in shadow but we will rectify that in just a bit. But for now, apply the "Neutral

Burnt.jpg" image to the Diffuse of the 3D text extrusion. Use the Texture Properties to scale the image to 300%, as shown in Figure 10.7, and let's move on to the next step.

FIG 10.7 Add texture to the 3D text extrusion.

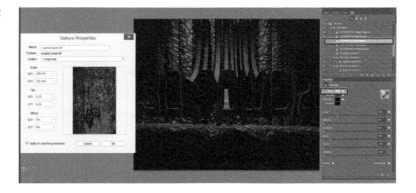

Adding Video to Enhance the 3D Text

To add some definition to the face of the text, we are going to do something different and use our Reflection properties from a video to get the face of the 3D text to stand out. We will concentrate our efforts on modifying the texture for both the Front Bevel and Front Inflation of the 3D object. Then we will create a video as a final result. Let's finish up.

Step 1

For both the Inflation and Front Bevel of the text, apply a Reflection setting of 90% (Figure 10.8A).

The video is footage of a sunset taken from a quad copter by Francis of San Diego. The movement of light and color, I felt, would be ideal for this. So, in the Environment tab, load in the "cloud sunset.mp4." The colors and luminance from the video will reflect onto the surface of the 3D text (Figure 10.8B).

FIG 10.8 Add video as the reflective source for the Front Inflation and Front Bevel of the 3D text.

Step 2

To see the final result, render out the video. Reduce the file to 1080x720 (Image>Image Size) to help render faster for HD format.

Make sure that your Timeline is open (Window>Timeline) (Figure 10.9). Click on "Create Video" to create the video time for each layer. Export your video to a location of your choice (File>Export Video). Set the format to the commonly used "H.264." The document size should read close to 720x1080 already. Finally, decide how many frames you would like to render and click the "Render" button on the top right. Sit back and relax and wait for it to finish. When done you will have a QuickTime format that most video players will display. You should see the reflection of the video illumination across the surface of the text. Pretty cool, huh?

FIG 10.9 Render the video.

 See the app for a video on rendering 3D text.

What You Have Learned

- Working in vector gives you the flexibility to edit and reedit your 3D objects.
- You can add video as a surface texture.
- You can render QuickTime files from a single 3D image.

Starship Battle Scene

We are now going to use third-party 3D models created in LightWave 3D to create the sci-fi battle scene. We will have a little different workflow for this exercise. In previous tutorials we have imported all of the models created in Photoshop into a single 3D scene. The process of merging models is RAM intensive and having multiple models in a 3D scene also takes up more resources than necessary. So, in this situation it will be desirable to keep the models independent in their own 3D layers, which will not tax as much of your resources. All files for this tutorial are located in "Ch 11 Starship Battle." Let's have some fun.

Compositing the 3D Models

We are now going to integrate the 3D characters into a photo composite that is an image of a waterfall with stone structures integrated into it and a misty

sunset haze. We will add some painting techniques to fade the 3D objects into the mist. Let's get started.

Step 1

Open the two files "background.jpg" and "war machine.tif." Place the 3D layer from the "war machine.tif" onto the background and use your 3D tools to resize and position similar to what you see in Figure 11.1. With your Brush tool (B) activated, sample the orange color from the background by holding down the Alt/Opt key as a shortcut to activate the Sample tool. Paint an orange mist into several layers above the war machine. Using more than one layer allows you to make subtle changes that will give your effect a three-dimensional feel. Make sure that you attach these layers as clipping paths to the war machine layer by holding down your Alt/Opt key and placing your cursor between the two layers and click and release. Now the effect will be restricted only to the contents in the war machine layer. Use light pressure with your stylus to paint the fog-like haze that dominates the lower half of the war machine. This will simulate low-level fog effect. If you are using a mouse consider using an opacity of 15% to create the same effects.

FIG 11.1 Place the 3D bust file into the background.

Now, let's reduce the saturation of the war machine by adding a Hue and Saturation adjustment layer as a clipping path. Bring down the saturation to -39. Less-saturated objects will visually recede the war machine toward the background. Finally, let's place the stone protrusions to appear as if they are in front of the war machine. Target your background layer. Use the Quick Selection tool (W) to select the stone protrusions in front and to the far right and use Ctl/Cmd- J to place them onto their own layer. Reposition this layer on top of the war machine layer. Now the war machine appears to be a part of the background with the protruding stones. Let's move on.

Step 2

Duplicate the war machine layers twice and place one in the center to the rear of the larger war machine and the other just behind the larger stones to the far right. For the one in the center, reduce its size so that it is a fifth of the size of the larger machine and rotate it so that it's facing forward. Make sure to place it just underneath the larger walker to sit on the ground. Use Figure 11.1 to assist you. Once done, you do not need to keep it as a 3D object, so rasterize it to save memory (right-click>Rasterize 3D object). Let's blend it with the atmosphere in the background. The further something recedes into a landscape's background, the more it will take on the color of the atmosphere. Let's simulate that next for the war machine in the center. Open your Layer Styles dialogue box and select the Color Overlay. Add an orange-colored overlay at 100% opacity to get it to recede into the background haze. Give a slightly deeper tone as well to allow it to stand out from the overall color cast.

For the other 3D object that we placed to the right behind the large jutting stones, reduce its size to about half of the larger war machine. Turn it so that it faces upward toward the larger figure. This will help guide the viewer's eye toward the secondary compositional element of the larger war machine.

Rasterize this as well and add a Color Overlay just as you did to the smaller war machine, but give it slightly less of an opacity at 50% (Figure 11.2).

FIG 11.2 Add two more war machine layers and add a Color Overlay to them.

Step 3

Open the "starship.tif" file and add the 3D object to the scene. We will not rasterize this one since it's the main character and we may need to make creative changes later. Set the camera FOV to 100 mm and position it

similar what you see in Figure 11.3. Make sure you have two Infinite lights where one lights the ship angled from behind. Give the light source a yellowish hue by sampling a color from the background. The other light should emit a cooler, bluish hue, representing the cooler color reflecting from the waterfall's cavern.

FIG 11.3 Place the starship into the scene.

Step 4

Let's add a little bit of motion to the ship. Select a piece of the side of the ship with your Lasso tool (L) and copy and paste it onto its own layer using Ctl/Cmd-Shift-C to copy all visible and Ctl/Cmd-V to paste. Add some slight noise (Filter>Noise>Add Noise) to give texture, but don't add too much so that you keep the overall color. Now give it some Motion Blur (Filter>Blur>Motion Blur). Play with the distance of the blur. Use a layer mask to restrict the effect to the rear of the ship (Figure 11.4).

FIG 11.4 Add a Motion Blur effect to the starship.

Adding Explosions

Now it's time to add the explosion effect. We will use brushes to simulate smoke and fire.

Step 1

Load the "smoke & shrapnel brushes.abr" brushes into Photoshop.

Step 2

Hit your "D" key to set the foreground and background colors to black and white. Use the smoke brush to paint in your smoke on a separate layer. This brush uses the foreground and background colors to alternate the two into the stroke. Whichever color is in the foreground will be the one that will dominate most. So, use black as the foreground color for darker details and hit the "X" key to switch the two colors to paint with white to get steam (Figure 11.5).

FIG 11.5 Paint in the smoke.

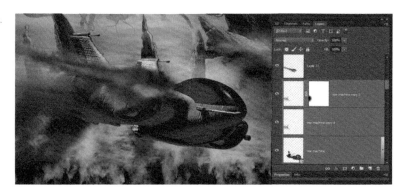

Step 3

Use the same brush to add fire effects. Change the foreground color to orange and the background color to yellow and paint into a separate layer. Make sure that layer's blend mode is set to "Overlay." This blend mode will blend the fire color into the dark smoke, as shown in Figure 11.6. To add more intensity, create a layer with a blend mode of "Color Dodge."

FIG 11.6 Paint in the fire.

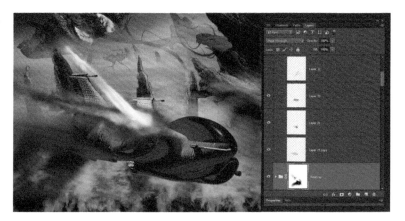

Now let's create the laser. Use your brush to paint in a laser that begins small at the war machine's laser tentacle and extrudes larger to hit the ship in the upper left shoulder. Once the initial shape is established, we are going to do the same thing as we just did above but this time use a standard soft edge brush and paint in yellow and red in separate layers to build up intensity. Remember to apply layer blend modes of "Overlay" and "Color Dodge" to intensify the effect.

Step 4

Use your Polygonal selection tool to create shrapnel shapes on a blank layer similar to what you see in Figure 11.7A. Let's give the shrapnel a feeling of motion. Add a Path Blur to the shapes to blur them in a 45 degree angle. Position them outside of blast where the laser makes contact with the ship. Use Figure 11.7B as a guide.

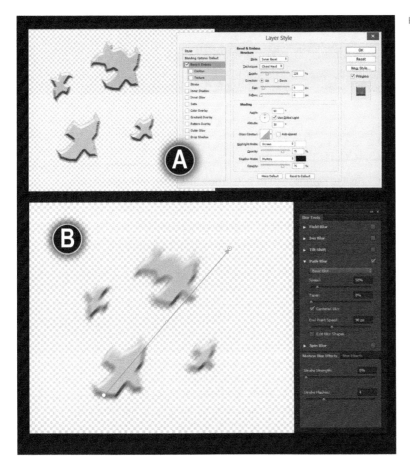

FIG 11.7 Add fire trails to shrapnel.

Step 5

Finally, use the fire brush technique to add fire trails to the shrapnel. Paint the trails with orange and yellow hues onto their own layer using layer blend modes of "Overlay" and "Color Dodge" to intensify the brightness. Use multiple layers to build up the effect as shown in Figure 11.8.

FIG 11.8 Add fire trails to shrapnel.

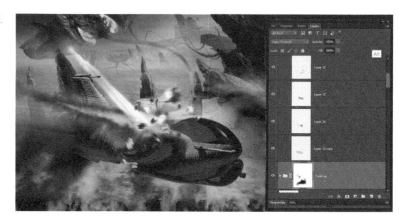

What You Have Learned

- How to compose third-party models in their own layers
- Keeping 3D objects in their own layers is less taxing on system resources.
- How to use brushes to create smoke and fire
- Overlay and Color Dodge are handy for creating glow intensities.

3D Printing

I am going to share a workflow of using third-party 3D programs alongside Photoshop to print your 3D creation. This chapter is not a step–by-step tutorial. It is designed to shed light into good workflow habits when printing your work.

In the examples you will see a bust of me that began in LightWave 3D and then was exported into Zbrush. Zbrush is often used to further detail a 3D object created in other programs. When finished, it is exported into Photoshop to prepare it for the 3D printer.

Workflow with Third-Party Programs

Figure 12.1 shows the initial stages of our bust being meshed out in LightWave 3D. All good 3D objects begin as simplified shapes using

FIG 12.1 Simplified version of the 3D bust

techniques that extrude the mesh into the desired shape, very similar to what we did in creating the 3D objects for this book.

Continuing on, Figure 12.2 shows the head with added detail in LightWave that adds personality to the bust. In addition, ears are added to complete it.

FIG 12.2 More detail is added to the bust.

Next, the eyes are modeled, as shown in Figure 12.3. They are then added to the bust, as shown in Figure 12.4. At this stage, personality is starting to show through.

FIG 12.3 3D eyeballs are created for the bust.

FIG 12.4 3D eyeballs added to the bust

Importing into Zbrush

Zbrush is often used to add to and finesse the structure of an imported object. It is also a program of choice to add great amounts of detail and texture into 3D objects made in any 3D package to include Photoshop. The workflow for most 3D modelers is to design the initial model in their 3D program of choice then export to Zbrush to add detail that is often difficult to achieve in other 3D packages. Then send the model back to the program of choice. The only thing that Zbrush needs is an Obj format of the 3D model for it to import. In this example the bust was exported into an Obj format then Zbrush was used to import the bust (Figure 12.5).

FIG 12.5 Bust imported into Zbrush

In Zbrush, cracks on the lips were added (Figure 12.6).

FIG 12.6 Details added to the lips in Zbrush

Next, pores to the face and head were added, as shown in Figures 12.7 and 12.8.

FIG 12.7 Pores added to the face in Zbrush

FIG 12.8 Pores added to the head in Zbrush

When completed, it is exported into Photoshop using a Zbush plugin called "GoZ." In essence, the object is altered into an obj format on the fly by Zbrush then exported to a GoZ-enabled application, which in this case will be Photoshop. The shortcut in Zbrush is "Ctl/Cmd-G" (Figure 12.9).

FIG 12.9 Use GoZ to export to Photoshop.

You will get a dialogue box asking you to define the GoZ-enabled application (Figure 12.10) of your choice using the "Preference" panel (Preferences>GoZ).

FIG 12.10 Enable the GOZ dialogue.

In this example, Photoshop will be our program of choice (Figure 12.11).

FIG 12.11 Photoshop defined as GoZ preference

When a version of Photoshop is found simply choose it from the list (Figure 12.12).

FIG 12.12 Photoshop chosen as
GoZ choice

Also, in Preference, change the default GoZ application to Photoshop
(Figure 12.13).

FIG 12.13 Photoshop set to first application to access

Printing the 3D Bust

Once the 3D object is in Photoshop, it can be printed with Photoshop's state
of the art 3D printing software. Figure 12.14 shows the bust imported into
Photoshop quite effectively.

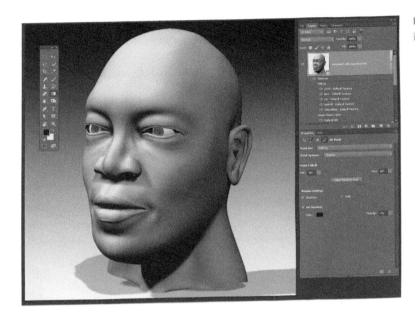

FIG 12.14 3D bust successfully imported into Photoshop.

To begin the printing process we must enter the "3D Printing Settings" (3D>3D Print Settings). This will place you into another environment that will show you the dimensions on the ground plane. When the Scene panel is targeted, you will be able to choose the printing service, material and size of the final print (Figure 12.15).

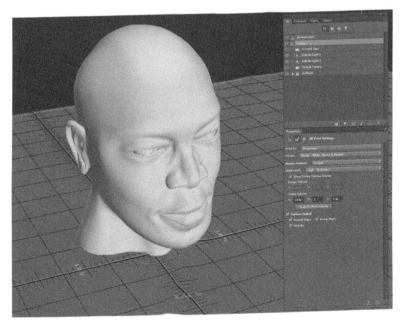

FIG 12.15 View of the 3D printing Setting environment.

289

Adobe has allowed us to send our files to service bureaus to be printed. You will find the name of the bureau in the "Print To" menu and the type of media in the "Printer" menu (Figure 12.16).

FIG 12.16 View of the 3D Print Settings.

To export your 3D object to be printed later, you will need to export it as a "STL" file format. "STL" files are the standard format for 3D printers. To accomplish this, choose "Export STL" from the "Printer" drop list (Figure 12.17).

FIG 12.17 File setup for an STL export.

This process will automatically merge the 3D object's geometry, if there are multiple meshes, to make it compatible with 3D printing (Figure 12.18).

FIG 12.18 Geometry being merged.

In addition, if there are multiple UV maps on the object then they are merged into a single UV (Figure 12.19).

FIG 12.19 Merged UVs.

When the merging of the mesh and UVs are complete you will get a preview, as shown in Figure 12.20.

FIG 12.20 3D Print Preview.

If you like, you can target the "Show Mesh" and "Show Repair" so that you can assess where Photoshop had to modify the mesh to ensure a successful 3D print (Figure 12.21).

FIG 12.21 3D Print Preview of "Show Mesh" and "Show Repair."

Brian Haberlin (http://www.experienceanomaly.com/anomaly/) assisted me with the use of his Makerbot 3D printer to print the bust. Figures 12.22–12.24 show several views of the 3D bust being printed on the Makerbot.

FIG 12.22 3D Print Preview of "Show Mesh" and "Show Repair" (photo by Brian Haberlin).

Figure 12.24 shows the final result with the scaffolding intact. In essence they will be removed when the bust is polished to achieve the finished look.

FIG 12.24 3D Print Preview of "Show Mesh" and "Show Repair."

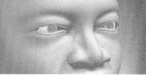

I truly hope that you have found this book to be educational in your efforts to take your work to the next level using 3D. Remember to use the app as a companion to the book and use your imagination to create alternatives to what I have shared with you.

What You Have Learned

- You can have effective workflows with other 3D programs.
- Zbrush is often used to improve upon the initial 3D creation.
- GoZ is an effective way to send 3D objects back and forth between Photoshop and Zbrush.
- To print your 3D object you must be in the Print Settings mode.

Index

Printed and bound by CPI Group (UK) Ltd, Croydon, CR0 4YY

25/10/2024

01779591-0001